OVER MALAYSIA

contents page: The forest and the river have long been dominant forces in Malaysia's landscape, and in the awareness of the people who make their living there. While many Malaysians are now city dwellers, for whom the forest exists only as a backdrop, other Malaysians, like these farmers in Sarawak, East Malaysia, live and work on the river and by the forest.

pages 6 and 7: the Rajang River is the longest river in Sarawak, navigable for 160 miles upstream.
Above the rapids, as seen here, it displays all the vitality of youth.

pages 8 and 9: Malaysia's humid forest mists, these on the West Malaysian peninsula, are lit by the rising sun.

pages 10 and 11: Kuala Lumpur is the showcase of Malaysia's coming of age, where graceful colonial buildings flank modern sky-scrapping edifices.

This book would not be possible without the active support of our sponsors:

 RESORTS WORLD BHD

Original photographs were taken from the helicopters of the Royal Malaysian Air Force.

Project Coordinator: Marina Mahathir
Editor: Peter Schoppert
Photos & French edition: Marie-Claude Millet

First published in 1992
Reprinted with updated photographs 1997

Published by Archipelago Press
an imprint of Editions Didier Millet
593 Havelock Road #02-01
Singapore 169641

© Copyright Editions Didier Millet 1992, 1997
Photographs © the photographers

ISBN: 981-00-3071-1

Printed in Italy by Milanostampa

OVER MALAYSIA

PHOTOGRAPHS BY GUIDO ALBERTO ROSSI

TEXT BY KEE HUA CHEE

ADDITIONAL PHOTOGRAPHY BY TARA SOSROWARDOYO, GEORG GERSTER, BERNARD HERMANN, AND ALBERTO CASSIO
ADDITIONAL CAPTIONS BY HEIDI MUNAN

ARCHIPELAGO
PRESS

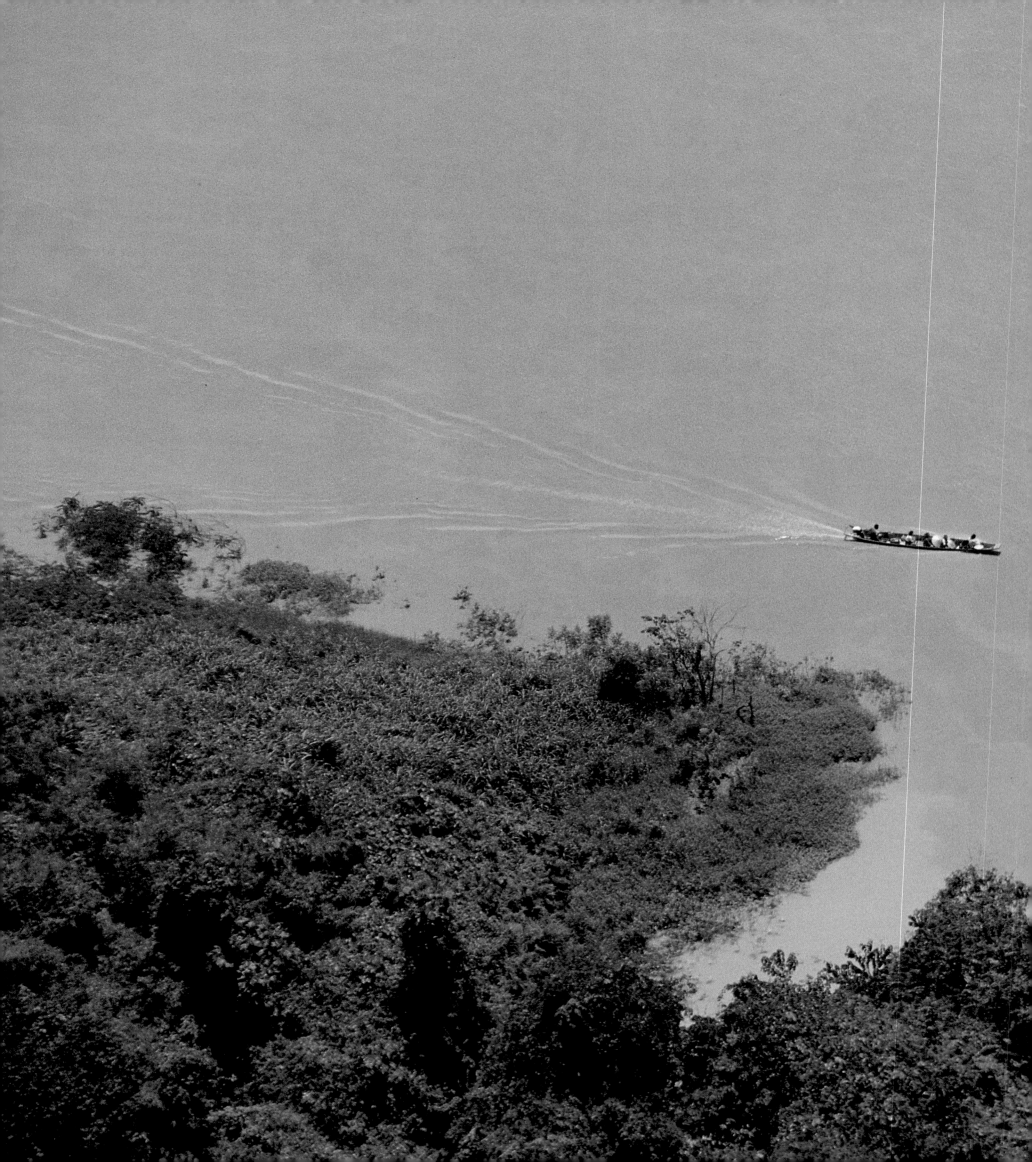

CONTENTS

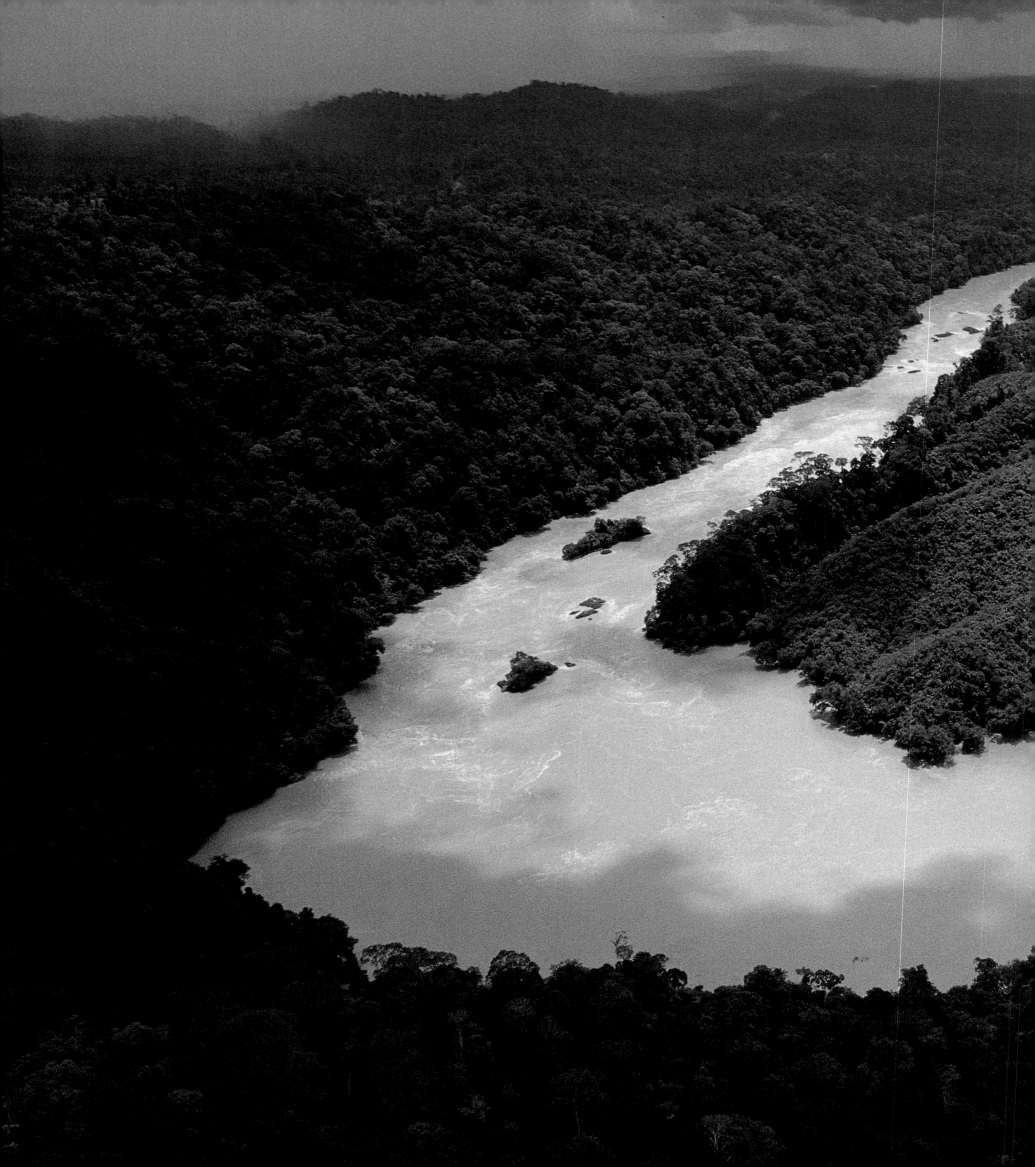

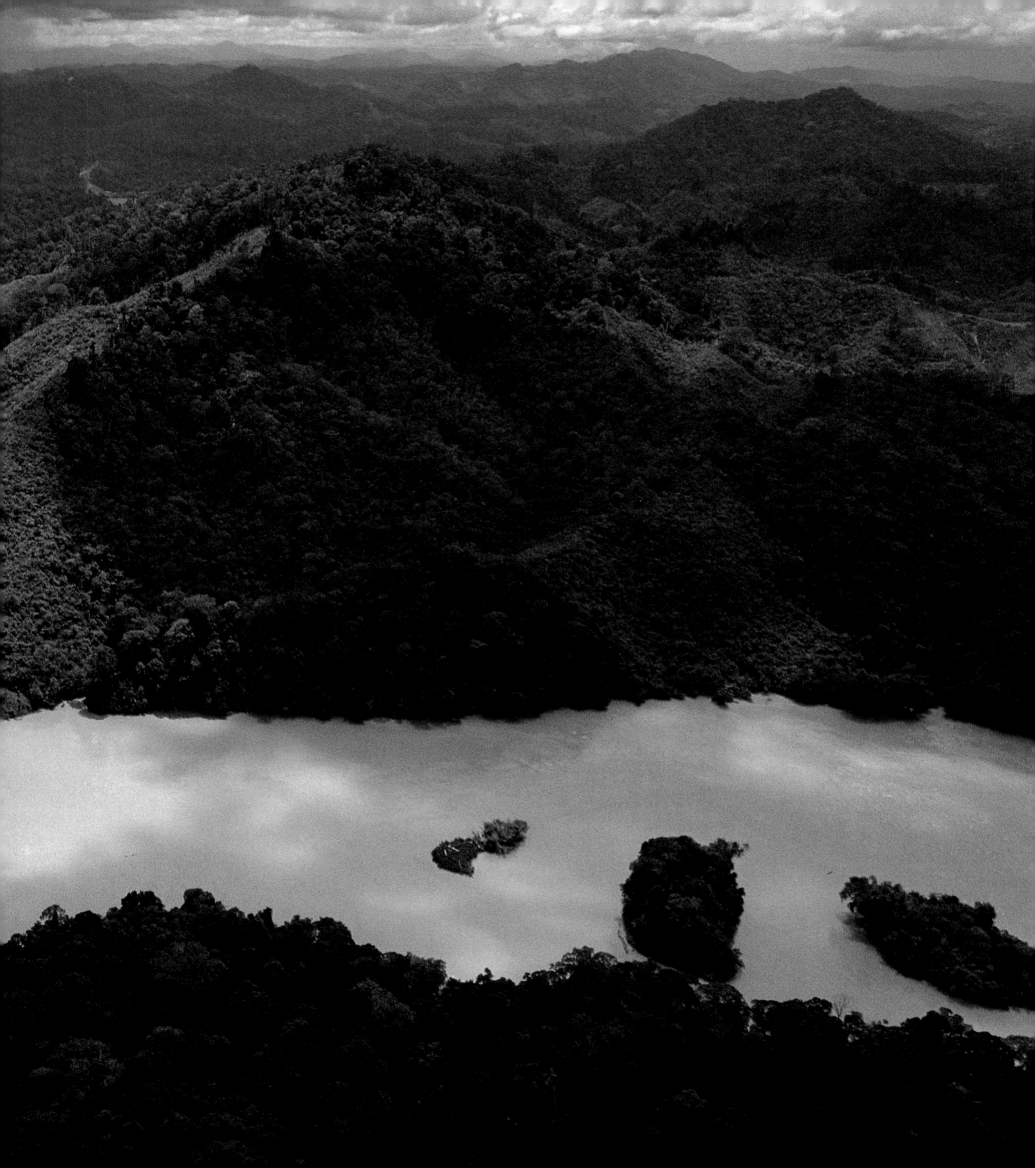

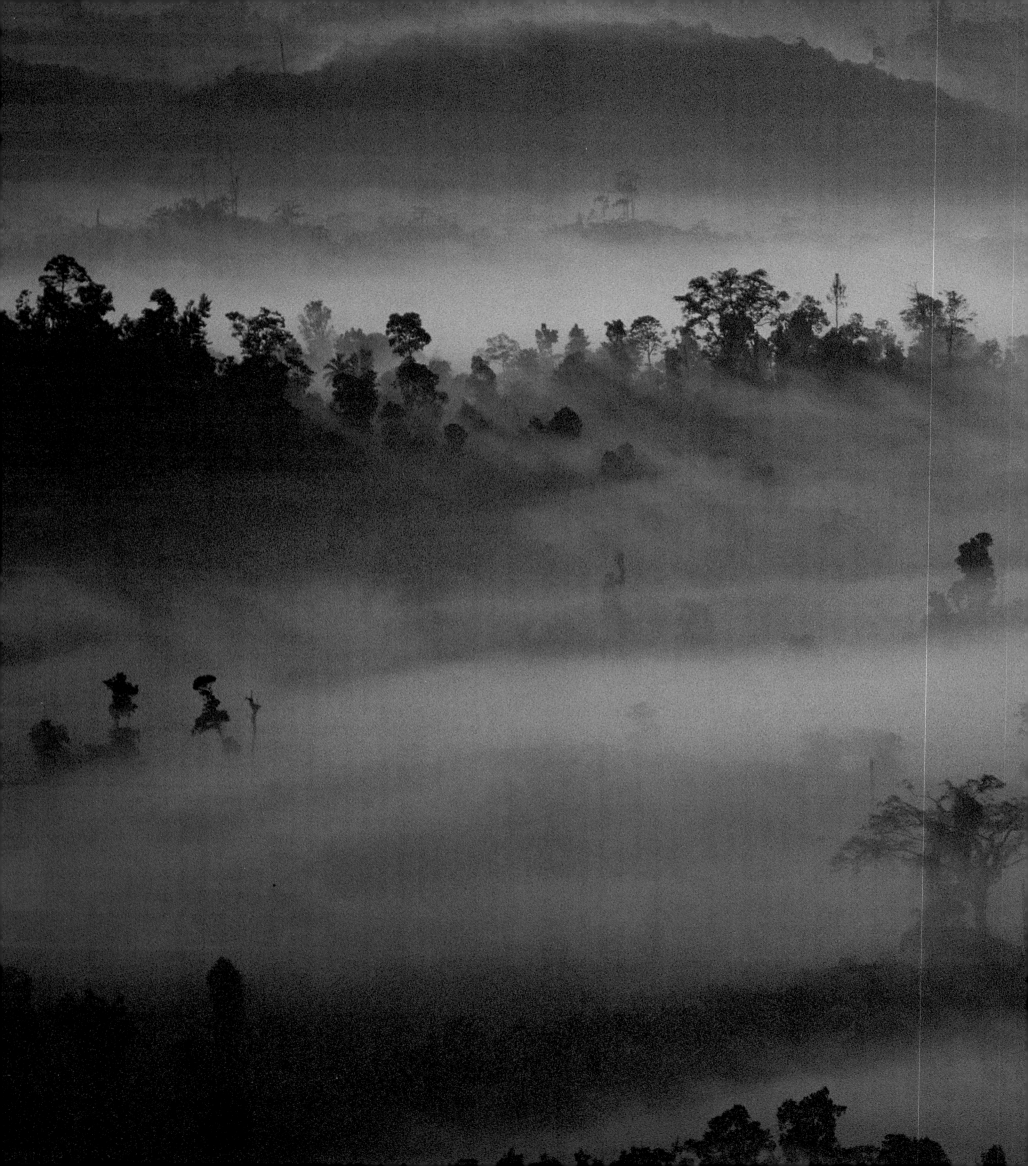

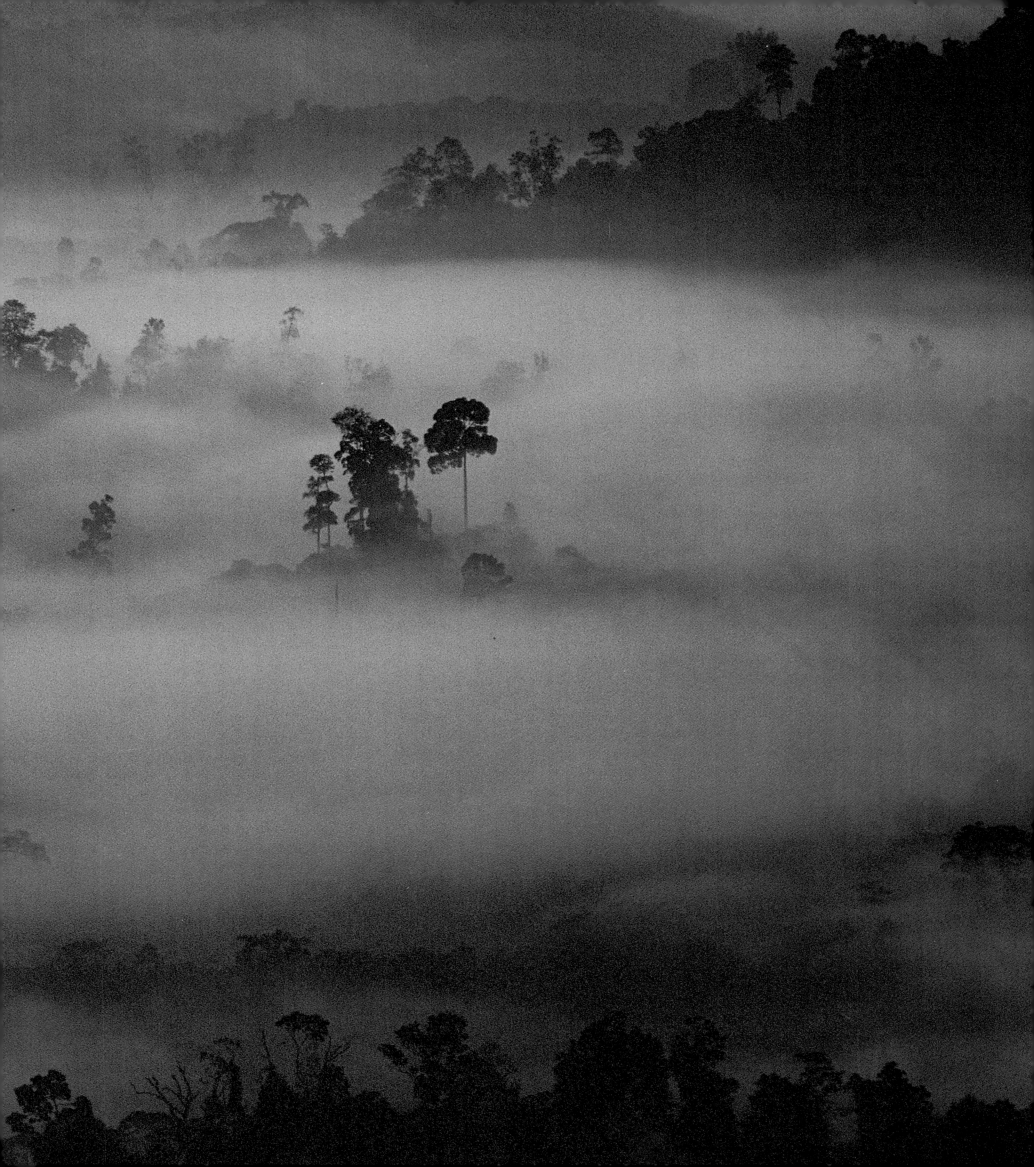

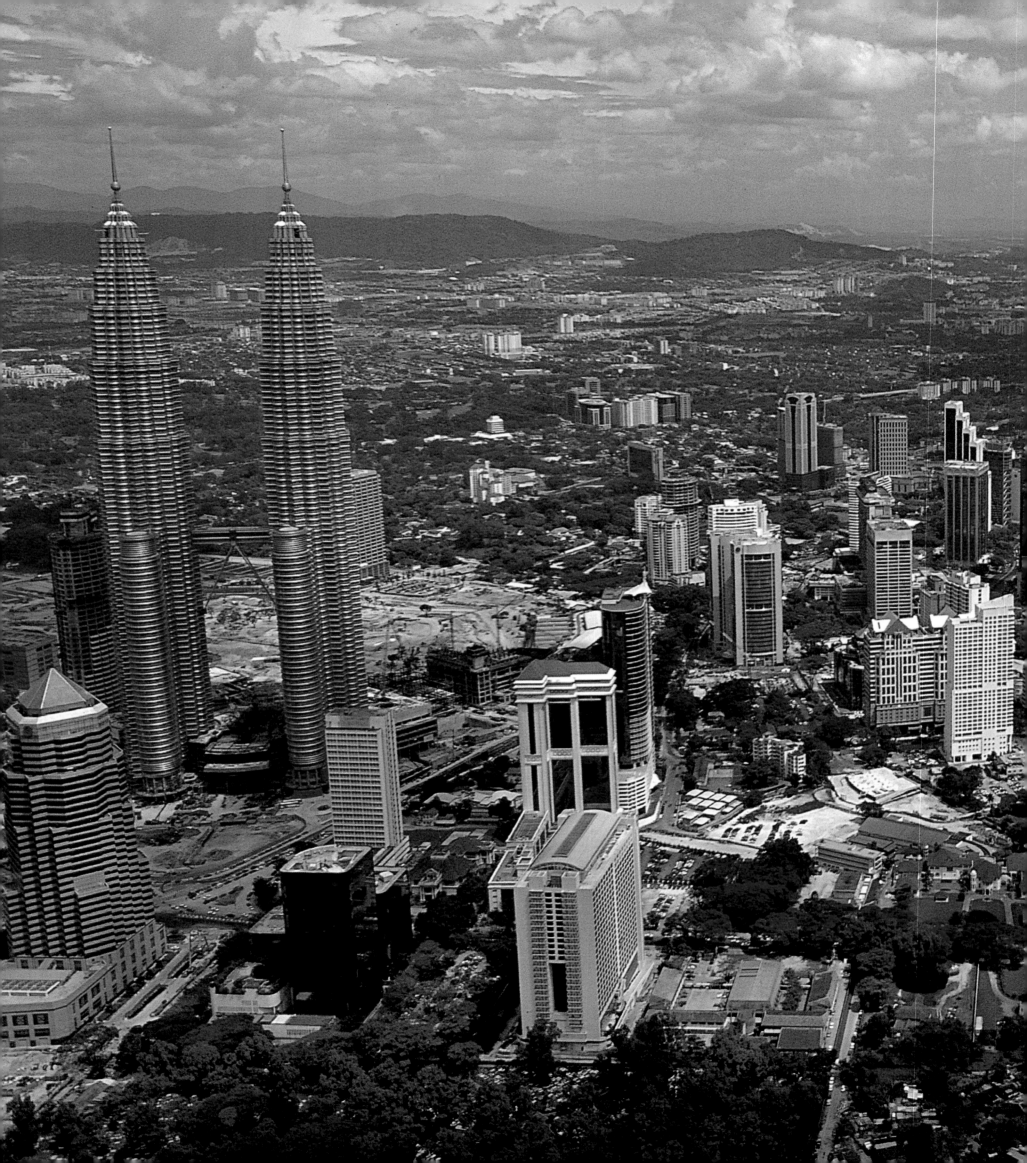

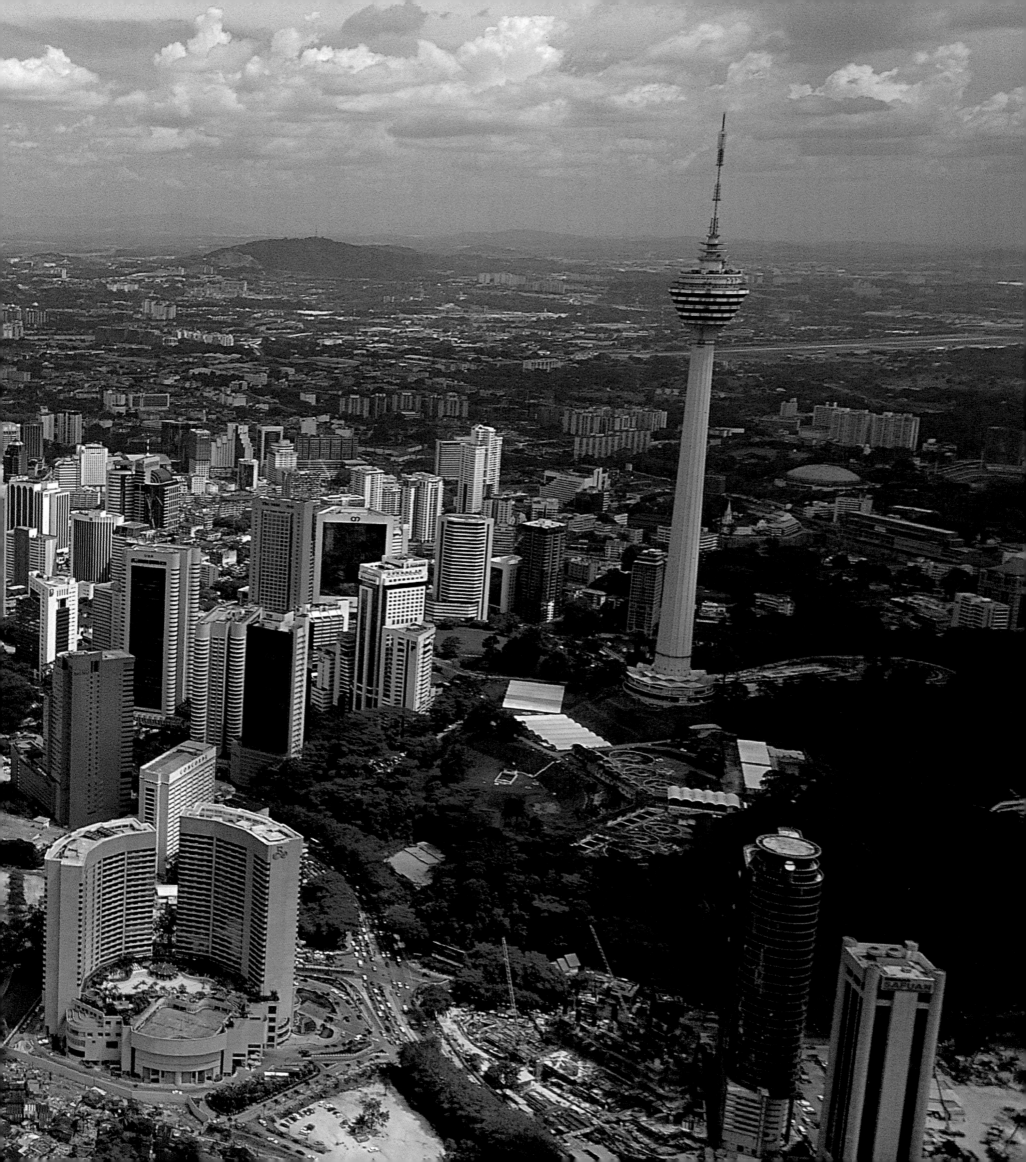

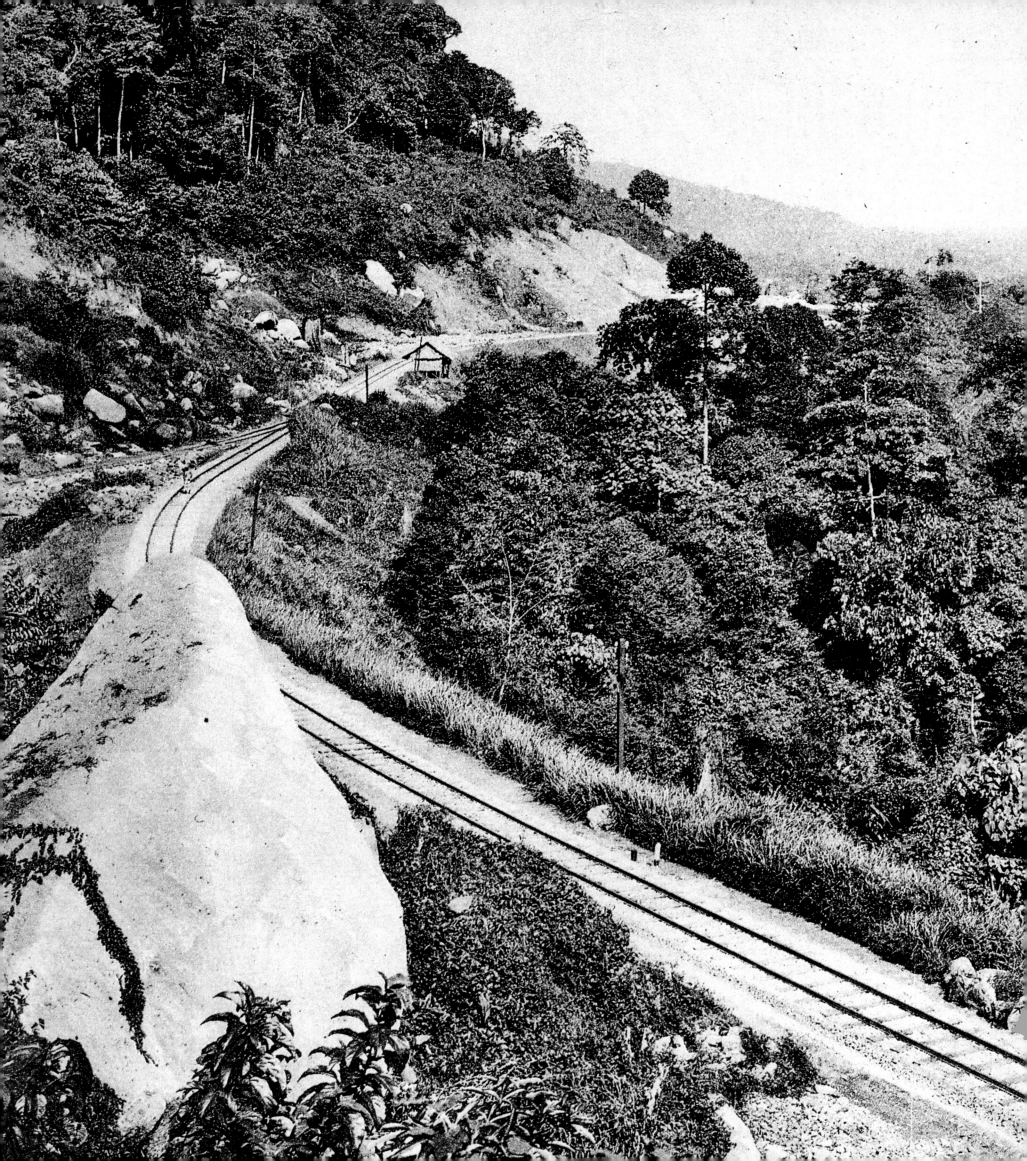

Whichever way you look at it, Malaysia is enchanting and exotic. None of these qualities are lost from above, but the exalted perspective of the aerial view does impose a certain uniformity that is not evident from the ground. From above, Malaysia spreads out deliciously like an endless carpet of broccoli. Despite massive opening of land for development, plantations, and lumbering, over 70% of Malaysia is still forested. Green, from every standpoint, is the clarion colour. Modern Malaysia constitutes the Malayan Peninsula on the Asian mainland and Sabah and Sarawak on the north coast of the island of Borneo. The mainland—West Malaysia—is separated from the two East Malaysian island states by the South China Sea. West Malaysia stretches 740 kilometres from Perlis in the north to the Johor Straits down south, encompassing Kedah, Kelantan, Melaka, Negri Sembilan, Perak, Pahang, Pulau Pinang, Terengganu, Selangor and the Federal Territory of Kuala Lumpur. Its 1930-kilometre coastline etches out a tantalising pear shape between the Straits of Melaka and the South China Sea. East Malaysia has a 1120km coastline running from Tanjung Datu in the west to Hog Point in the east.

Peninsular Malaysia's green blanket heaves and undulates along its backbone—the Main Range—, running from the Thai border southwards till Negri Sembilan, effectively isolating the east from the west. This topographical division has historically served to differentiate and define two regions, deserving of capital letters, the West Coast and the East. Within the regions, their rivers, running out from the Main Range were the main avenue of communication. Almost all the states here take their names from their principal rivers and the state capitals tended to spring up at the river mouth. Malaysia's longest rivers are across the South China Sea; the Rajang of Sarawak (563 kilometres) is navigable 160km upstream and the Kinabatangan of Sabah, equally long, flows eastwards to the Sulu Sea. Sabah boasts Southeast Asia's highest mountain: Mt Kinabalu rises to 4176 metres, or 13,700 feet, the culmination of the Crocker Range. In Sarawak, the interior is generally mountainous, and the highest peaks line the border with Indonesia's Kalimantan.

Rice cultivation breaks the forest monotony with its patch-works throughout the Peninsula, especially in the traditional centres in the Peninsula's north. Depending on the season, the fields take on hues of green, gold, or brown, and when flooded before planting they reflect the hues of the sky. Other tracts in the West Coast begin to rival the forest, with visions of carbon-copy slender trees and elegant, stately fronds. The huge rubber and oil palm estates that seemingly go on forever, relentlessly, are mostly here. The coastal regions are fringed by dark ranks of mangroves, their aerial roots poking out from the brackish waters. The East Coast is justly famed for its more sandy shorelines, with beaches flanked by sentinels of fruit-laden coconut trees. Like emeralds set in a literal sea of aquamarine, the pristine and suitably coral-reefed islands of Perhentian, Redang, Tioman and myriad others wink enticingly.

In East Malaysia, settlements are concentrated along the rivers and coasts, and vineyards of pepper, gambier and other spices are reminders this was once the first outpost of the Spice Islands. The Malayan Peninsula was known to ancient Europeans as the land of the `Golden Chersonese'. It was a vital stopover between churlish monsoons for traders enroute to the Orient or Occident. The gold still shimmers. For its natural and economic wealth, Malaysia remains pivotal as the heart of Southeast Asia.

Charles Kliengrothe photographed British Malaya in the early 1900s, capturing images of the colony's industry and infrastructure, as in the photo, preceding, of Padang Rengas Pass.

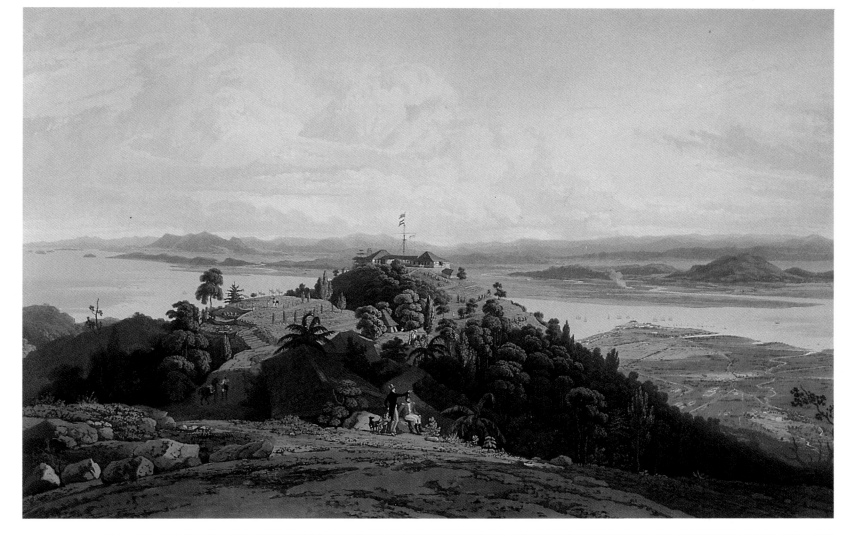

Penang was an early base for the British in Southeast Asia. And very quickly after the founding of Georgetown in 1786, the colonials found the cool heights of Penang Hill to be an ideal retreat from the heat and bustle of the port some 1000 metres below. These views, from an album published in 1821, foreshadow the appeal of aerial photography, and demonstrate the 19th century British fascination with landscapes and vistas.

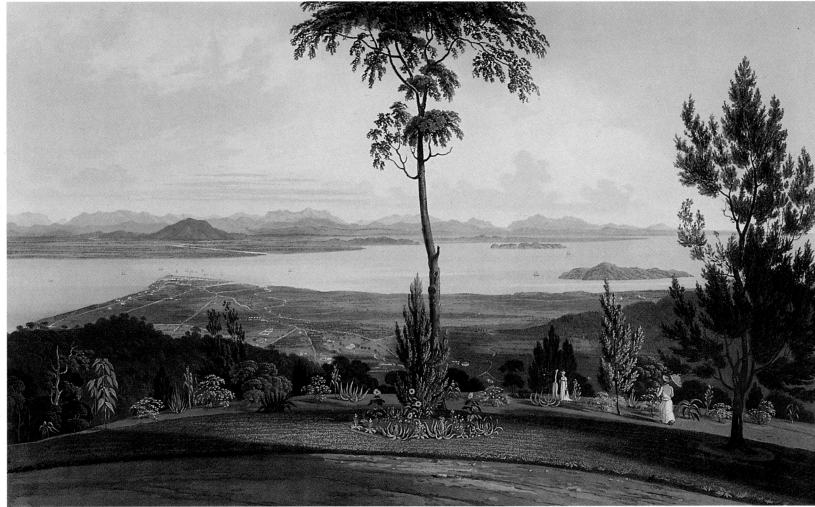

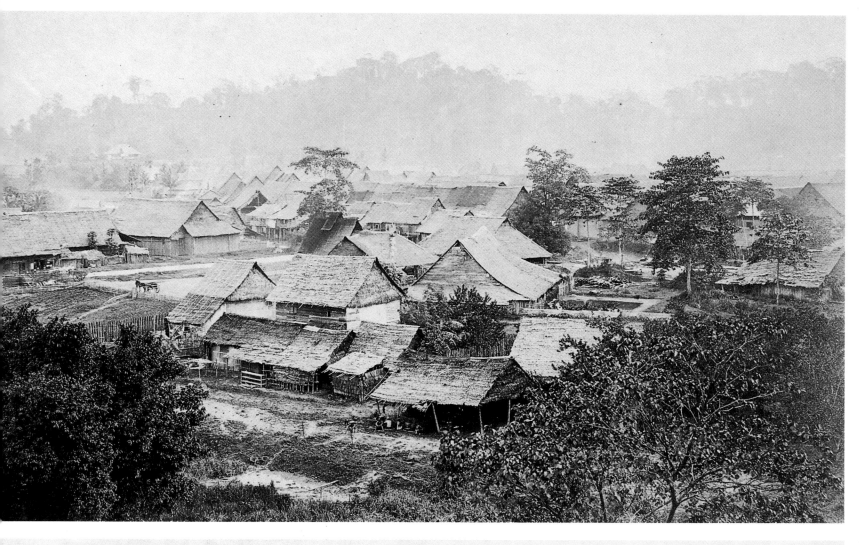

These two panoramic views date from 1884 and 1882 respectively. The top photo is of Kuala Lumpur, and the wild and woolly appearance of what was little more than a trading post at the time underscores the city's relative youth. It will strike some as odd that KL was so undeveloped compared to Taiping two years earlier, in 1882 a tidy town of brick houses, well-laid out pathways and a *padang*.

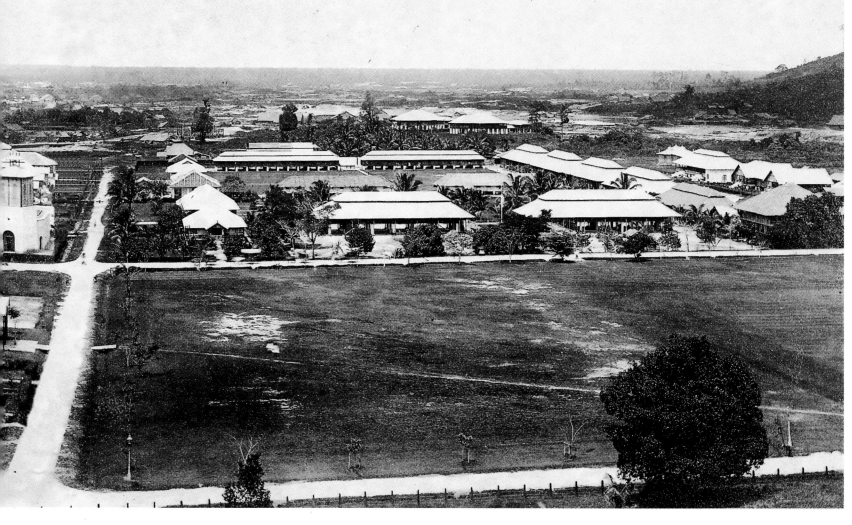

THE PENINSULA

From the knotted Trans-Himalayan plateau of central Asia, a spine of mountains works its way down to East Burma, following a loopy line of gravity through Thailand to form the backbone of the Malayan Peninsula, southernmost appendage of the great Eurasian landmass. It would be simplifying reality to say that Malaysia's Main Range—or Barisan Titiwangsa—divides the Peninsula into two, but the two coasts, West and East, have a distinct identity, brought about in part because of this mountain barrier. The range runs down to the south-southeast, with the ridges slicing now and again unevenly off to the east, effectively isolating the East Coast states of Kelantan, Terengganu and vast tracts of Pahang. The lop-sided thrust ends at Negri Sembilan, and the relatively low-lying southernmost state—Johor—is traditionally part of the West Coast. The landforms of the peninsula bear the marks of a watery past. The Main Range was uplifted from the seabed eons ago, and its granite heart is often covered over with sedimentary rock that formed when the area was under the sea. Great chunks of white seabed limestone litter the Peninsula, and the exfoliating action of the elements has shaped them into spectacular forms, especially outside of Kuala Lumpur, in the Kinta Valley near Ipoh and at various outcrops in Kelantan, Pahang, Kedah and Perlis. Lying at the interstices of these limestone formations are sands and clays, loosely packed debris of eroded sedimentary rock. If the peaks of the Main Range form the geographical spine of Malaysia, the sands at their feet make a foundation of a different sort: these alluvia are loaded with precious tin ore. Tin opened up Perak and Selangor in the 19th century, luring miners from China and transforming a shanty town into a boomtown that later became the nation's capital. The modern capital of a dynamic nation retains its original trading post name, describing itself in an apt if unflattering fashion. Kuala Lumpur means literally 'Muddy River Mouth'.

From the air, or even from a highrise vantage, Kuala Lumpur can be seen to share all the elements of the Peninsula's geographic setting. The city is watched over by the peaks of the Main Range, including the 2000-metre Gunung Ulu Kali. Arranged in tiers below the blue shadow of the highlands are limestone formations, including Klang Gates and the dramatic sugarloaf of Batu Caves. The alluvial tin-bearing sands that first brought settlers to the area are in evidence on the city's outskirts, where huge residential developments arise on the sites of disused tin mines. The residents of Kuala Lumpur share the joys of living in a tropical environment. Despite thirty years of sometimes headlong urban growth, green lungs rejuvenate and rehydrate the city. The Lake Gardens are the most well-known and romantic of the city's green spaces, with blossoming plants, stately trees, and a man-made lake. It is here, on two green hilltops divided by a surprisingly unobtrusive highway, that one finds two of the nation's most potent symbols, the National Monument, which commemorates the sacrifices attendant on Malaysia's birth, and Parliament House, beacon of democracy.

During the official launch of Visit Malaysia Year 1990, a promotional effort that did much to put Malaysia on the world tourism map, the Prime Minister Dato Seri Dr Mahathir Mohamad declared Kuala Lumpur a 'Garden City of Lights'. Garrisons of elegant trees and flotillas of flowering plants line Kuala Lumpur's

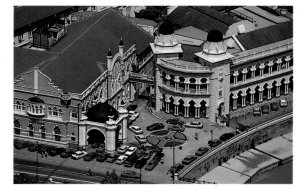

The aerial view (preceding) gives a scene of pineapple and oil palm plantations a delightful texture. Kuala Lumpur's downtown is dominated by fanciful architecture.

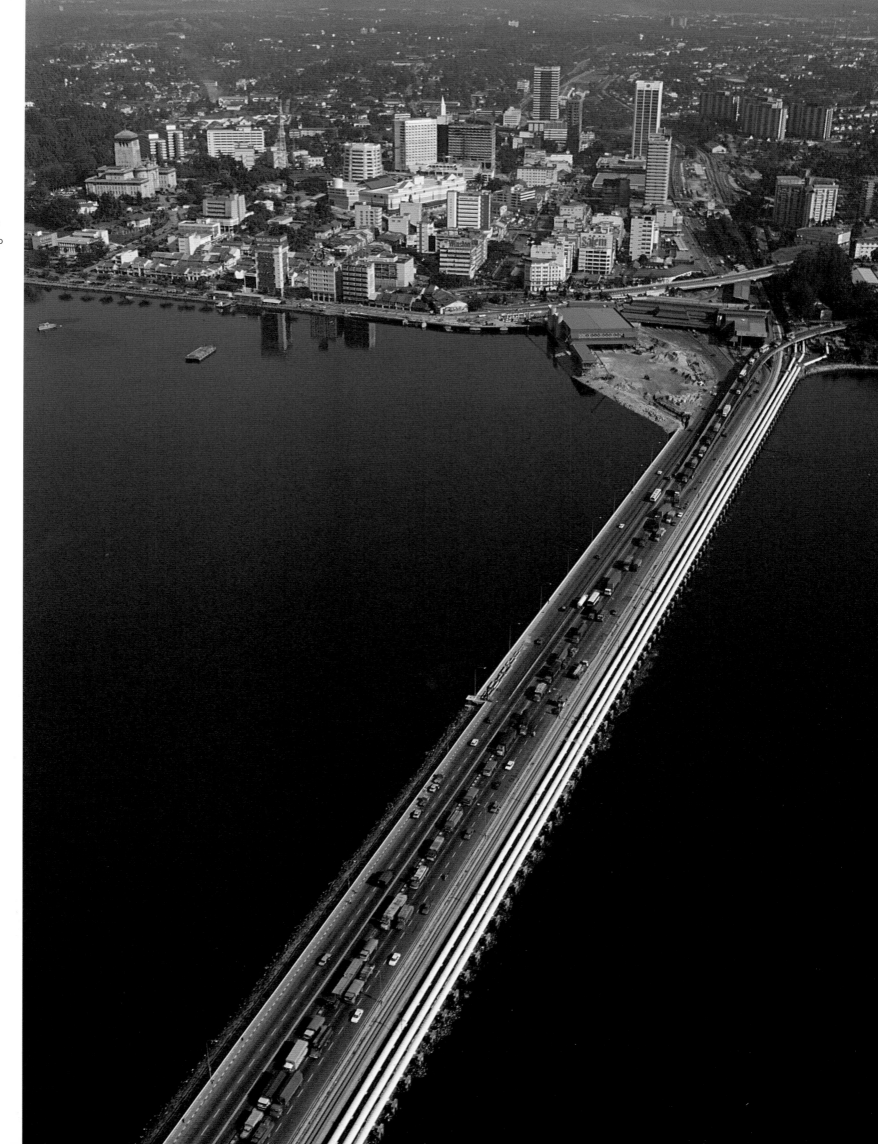

This causeway links the extreme southern tip of the Asian continent, the Malaysian town of Johor Bahru, with the island of Singapore. While Singapore left the Federation of Malaysia in 1965, the two countries are still closely tied together: the 1924 causeway is often jammed with traffic, and the pipelines visible here carry a sizeable portion of Singapore's fresh water needs. Increased arrivals into Malaysia from Singapore necessitated the expansion of the Immigration Post on the Malaysian side, and the building of a second road link west of Singapore.

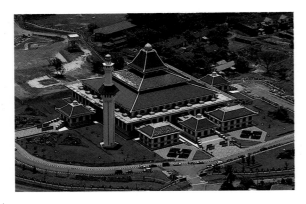

The green colour that dominates the Malaysian landscape is also said to be the favourite colour of the Prophet Mohammed. It is used here for a new mosque built in traditional Melaka style.

boulevards and streets, softening the concrete outlines of the city with a soothing—or to use a local expression—'cooling' effect. The University of Malaya's Rimba Ilmu, or Jungle of Knowledge, contains no less than 1500 species of native plants on 40 hectares of campus land. The 're-forestation' of the city has been so successful that birds once confined to the snobby suburbs on the hills have condescended to flutter into town every now and then. Kuala Lumpur is relaxed and liveable. Its growing middle class, has enough economic clout to fill shopping malls, cultural centres, cinemas and entertainment plazas.

Being just a heartbeat from the equator, the median temperature in the peninsula is high, from 25°C to 28°C. The humidity and rainfall are also suitably equatorial. But a few hours' drive from Kuala Lumpur are the cool getaways of the highlands and foothills of the Main Range. The sweltering heat of the lowlands evaporates among the mountains, and the thermometer can plummet to a temperate-seeming 16°C. And besides relief from the heat, many of the hill stations offer another attraction, a panoramic view from on high.

The nearest of the hill retreats to Kuala Lumpur is Genting Highlands. From the city centre it can be seen, when not hidden by cloud cover, as a far-off speck dominating the highest visible ridge of the Main Range. Seen from closer up, or from a helicopter hovering over the knife-sharp ridge, it is a glitzy multi-million-dollar mega-resort, perched unabashedly, provocatively, almost impossibly, on top of a mountain. Genting's Casino and famous night-time entertainment combine with the altitude and setting to give many a lowlander shortness of breath. The founder, Tan Sri Lim Goh Tong fancied a holiday bungalow atop Gunung Ulu Kali, but calculated that the cost of driving a road through some of Malaysia's most impregnable terrain did not justify just a single building. When the bulldozers started up in 1965, they cleared a pathway to a highland farming and tourism resort, in a feat of tremendous engineering skill and ingenuity. In 1971 the Highlands Hotel opened its doors, and in 1978, the new Genting Hotel, making a total of 1115 rooms and 1770 apartments available on the mountain top. Those seeking the aerial view might consider the Genting Cable Car as an alternative to a helicopter or a light plane. The cable car floats from a 912-metre elevation to 1768 metres, beginning from a landscape of upmarket country clubs, and horse ranches, passing over deep forest, and a multi-tiered, multi-hued Chinese temple pagoda that arises out of the jungle like some bizarre and exotic mirage. Forever might not be visible from Genting, on a clear day, but most will make do with Kuala Lumpur, the Straits of Melaka to the west and the South China Sea to the east.

In its brashness and exuberance, Genting Highlands may be very Malaysian, but the hill resort was first an obsession of the British. In the colonial days, when they were masters of the country—if not the climate—they used to migrate each season to high plateaus like Pahang state's 1500-metre-high Cameron Highlands, named after its discoverer. In 1885 William Cameron stumbled onto "a fine plateau with gentle slopes, shut in by mountains" while on a mapping expedition. When the plateau was found to be ideal for tea growing, a boom began. A clutch of charming cottages and bungalows with functioning fireplaces nestled among scented rose gardens made Cameron Highlands a Lilliputian

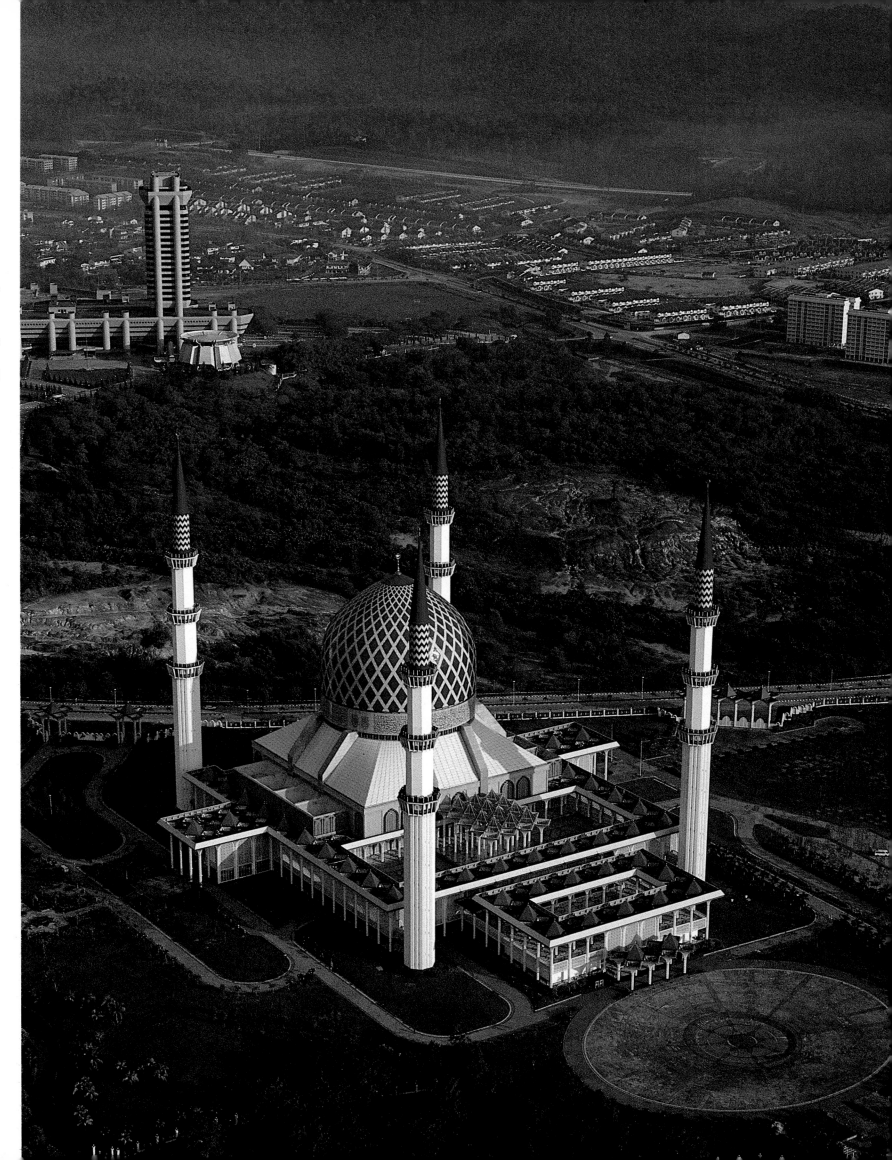

The magnificent
Sultan Salahuddin
Abdul Aziz Shah
mosque of Shah Alam,
Selangor's capital,
encompasses both
classical and high-tech
elements.
It draws on the refined
tradition of Sinan,
architect of Istanbul's
great mosques, yet
modern technological
innovations ensure
that the building has
brilliant acoustics,
and provides a new
level of comfort for
worshippers.

England flourishing at the height of summer all year round. Today, a modern condominium flaunts window boxes laden with the most un-tropical of fruits, strawberry plants! Also in Pahang is Fraser's Hill, around the altitude of the lower Cameron Highlands. The adventurer Louis James Fraser built a house in the hills, and operated a lucrative if primitive mule train, carrying tin ore over a mountain pass. When he mysteriously disappeared before World War I, Bishop Ferguson-Davie of Singapore set out on a search-and-rescue mission. Though he came back without news of Fraser he did tell of a small, hidden plateau, an ideal retreat for those who couldn't, well, take the heat. The last eight kilometres to Fraser's is along a winding road called the Gap, so narrow and deliciously precarious that only one-way traffic is permitted. Traffic follows a strict timetable.

Further north is Maxwell Hill, or Bukit Larut, in Perak. This is the country's oldest and smallest hill station, but it is blessed with the biggest sunflowers, dahlias, daisies, pansies, lupins and marigolds. About a thousand metres high in all, the hairpin road makes for a hair-raising ride only possible for four-wheel-drive vehicles. But at the top, a panoramic view awaits. And gleaming in the distance is Penang, Pearl of the Orient

If there was a need to show a historical precedent for the appeal of aerial photography, Penang Hill, now Bukit Bendera, would do. Like a good aerial photograph, the view from Penang Hill is transcendent, taking in far horizons as well as bringing the eye down a precipice, to see the city of Georgetown below, flattened out as in a map. The view from the Hill was popular from the time of Francis Light, who sequestered the island from the Sultan of Kedah in 1786, as a naval and trading base for the East India Company. In 1821 a series of views from the heights was published in England (see page 15). The hill, a mere 850 metres, is best scaled via a funicular railway, built in 1923. Modern coaches have replaced the wooden carriages, but the ambience remains, and the rider still needs to change trains midway. The leisurely ride is a treat, and the temperatures lighten to 18°C, as the flowers run riot. Cool Penang Hill was once a hot favourite, as the sedate European mansions testify. From here, in one fell swoop, you can take in Penang's capital, Georgetown (after George III), Province Wellesley (after the Marquis of), the North Straits, the Kek Lok Si Temple at Air Hitam, and Penang Bridge, a long arc which links the island to the mainland.

The hill stations thrive best when they are paired with an urban centre. Their refuge is only necessary when there is a place to flee from: KL in the case of Genting and Fraser's, Ipoh for Cameron, and Georgetown for Penang. The West Coast developed in an entirely different fashion from the East, and as a result of the tin industry, better transportation and ports protected from the monsoon, and its position flanking the Straits of Melaka, the West Coast is more urbanised, more industrial, and relatively better off than the East. The East is quieter, more traditional, and has no hill stations.

The East Coast states of Kelantan, Terengganu and Pahang share many similarities by virtue of their relative isolation. Malay folk culture is generally accepted to be at its purest in the East Coast, where Chinese, Indian, Indonesian and Western influences have been more or less muted. The ordinary folk live simple, unpretentious lives in fishing and farming villages scattered along the 544-kilometre coastline, lapped by the South China Sea. All administrative bodies conduct their

This city sidewalk is decorated with planters for bougainvillaea. Malaysia's city planners are making use of the colourful possibilities provided by tropical vegetation.

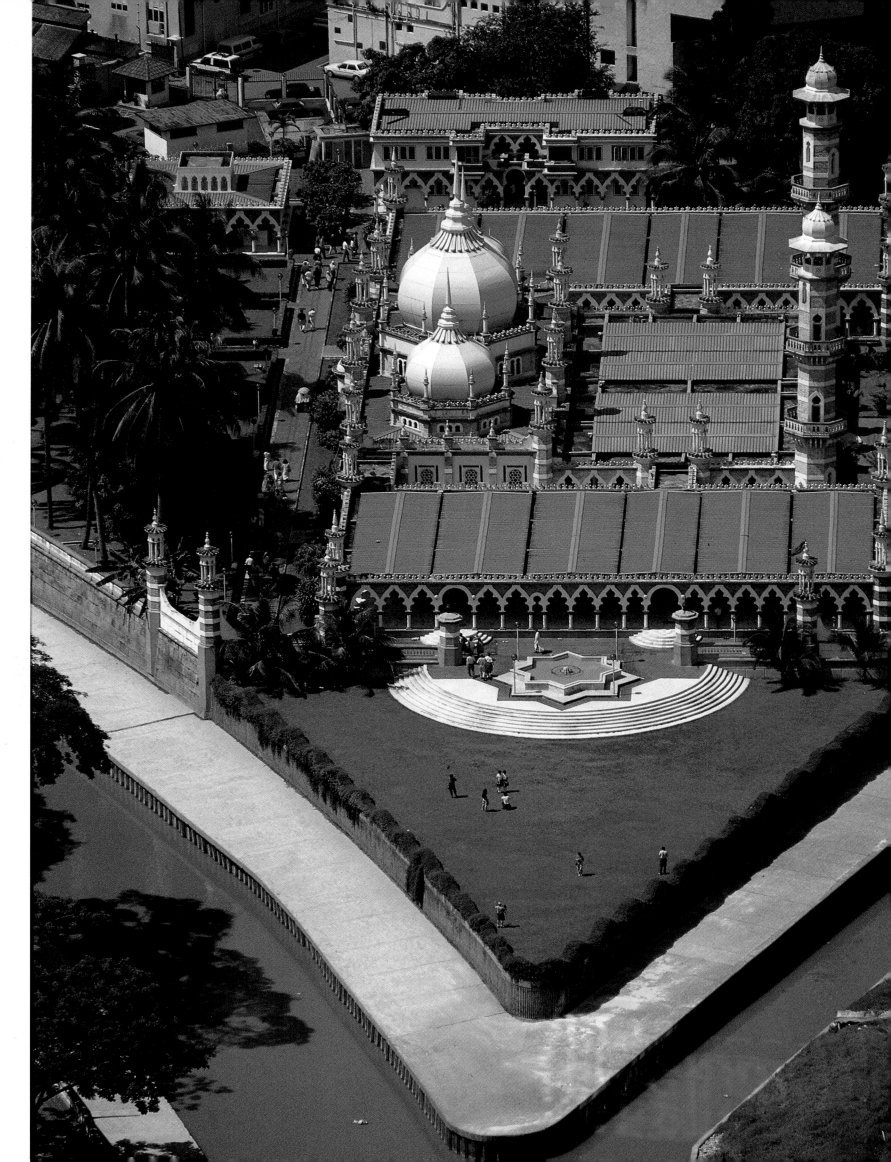

The place where Kuala Lumpur began. This is the famous muddy confluence of the Gombak and Klang rivers, now hemmed in by concrete, in the heart of Kuala Lumpur's business district. The confluence is dominated by the Jame Mosque, the city's oldest, and arguably its most graceful.

business from the capitals of Kota Bahru, Kuala Terengganu and Kuantan. Ditto for banking, trading, and manufacturing. The population hovers around a million each for Kelantan and Pahang, and over 600,000 for Terengganu. Still, each state nurtures a distinct personality.

Kelantan holds the singular honour of being the only state to have been governed by female rulers, the famous beauties Che Siti Wan Kembang and Puteri Saa'dong whose grace, power and prestige spread far and wide. To this day, only women transact retail trade and hold court in Kota Bahru's bustling Central Market. Being next door to Thailand, Kelantan's history tended to be intertwined with its larger, more aggressive neighbour. Once a vassal of the Srivijayan Empire, Kelantan converted to Islam in the 15th century and by the 19th it was the most densely populated state on the peninsula. It fashioned the fabulous 'Bunga Mas' or Tree of Gold as tribute to Thailand in exchange for relative autonomy. Only in 1909 did the British assume overlordship. Kelantanese are among the friendliest, most easy-going and musically inclined of Malaysians. Their beaches ore acclaimed for their pristine allure, their swathes of golden sand and their fantastic names with meanings such as the Beach of Passionate Love, the Beach of Harmonious Melody, the Beach of Whispering Breezes, the Beach of the Seven Fatally Charming Maidens...

Terengganu has long languished in Kelantan's shadow. The East Coast arts, batik, *songket* weaving, and silk however find a home here. Kelantan invariably gets the credit for these crafts, by virtue of entrenched association. But new petroleum drilling and refining industries mean Terengganu can flex its economic muscles. Its mesmerising islands of Perhentian, Redang and Kapas are irresistible bait for sunseekers and scuba divers. Pahang state, the peninsula's largest. is also home to several top-class beach resorts, and it too has benefited from new prosperity.

Despite their importance for the modern nation, all talk of the two coasts, the cities and the highlands just delays the inevitable reckoning with the dominant personality of the landscape of the Malayan Peninsula. Only a little way up the slopes of the East Coast foothills of the Main Range, on the margins of Genting Highlands, at the edges of the pleasantly gardened atmosphere of Cameron Highlands or Fraser's Hill, on the gentle peaks around the plateaus, and falling from the ridgelines that snake south and west, is pure untamed jungle. It claimed Fraser, it may also have claimed a famous visitor to Cameron Highlands, Jim Thompson, the Thai silk king, who went for a stroll one day and never returned. As recently as the 1960s, a tiger was spotted strolling across the well-tended fairways of the Cameron Highlands golf course. The peaks of the Main Range rise only a little above the levels of the hill station plateaus. Ridgelines run to the east from Cameron Highlands to form the Pahang-Kelantan

This paradisical hideaway on Malaysia's East Coast is tucked away amidst the natural flora of the beachside, its height limited to that of the casuarina pines.

border, the peaks of Gunung Swettenham (2181 metres) and Gunung Tangga (2014 m) standing out. To the west, the ridge that cradles Cameron's and separates Pahang from the West Coast state of Perak boasts of Berinchang, Tumang Batu and Batu Putih, all over 2000 m. The highest mountain on the Peninsula is Gunung Tahun, which reaches 2187 m, its peak standing fairly undramatically over a high plateau of dwarf montane forest.

The highest ridges, pummelled by wind, are enmeshed in a stunted forest of mass and ferns, where oaks and laurels struggle to grow a few metres high. Lower on

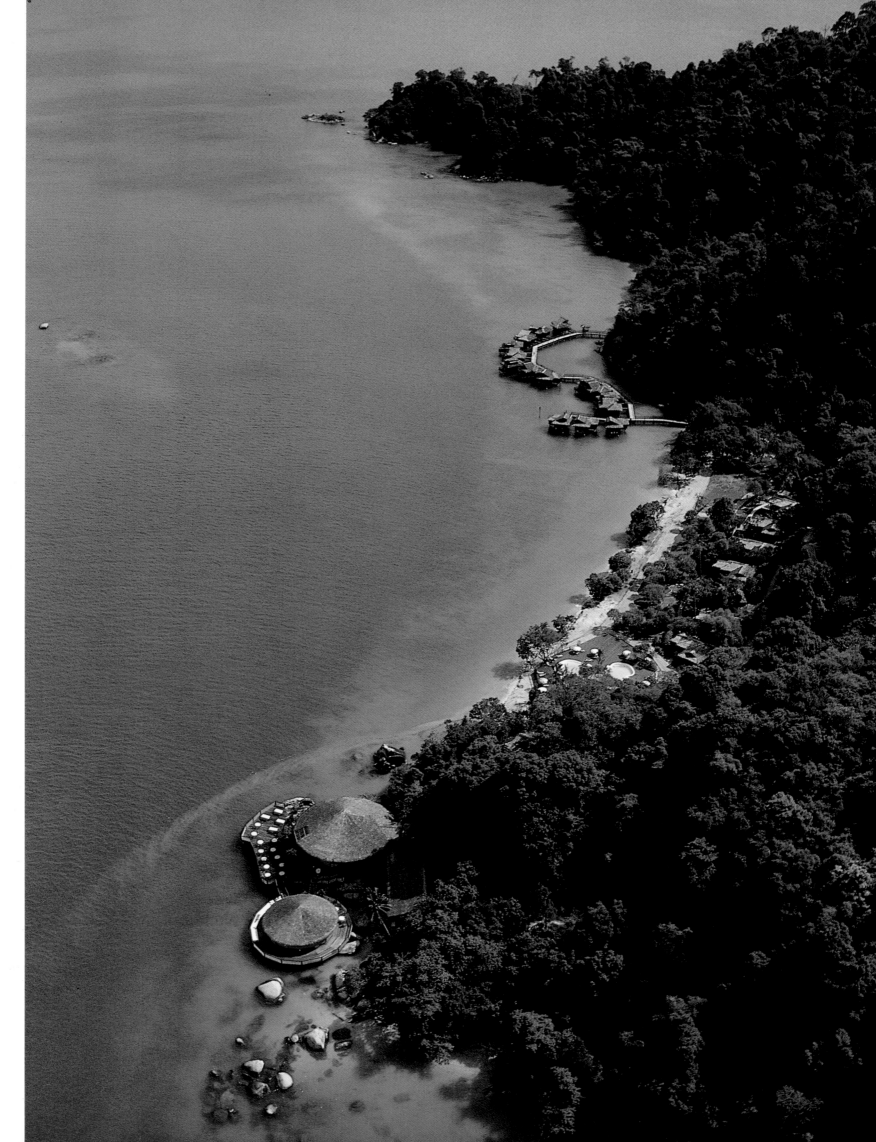

A resort hotel on the island of Pangkor, off the West Coast, in the Straits of Melaka. The design of the resort blends well with the environment, and the Water Villas built just off the shore allow tourists to share in the atmosphere of Malaysia's many 'water villages', settlements built on piles over shallow seas or estuaries.

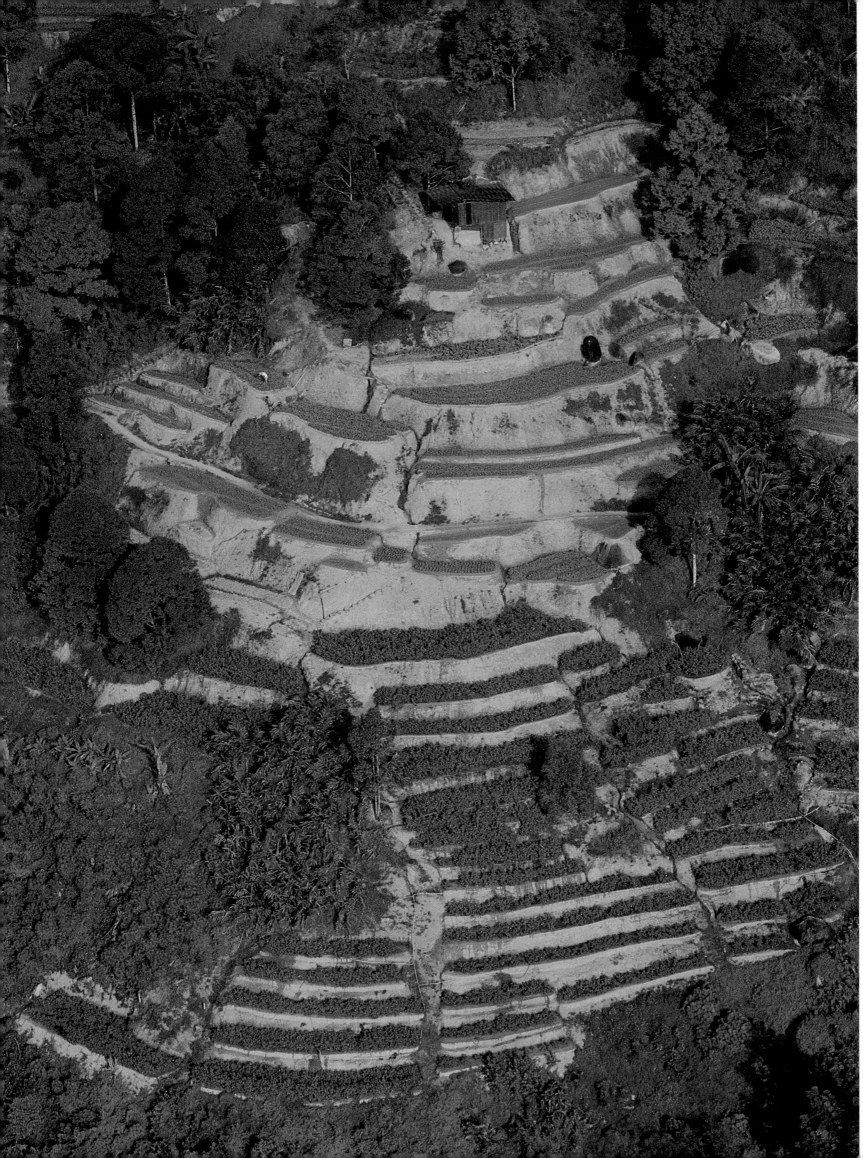

The steep slopes of Penang Hill, which looms over the city of Georgetown, are planted with terraced vegetable fields. Malaysian soils are too soft for terraced rice cultivation, so unlike Indonesia or the Philippines, hillsides are used to cultivate vegetables and other crops which require less water.

the ridges the trees reach 25 metres or so, and tree ferns dominate the hill station trails. But it is at the base of the hills, in the dense lowland forest, that the jungle expresses itself most completely, in every possible shade of life-giving green. The roots of the Malaysian jungle go back 130 million years, for it has been propagating that long in an endless cycle. This rainforest is innocent of upheavals like the Ice Age, which interrupted the flourishing of rainforests elsewhere. The jungles or the Amazon and the Congo Basins, which are often assumed to be the world's most ancient, are secondary forests in the geological terms by which the

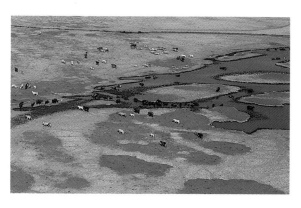

Malaysian forest's age is measured. From the air, the embrace of over 21 million hectares of Malaysia's tropical rainforests beggars description. Greenies will marvel at the statistics: 2500 different types of trees and over 5500 species of other plants. It is not completely unusual to find a hundred species of tree on one acre. In what must be the record for forest diversity, about 820 tree species have been counted in a mere one-fifth of a square mile. And nowhere in Peninsular Malaysia is this rainforest better preserved than in Taman Negara, Malaysia's premier National Park. It covers 4343 square kilometres in the centre of the peninsula, a border area between the states of Kelantan, Terengganu and Pahang. The Park was born in 1925 when Pahang designated 1300 square kilometres of jungle on the slopes of Gunung Tahan as an inviolable gaming reserve. In 1935, in what was for the time a grandly far-sighted gesture, the Sultans of the three states agreed to form the King George V National Park, which became the Taman Negara after Malaysia's 1957 independence. The keepers of Taman Negara have one sole objective, "to utilise the land within the park in perpetuity, for the propagation, protection and preservation of the indigenous flora and fauna," The park has never heard the ominous buzz of a chainsaw. Trees fall here only at nature's behest as an intrinsic part of the cycle of life. Consistently flowering trees are uncommon, but epiphytes like the bewildering orchid more than compensate. The world's largest, the 'mother of all orchids', is *Grammatophyllum speciosum,* native to the region and capable of clawing its way up to eight metres.

Taman negara is a limitless aviary. Birds of over 620 sorts of feather flock together here. The Great, Rhino and Pied hornbills each hover and hop, perching on legs that are thickly feathered, like pantaloons. Fireback pheasants, Fishing eagles, the Masked finfoot, kingfishers and others are often heard and seen together with tens of thousands of species of insect and butterfly. Wild game is generally more abundant and varied in the lowland jungle especially near the meandering rivers. There are over 190 vertebrates. Leading the carnivore pack must be the tiger, rarely seen but still fairly plentiful. The leading omnivore is the Malayan Honey bear and the hottest herbivore is surely the elephant. Taman Negara's various hides deep in the jungle's recesses provide the patient observer thrilling glimpses of such large animals as the Tapir (actually a close relative of the elephant) and Barking deer, Wild boar, Sambar deer, Leaf monkeys, Long-tailed macaques, White-handed gibbons, squirrels and the 'shy' Seladang (Wild ox), which is reputed to attack on sight. The endangered Sumatran rhinoceros, the Clouded leopard, panthers and the Javan rhino are all here too, but their shyness forces them to forego your company.

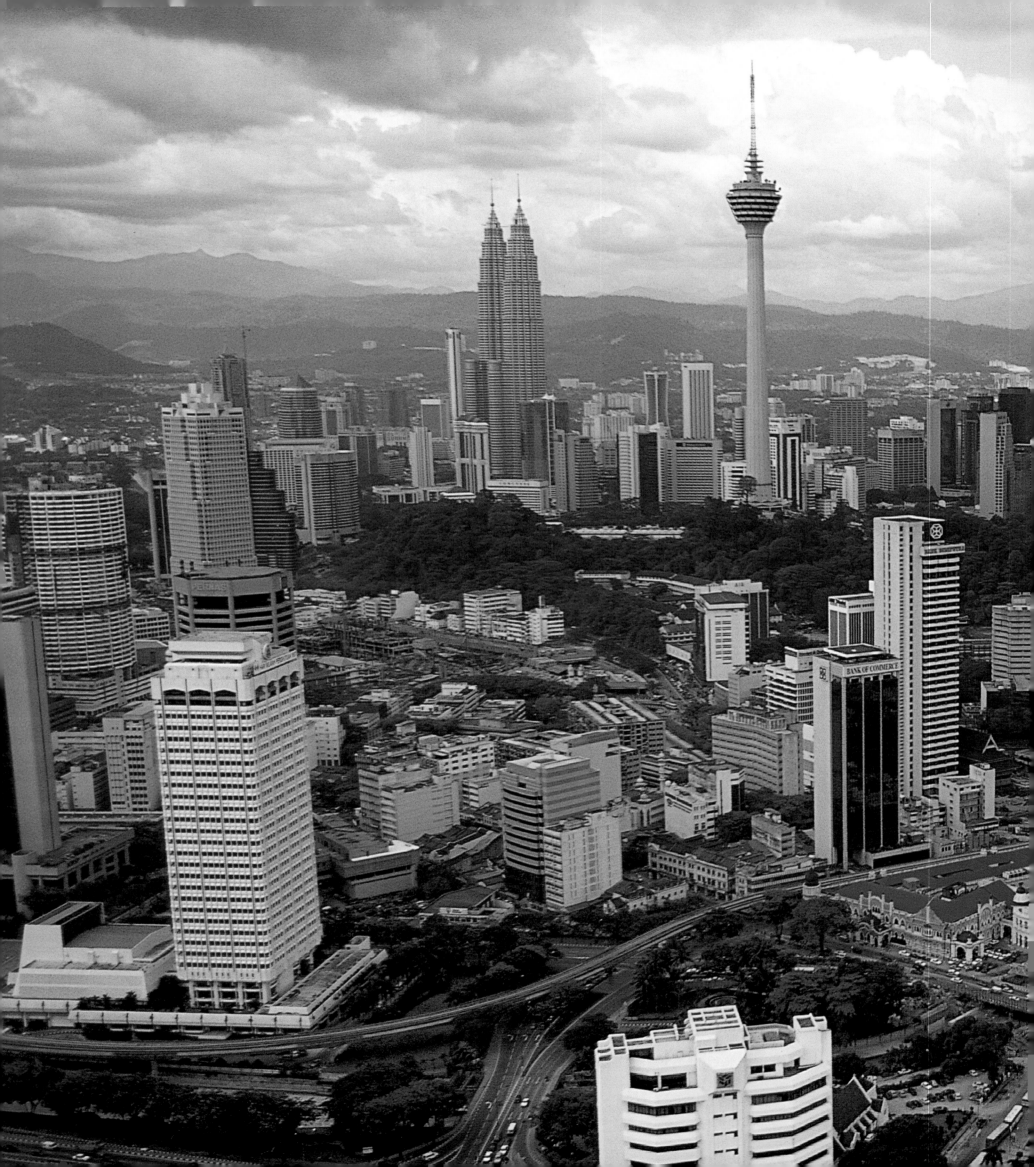

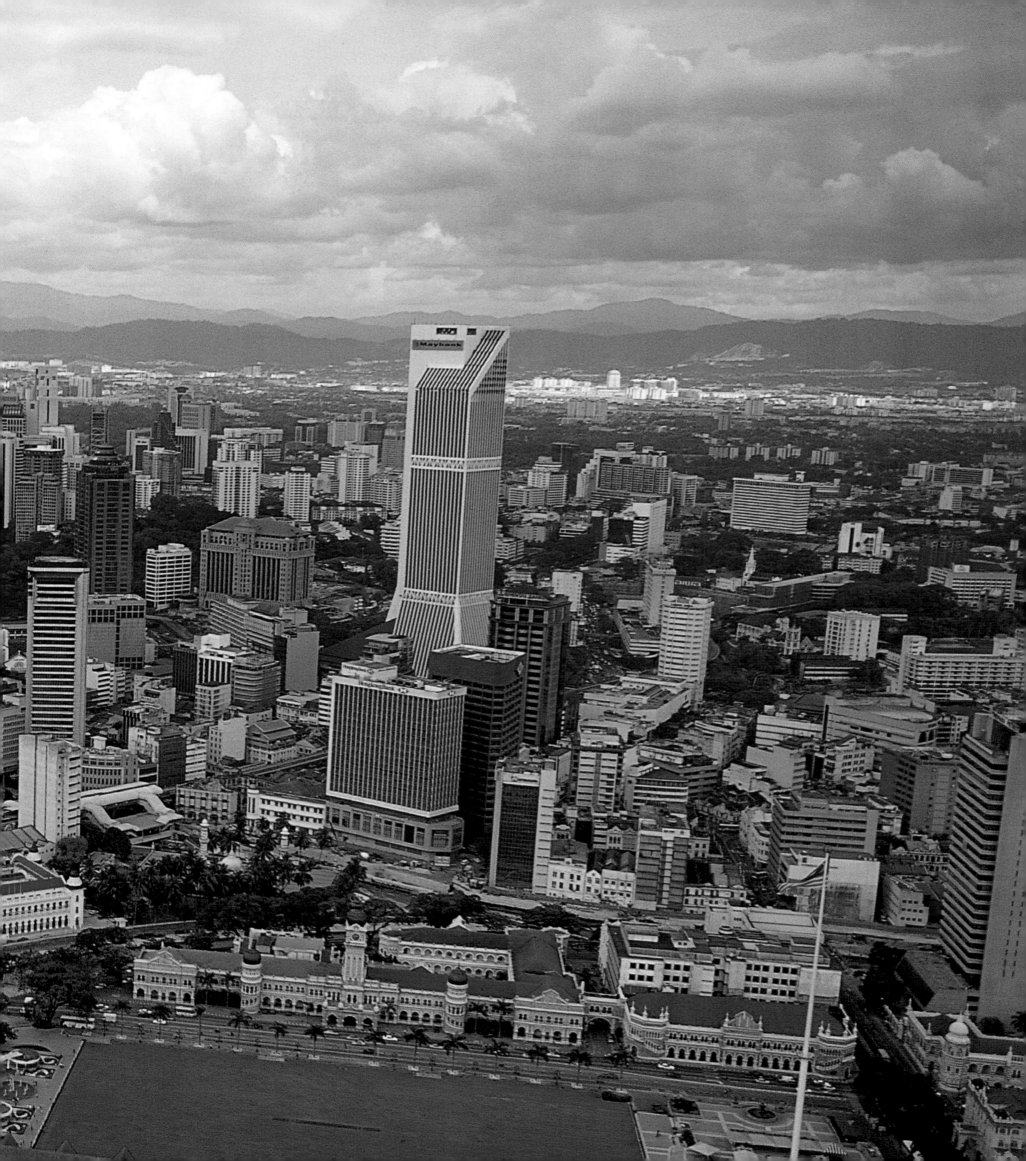

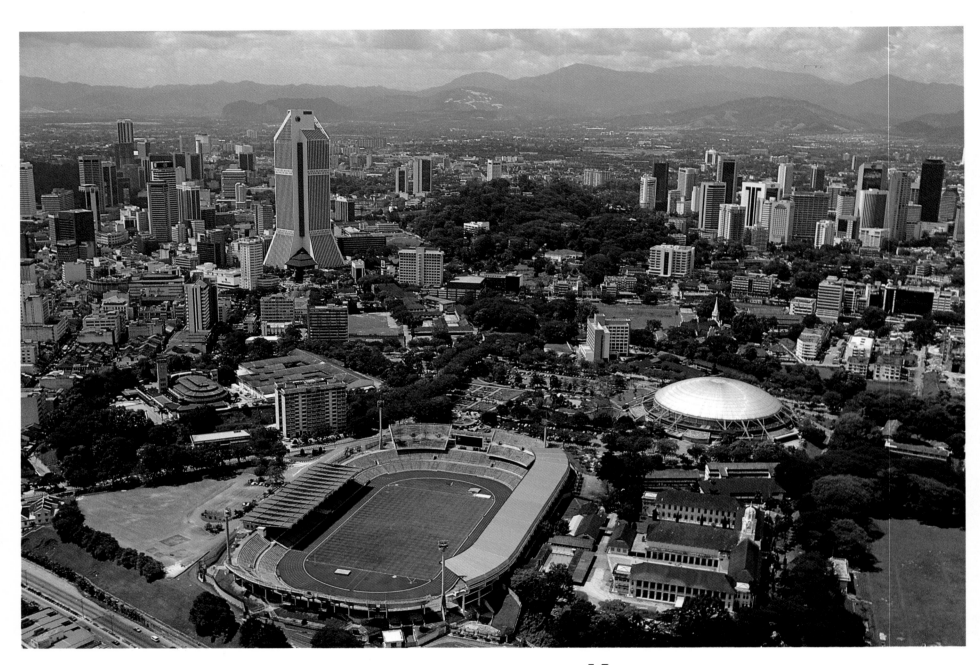

Kuala Lumpur, KL to its citizens, is a heady mix of high-rise architecture, and a tropical sort of old-world charm (preceding). It has grown quickly, as Malaysia has, but the city is full of greenery, and retains an easy atmosphere.

Merdeka Stadium is Malaysia's Wembley, hosting football matches, concerts and international athletics events.

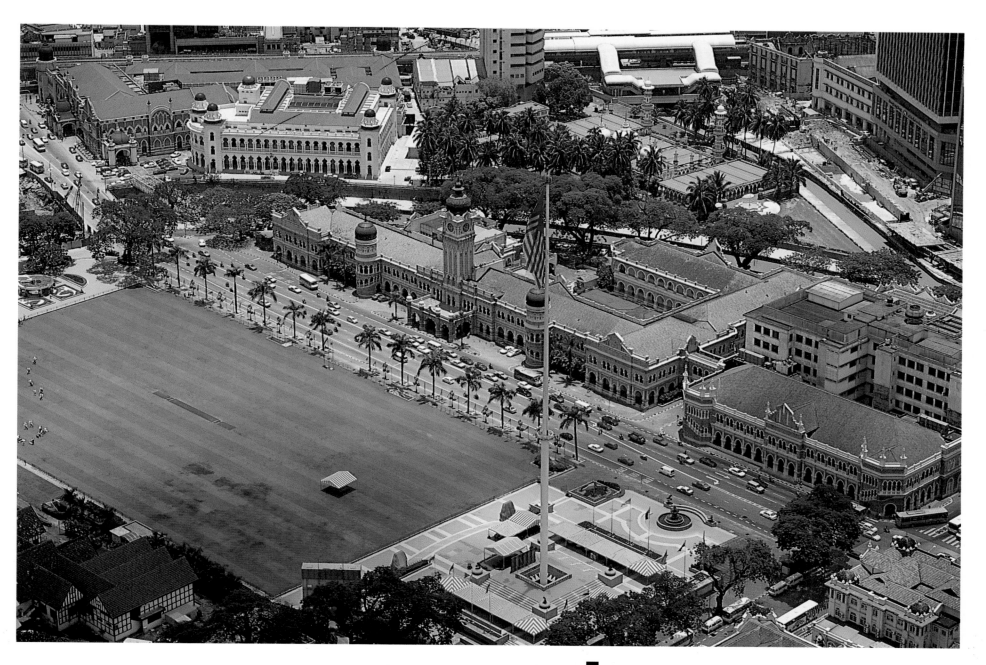

Tunku Abdul Rahman, Malaysia's first Prime Minister, declared independence for Malaysia at the stroke of midnight, August 31st, 1957, here on Kuala Lumpur's *padang*, or common. Later renamed the Dataran Merdeka, Independence Square, the padang is flanked by listed buildings, including the Royal Selangor Club (off left), nicknamed the 'spotted dog', and the Sultan Abdul Samad Building across the road.

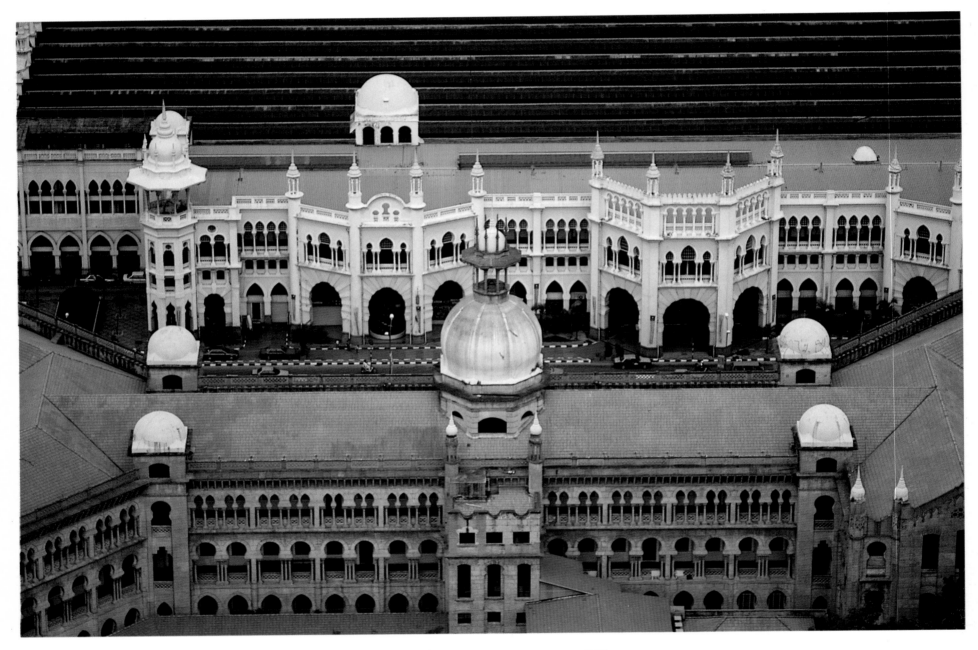

Two graceful, turn-of-the-century buildings are among the chief assets of Malayan Railways, or Keretapi Tanah Melayu. The terracotta-roofed building in the foreground houses KTM's administrative headquarters. Behind that is KL's railway station, often considered to be one of the world's most exquisite. The onion domes, mock minarets, arches and dainty pillars are more reminiscent of an exotic Moorish palace than of a busy hub of transport and commerce.

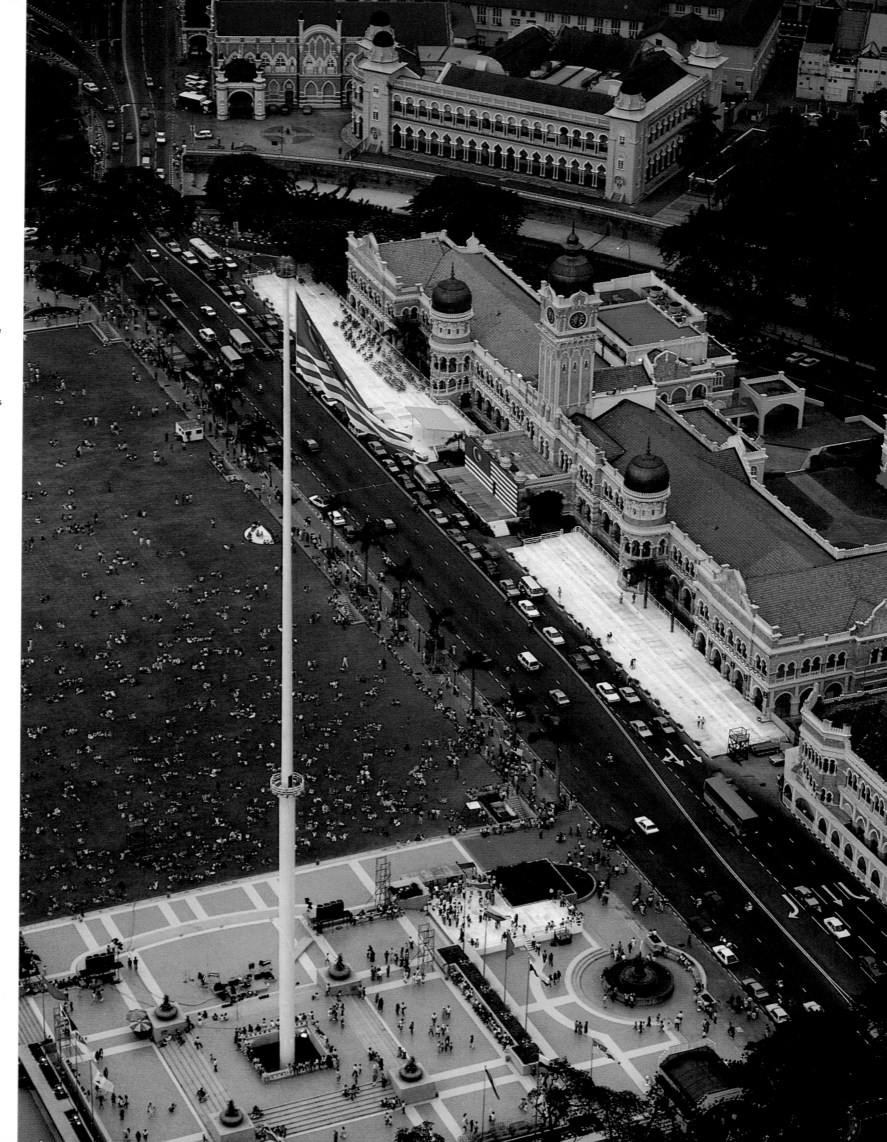

A Moorish style also dominates the Dataran Merdeka, seen here after an Independence Day parade. The pink plaza and its flagpole are new additions to this historic spot: the free-standing flagpole is currently the world's tallest. Its base looms one storey high, dominating the green *padang,* and hiding beneath it a vast underground carpark and shopping centre. Now beautifully decorated above and below, Independence Square is a firm crowd-puller with the city's youth.

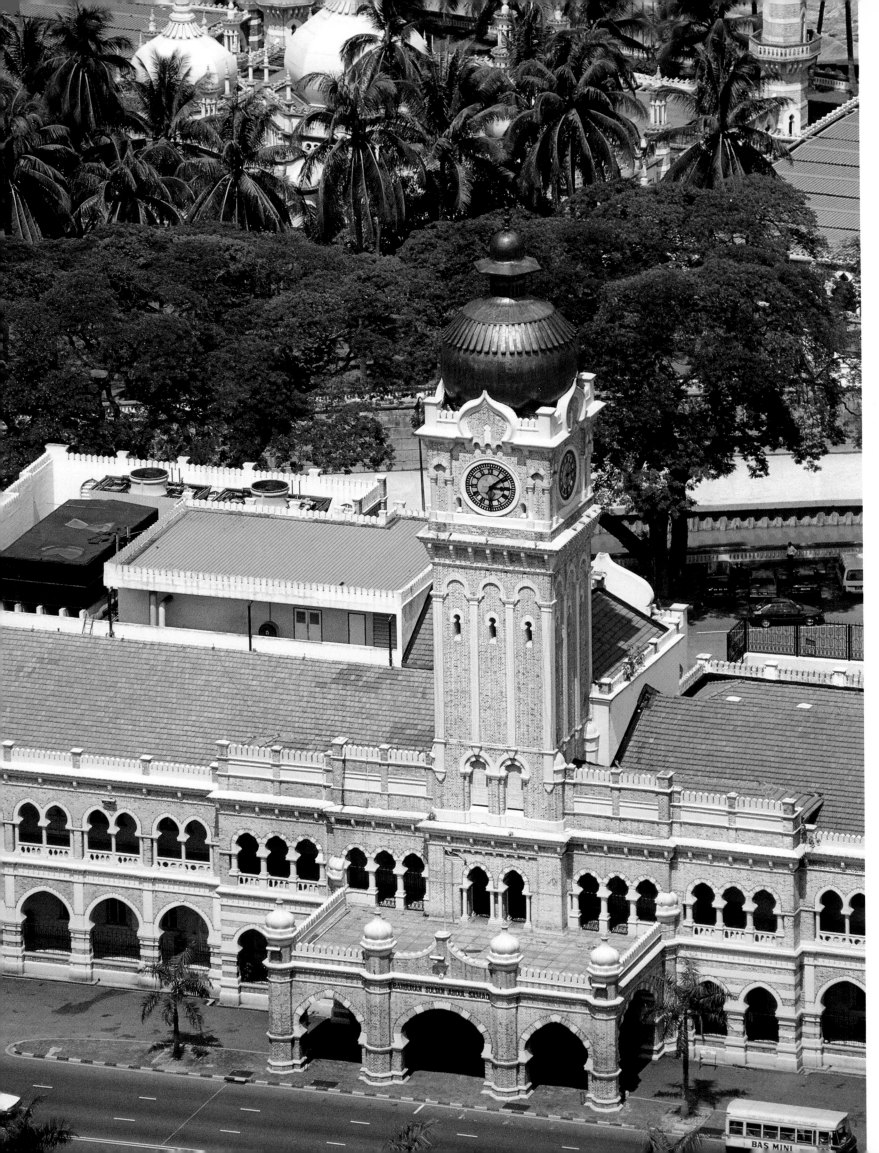

The Clock Tower of the Sultan Abdul Samad Building is part of the old State Secretariat building. This is the most famous and most-photographed landmark in Kuala Lumpur. It is the oldest of the Moorish and Mughal-fashioned buildings erected in colonial days in the centre of Kuala Lumpur. Today's city-dwellers count down the New Year here, while holding their celebrations under the watchful eye of the clock.

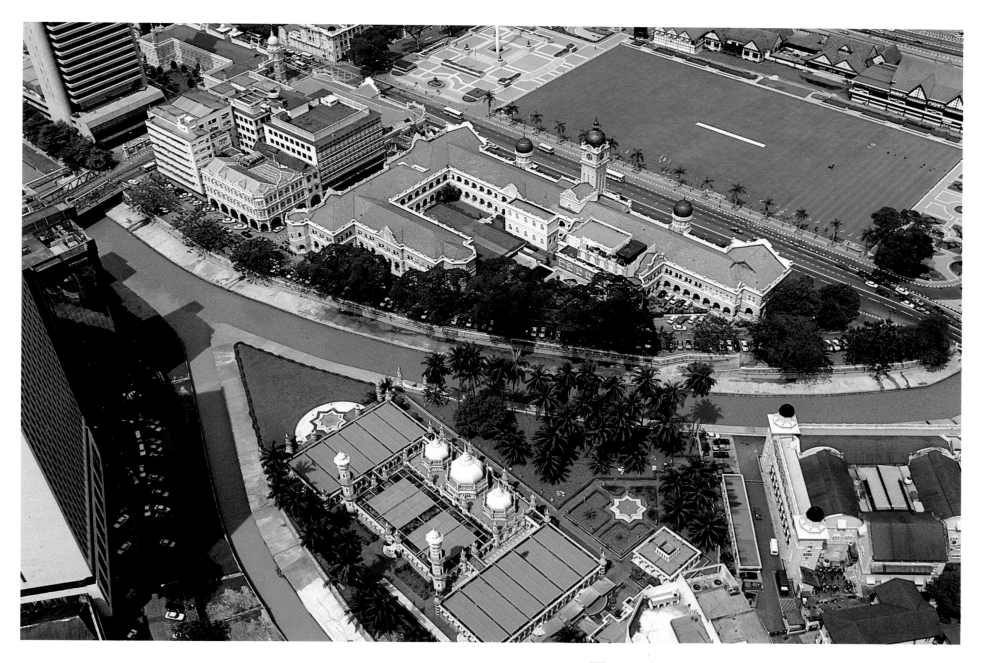

The heart of old Kuala Lumpur. This image puts it all together: the Jame Mosque at the confluence of the Klang and Gombak rivers, the Sultan Abdul Samad Building and the Clock Tower at Jalan Raja, and the *padang*, Dataran Merdeka, the symbolic green field that is the city's great common space. These landmarks are the core symbols of the city.

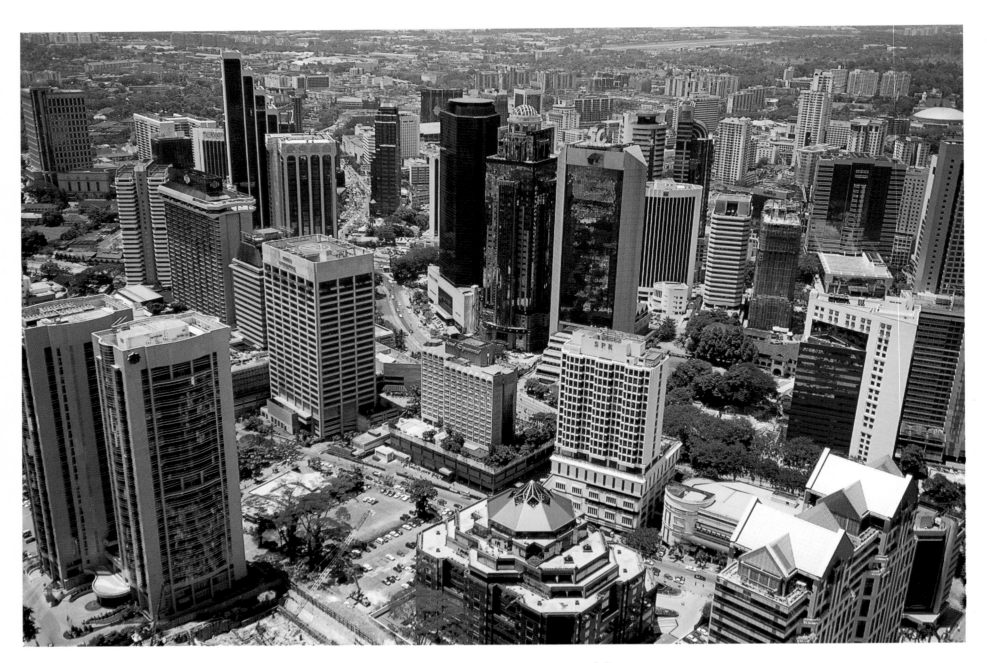

Hotels, shopping centres and more highrises, including the headquarters of Malaysia Airlines, are found along Jalan Sultan Ismail. Rising values in downtown Kuala Lumpur's Golden Triangle prime property area have built many a fortune.

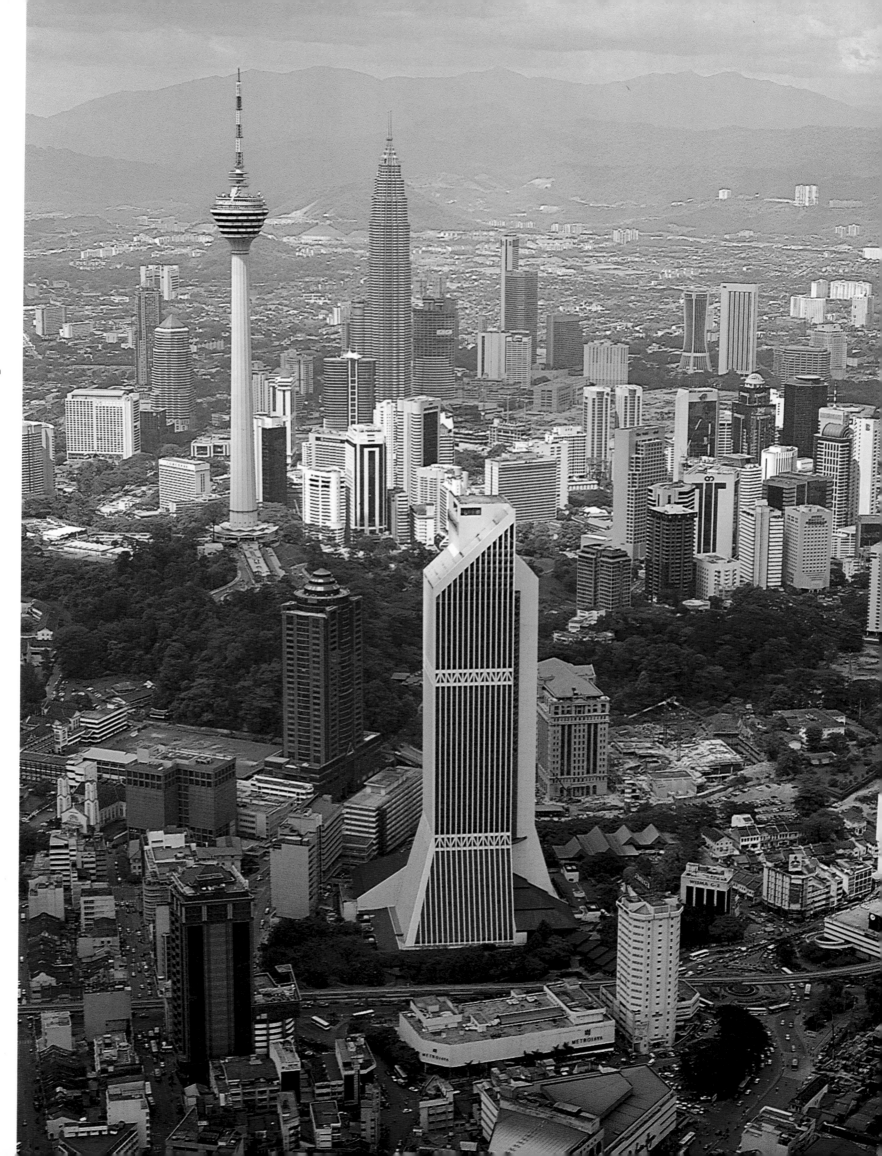

The sharp upward angles of Malayan Banking Berhad's Maybank building in the foreground, KL Communication Tower and Restaurant to the centre left and Petronas Twin Towers in alignment at the centre.

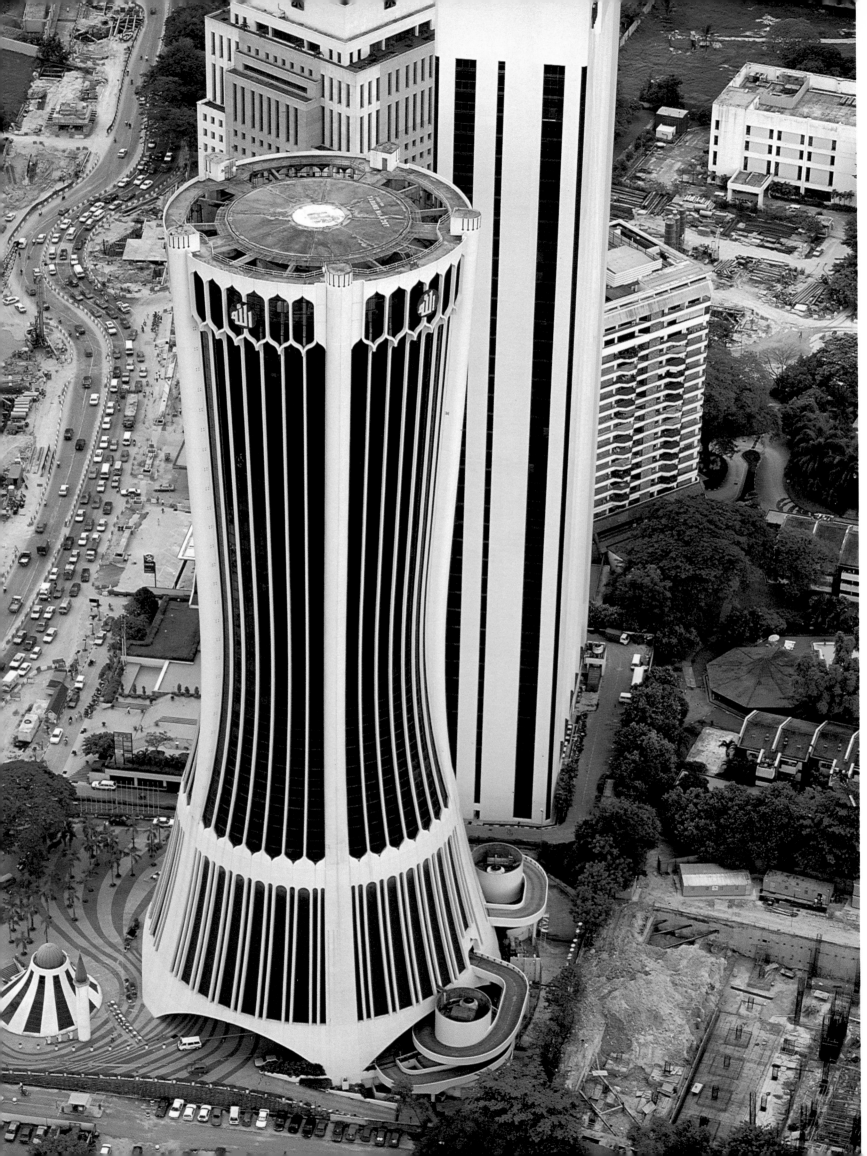

Another prominent building in KL has an Islamic connection: the Tabung Haji Building, a cylindrical structure, with an unusual 'waspish' waist, houses the foundation which assists Malaysian Muslims in their efforts to make the pilgrimage to Mecca. The building is a rare example of local architectural innovation. The PNB Building next door is more conventionally international modernist, but it successfully incorporates a classically Malay istana-like annexe.

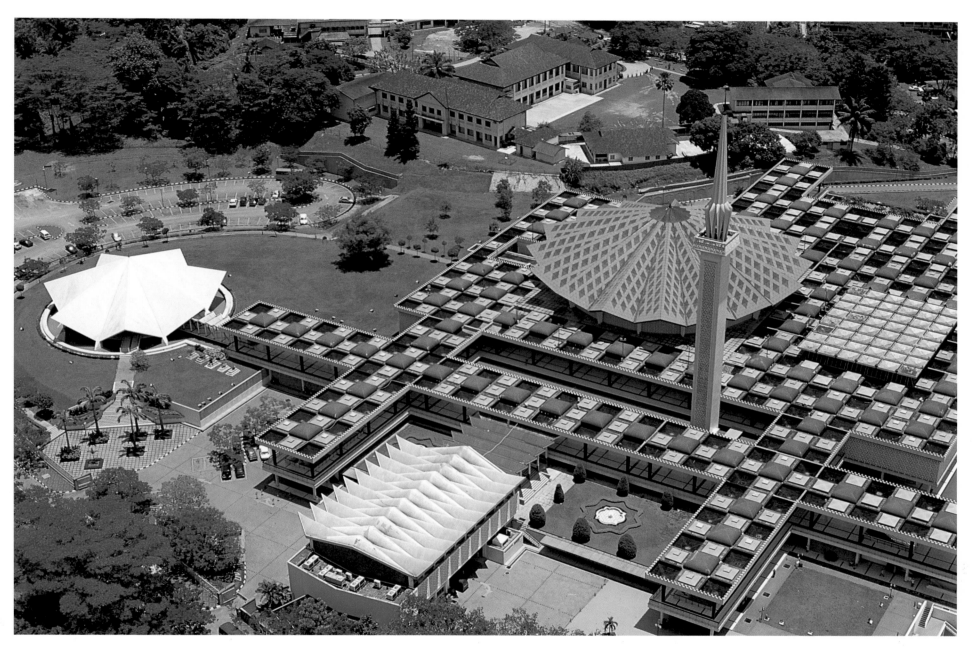

From the air, the National Mosque, the Masjid Negara, in Kuala Lumpur is a vision in blue. The structure, covered with abstract patterned filligree, used to be a pristine white, signifying the purity of Islam. But after renovations, the dome is now aqua blue and green, symbolising the magnaminity and magnitude of the national religion. Prayer halls too have been enlarged.

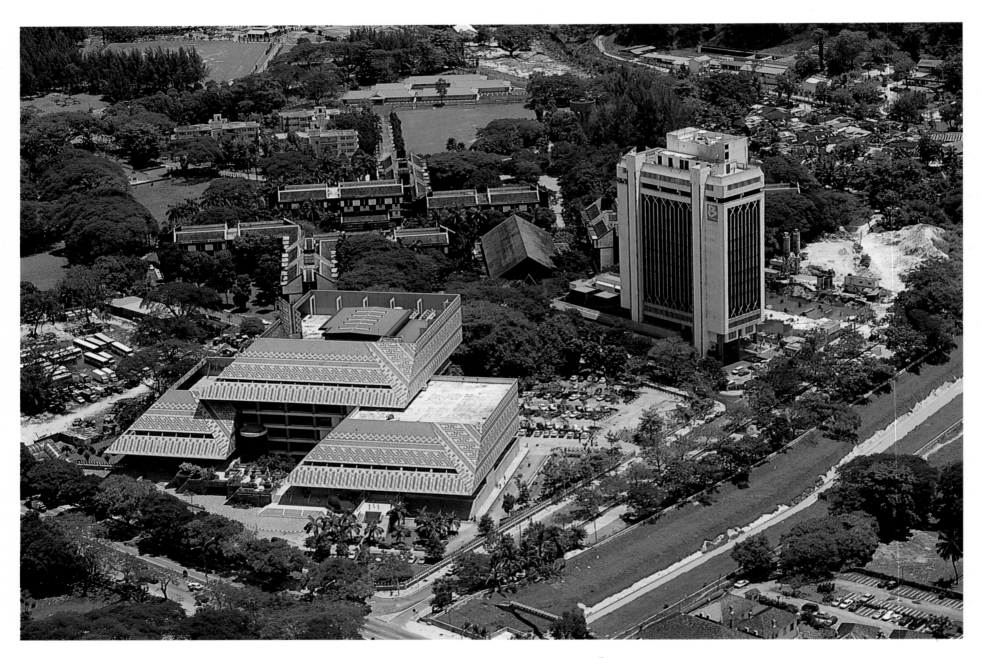

On Jalan Tun Razak, in Titiwangsa in northern Kuala Lumpur, the new National Library boasts striking modern architecture adorned with the traditional motifs of the *songket tengkolok* (folded brocade headgear). Its sloping sides are ideally suited to the tropical climate, offering shade to its base and windows, and promoting a cooling updraft over its walls. The library reflects a commitment to promote reading and knowledge.

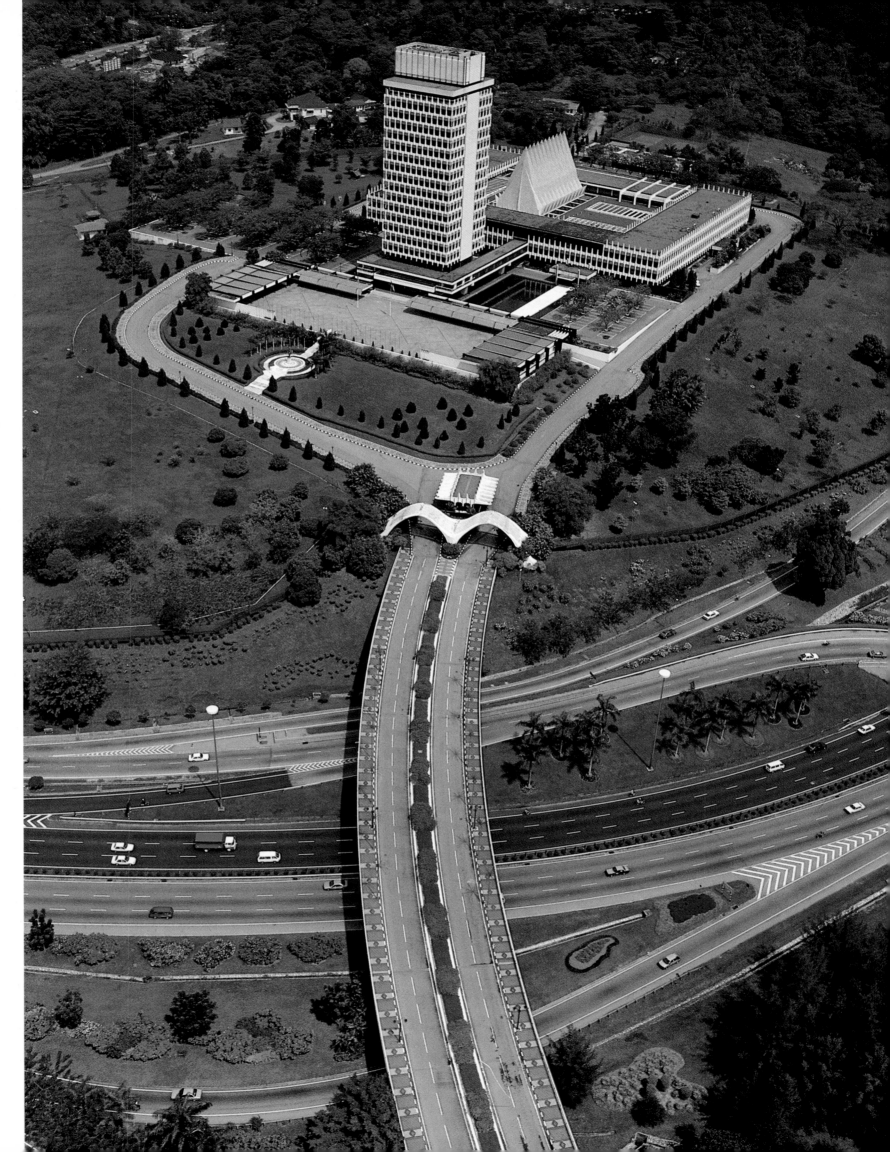

Parliament House has a pleasant hill of green all to its own, near Kuala Lumpur's large Lake Gardens. For years, the 18-storeys of Parliament House made it the country's tallest building. It still looms over the city, and the nation, as the preeminent symbol of the values of democracy and openness.

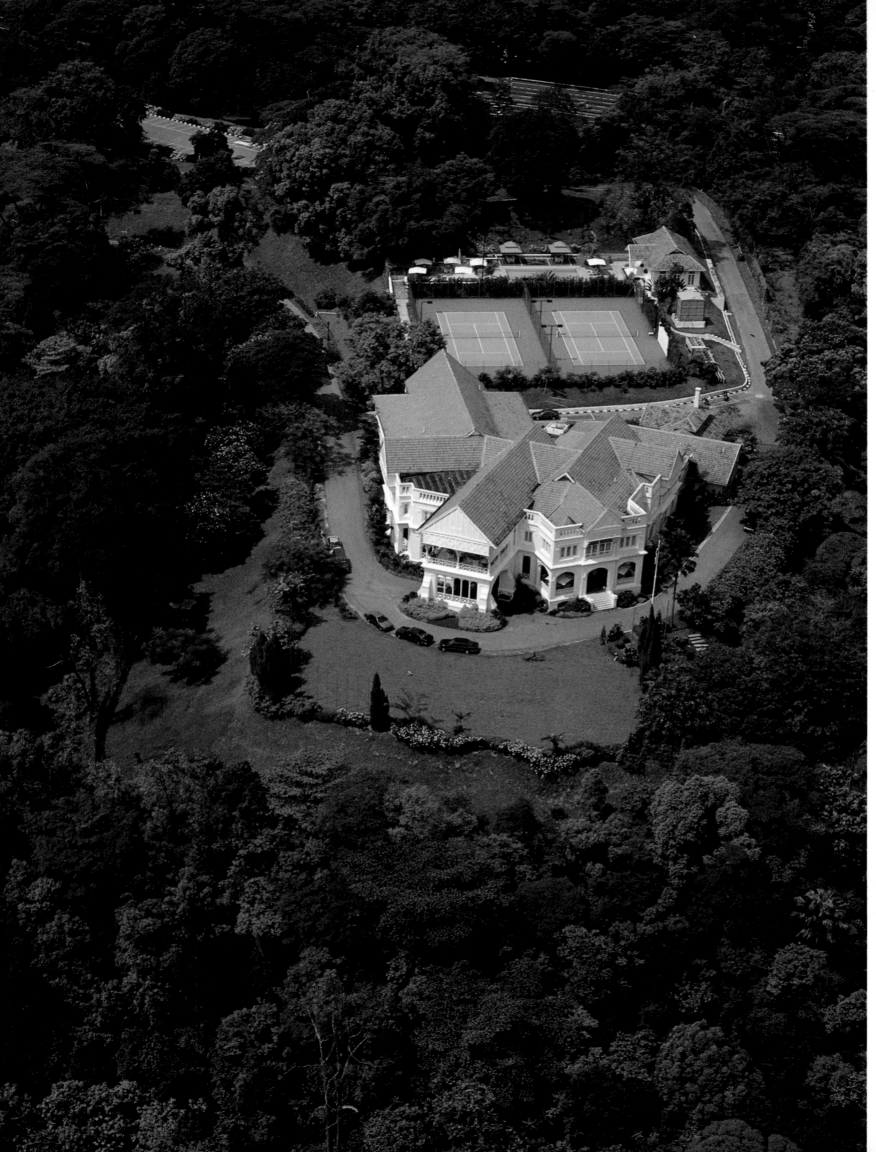

Carcosa Seri Negara was once the residence of the highest civil servant of the colonial administration, and was given in perpetuity to the British Government by Tunku Abdul Rahman as the residence of the High Commissioner. It has since been returned to the Malaysian Government. It is now one of Asia's most acclaimed and most luxurious hotels. The Queen of England was its first guest in 1989, when she attended the Commonwealth Heads of Government Meeting held in Kuala Lumpur.

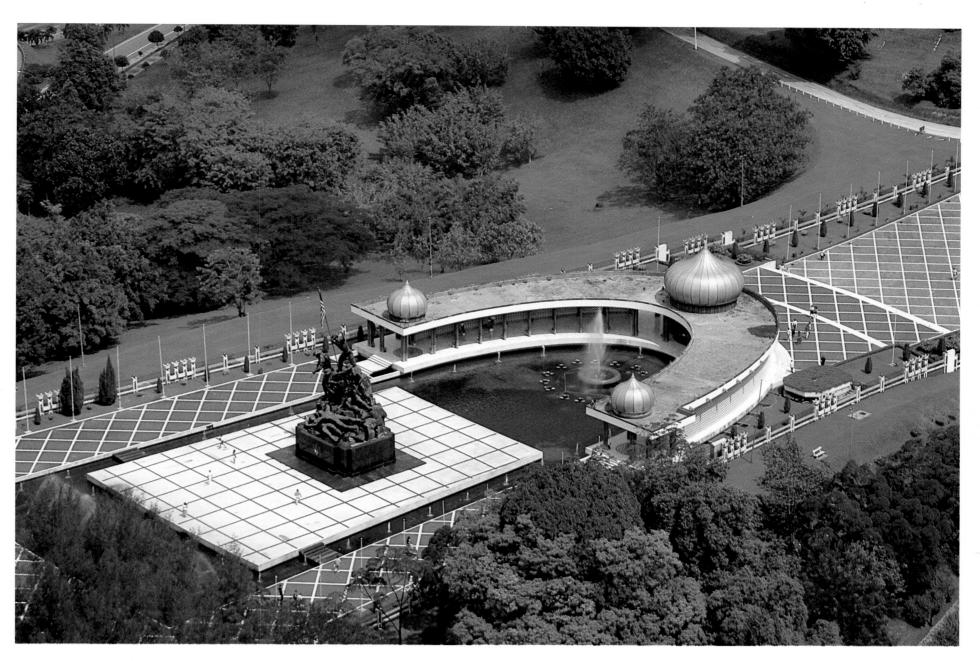

The National Monument, or Tugu Negara, is a permanent reminder of the debt owed by the nation to those slain defending the country from its enemies. The bronze sculpture depicts a group raising the Malaysian flag in victory; the surrounding gardens make for a peaceful sanctuary.

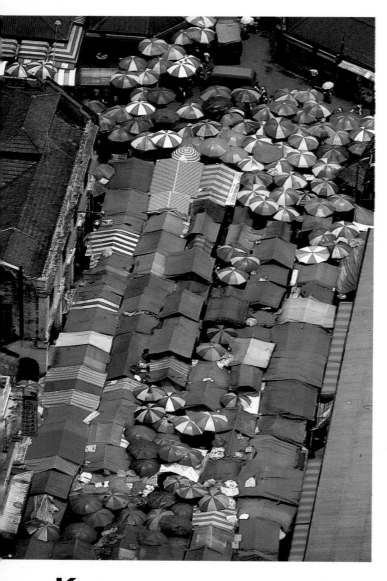

KL consumers can choose between air-conditioned shopping centres and supermarkets and the hustle and bustle (and fun) of fierce bargaining in markets like these, both in the centre of town. While the haggling may occasionally heat up, umbrellas and awnings shade market-goers from the sun. Some stall-holders say they prefer the independence that goes with being a small-scale entrepreneur to the enforced uniformity of an office or factory job. Market stalls can be packed up and reassembled at short notice.

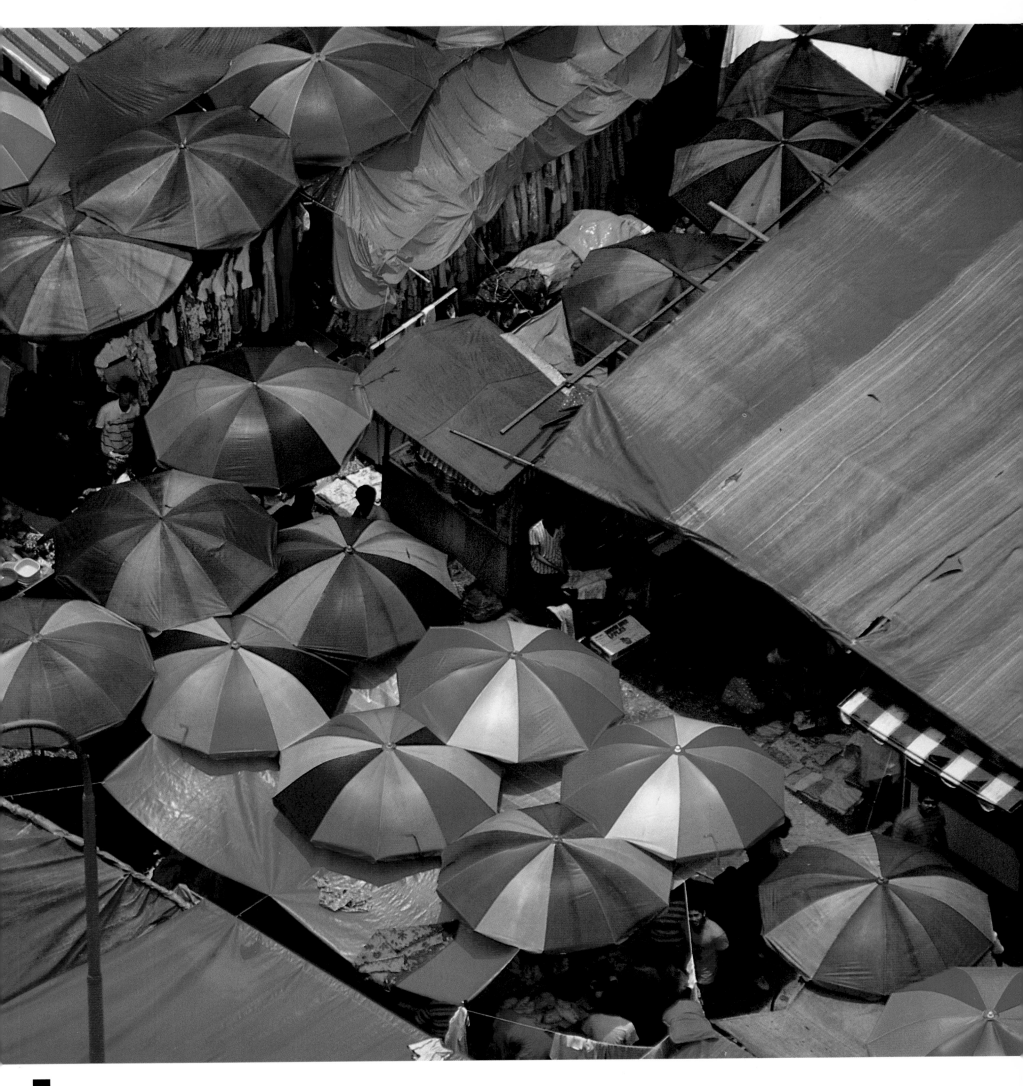

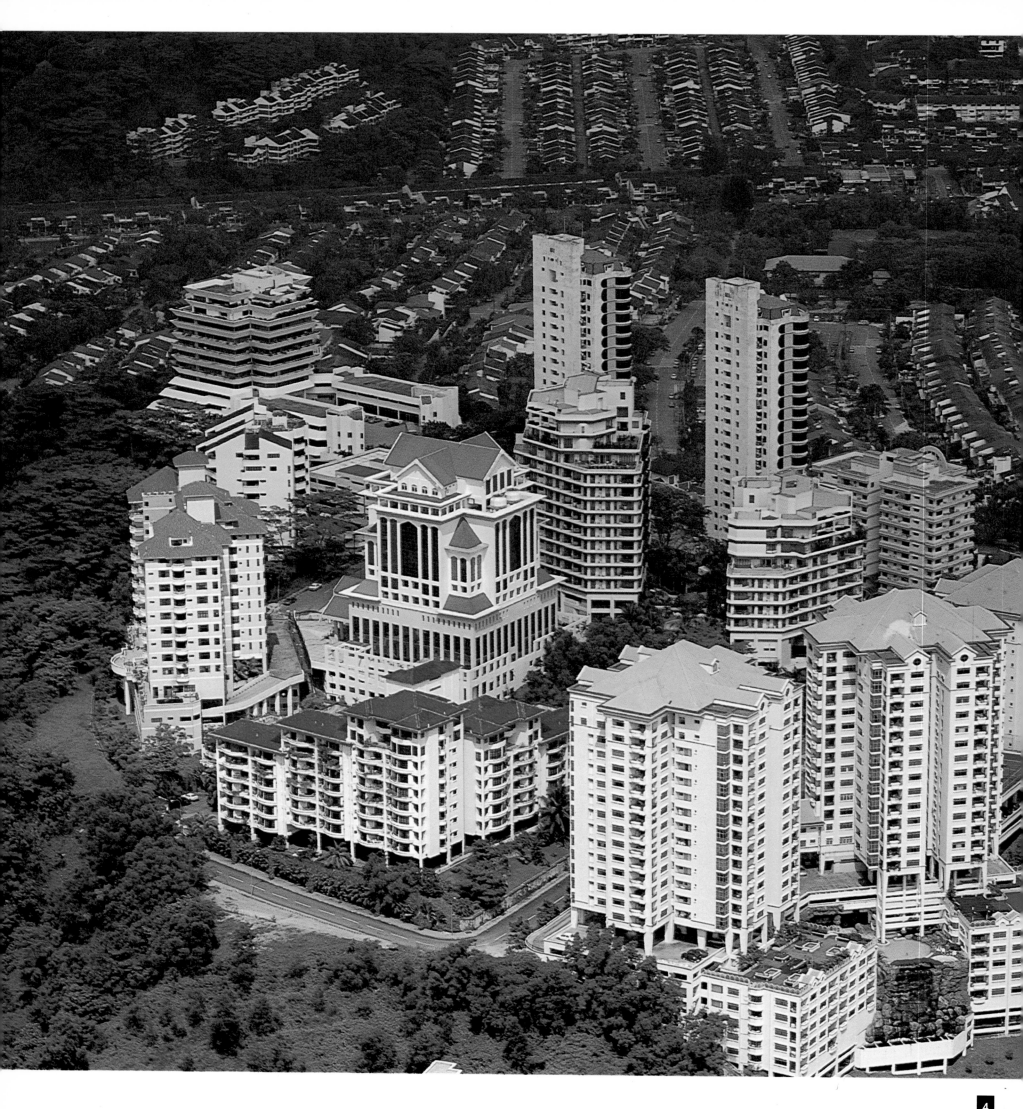

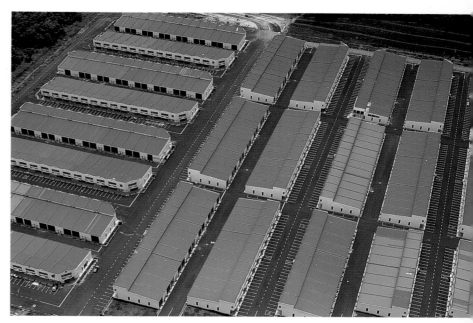

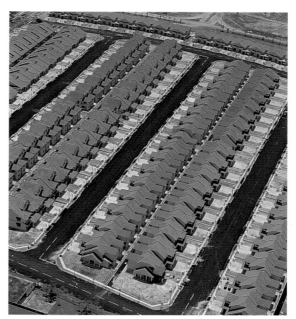

A booming economy and increased personal wealth have enabled more people to buy their own homes, and so stimulated a rapid growth in the building of housing estates. Luxury condominiums (far left), modern industrial parks (above) and suburban housing estates (left), offer a well-ordered lifestyle on the city's outskirts.

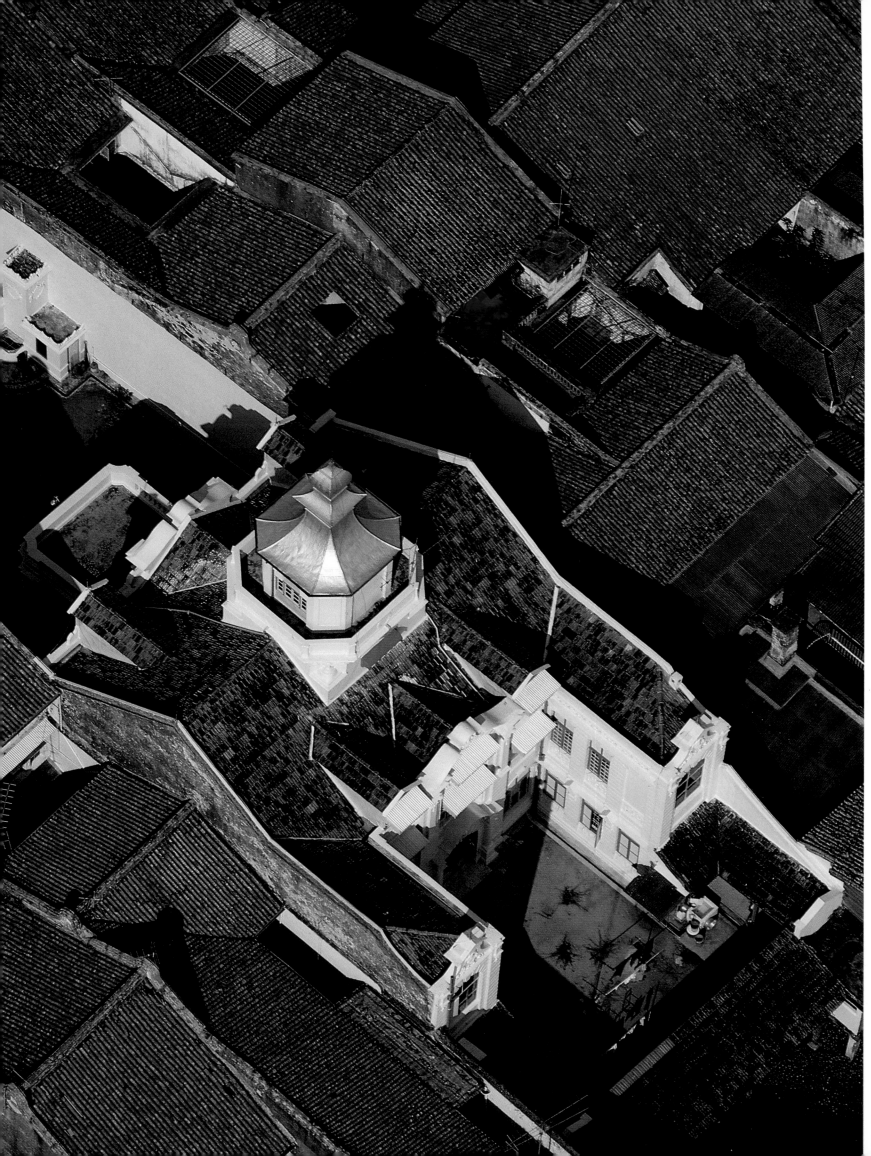

Melaka, Malacca
in its older spelling, is
one of the magical
towns of Southeast
Asia. Founded by a
line of Malay princes
from Sumatra, it
quickly became a
powerful and sophis-
ticated trading empire.
It drew support from
the *orang laut,* a
literally floating
population that control-
led the inlets and
byways of the Straits. It
also had an alliance
with the Ming Chinese,
through the Muslim
Admiral Zheng Ho.
The Muslim faith of
Melaka's leaders
brought the city into
contact with a thriving
trading network that
stretched from Arabia
to China.

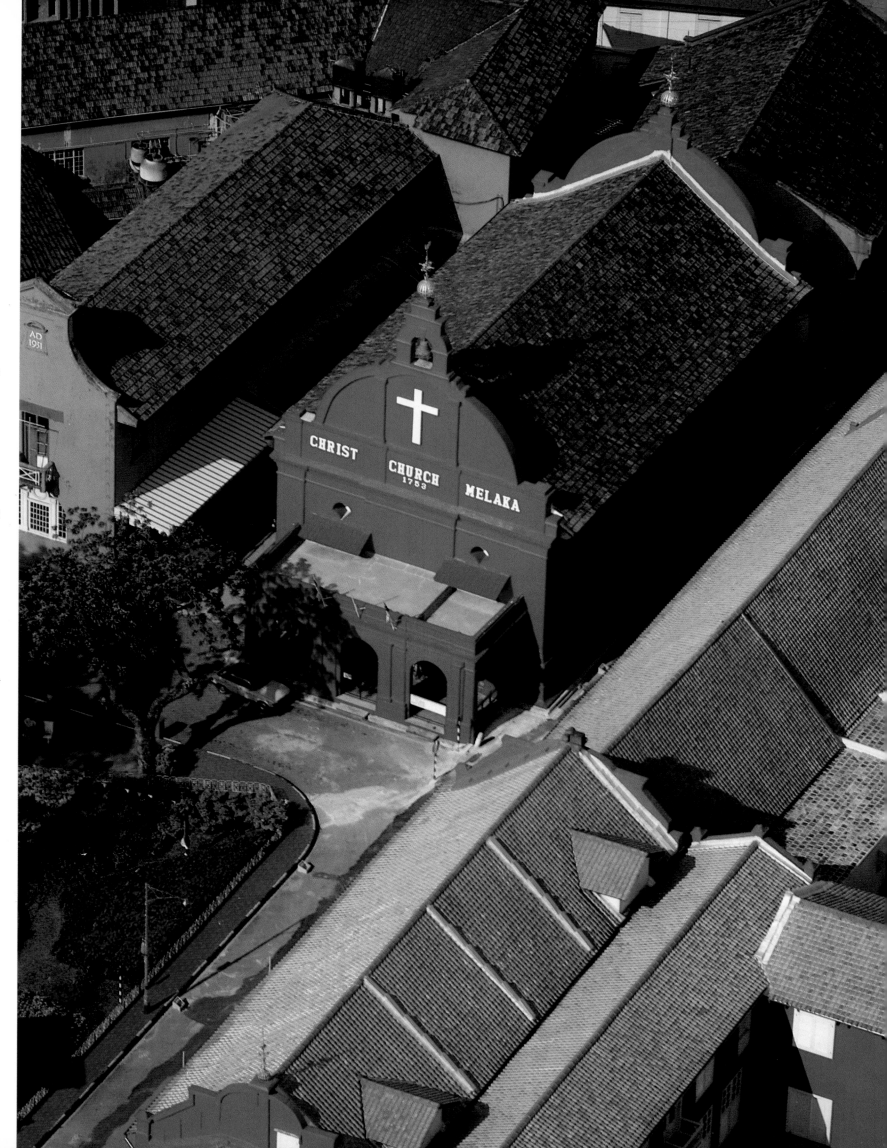

The wealth of the Sultanate of Melaka made it an attractive target for the Western powers covetous of controlling the spice trade. The Portuguese took Melaka first, and fortified the city. It was later taken by the Dutch, who have left their mark with buildings in the city centre, including the Christ Church and Stadhuys, or Town Hall. The Melaka court reestablished itself in Johor and elsewhere: most of Malaysia's current sultans trace their ancestry back to the Melaka sultanate.

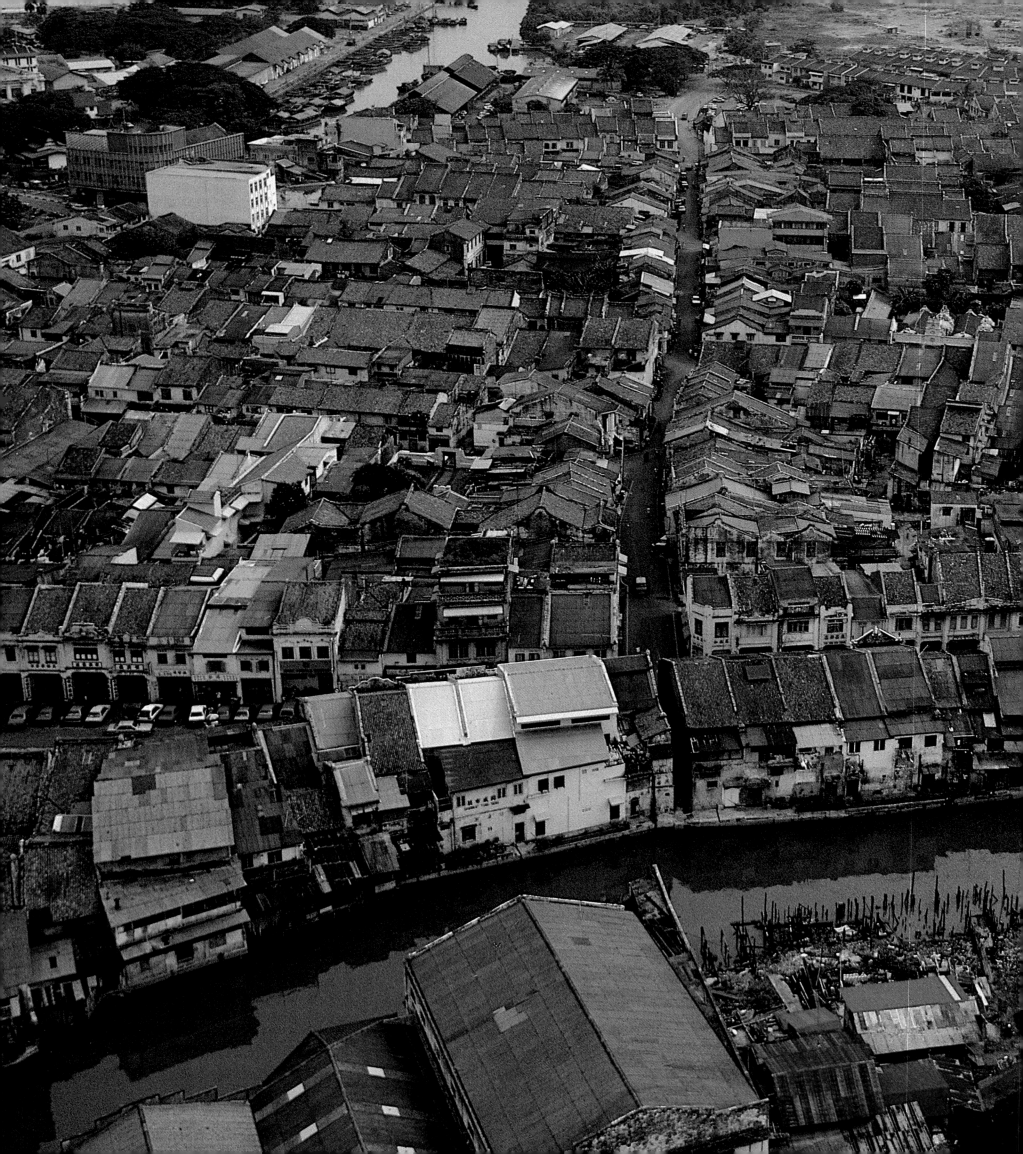

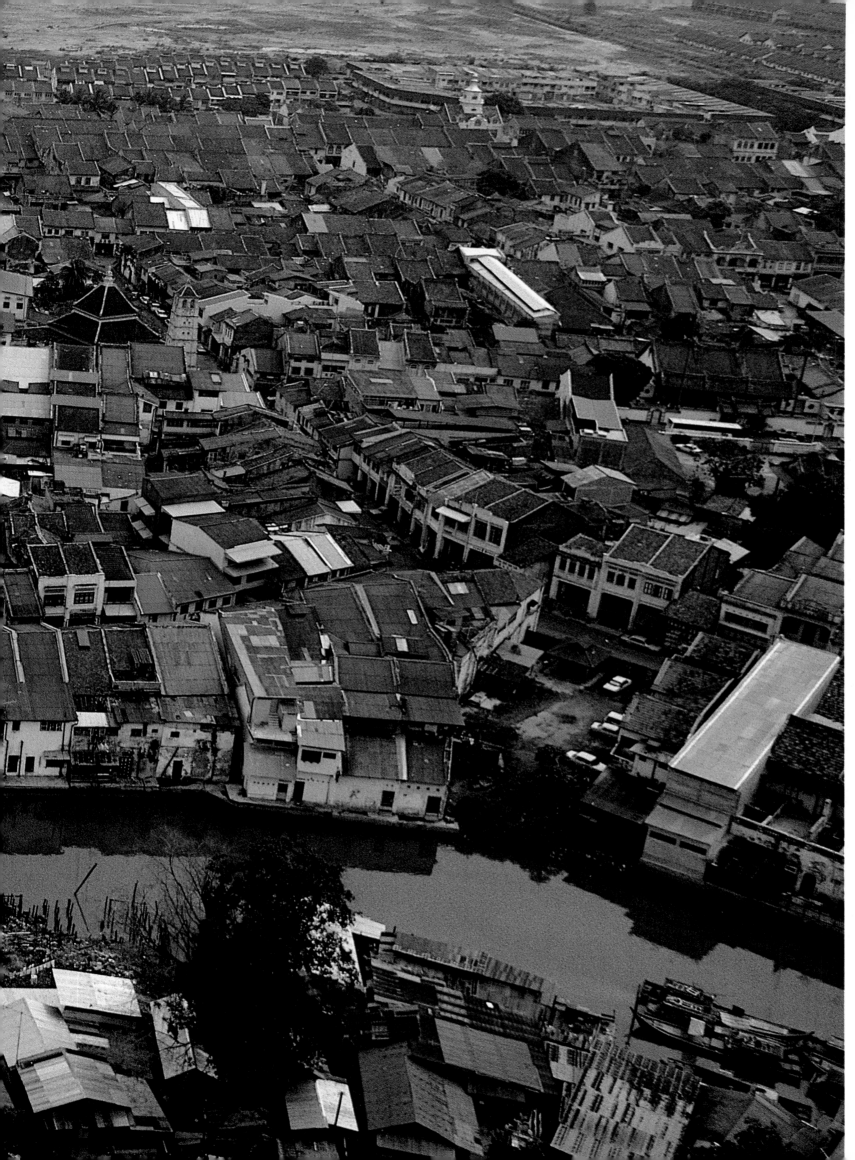

The British took Melaka from the Dutch in a complicated trade of territory that was part of the end of the Napoleonic Wars. They largely dismantled the Portuguese fort, but many of the city's oldest buildings survived. Visible in this image are the Tranquerah mosque, and the Cheng Hoon Teng Temple, from 1645. The city did well out of the rubber boom, but the silting of the port spelled doom for its role as a trade emporium. Today, land reclamation projects reach seaward, and cultural tourism is touted as a major growth industry for the city.

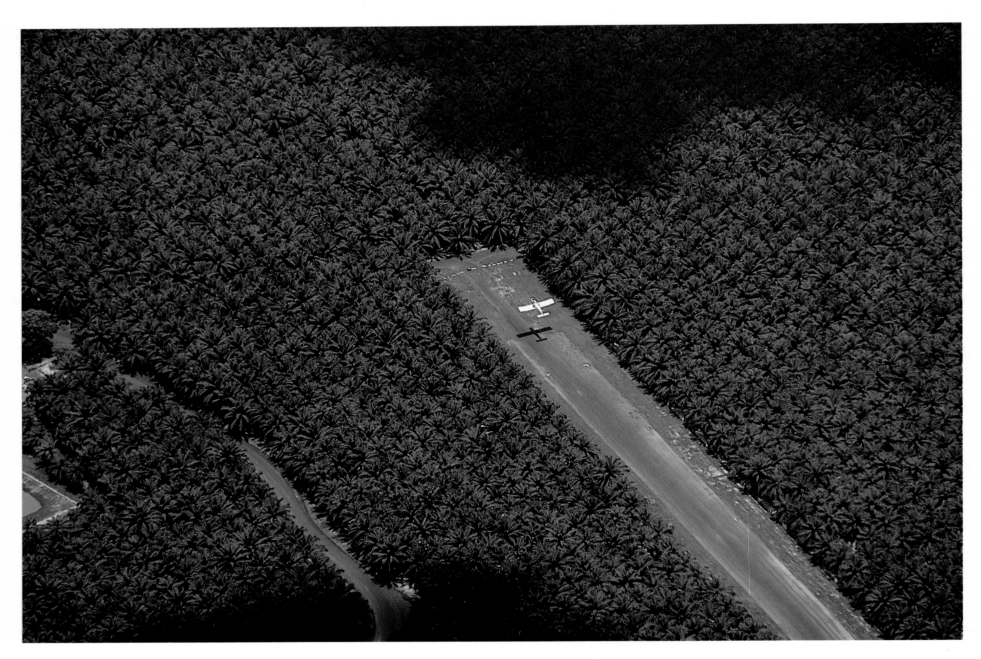

Although rubber is still more or less the most significant crop in the Malaysian agricultural sector, the multi-billion ringgit oil palm industry is one of the country's great success stories. Around 1.5 million hectares are under oil palm cultivation making Malaysia the world's biggest producer of palm oil. The Palm Oil Research Institute of Malaysia (PORIM) works to keep Malaysia's competitive edge. Here a private plane takes off from a plantation airstrip deep amongst the palms.

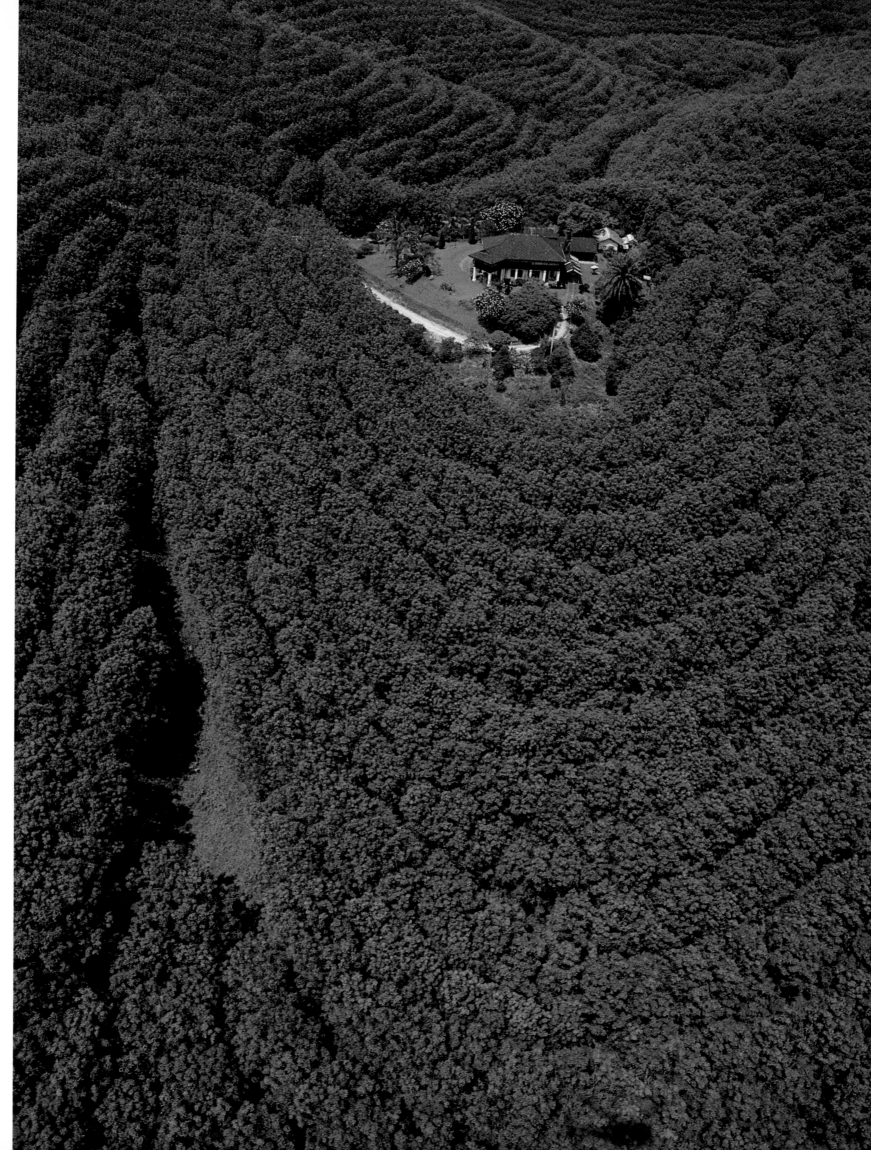

A magnificent solitary mansion straddles the top of a hill lined with rubber trees. This type of grand, stately and practically self-sustaining home is not all that uncommon. It harks back to the days when the white colonial masters held huge thousand-acre estates, and commanded a retinue of servants to run the house, man the gardens and pour the stengahs. Life on such estates may have been isolated, but it was never deprived.

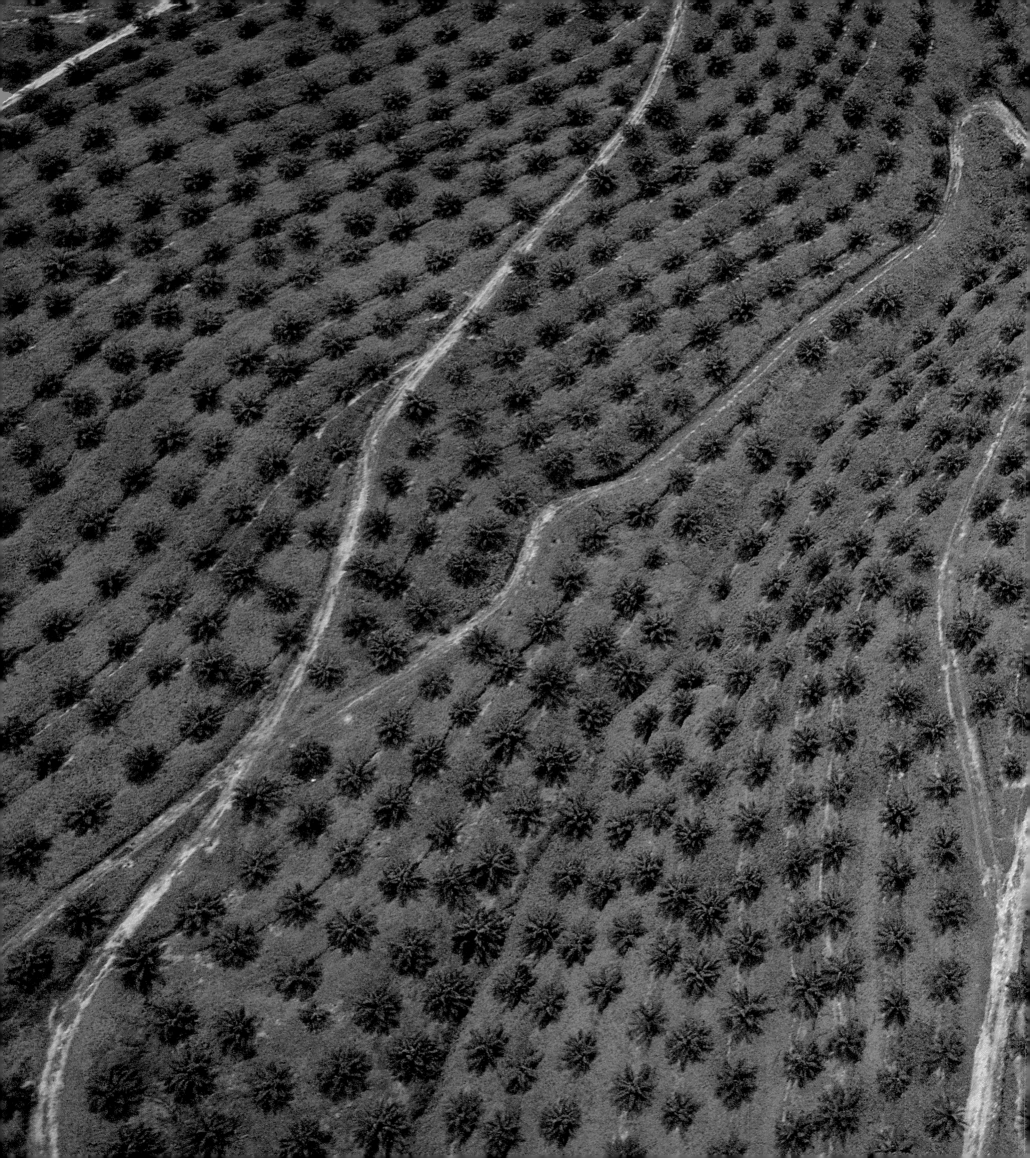

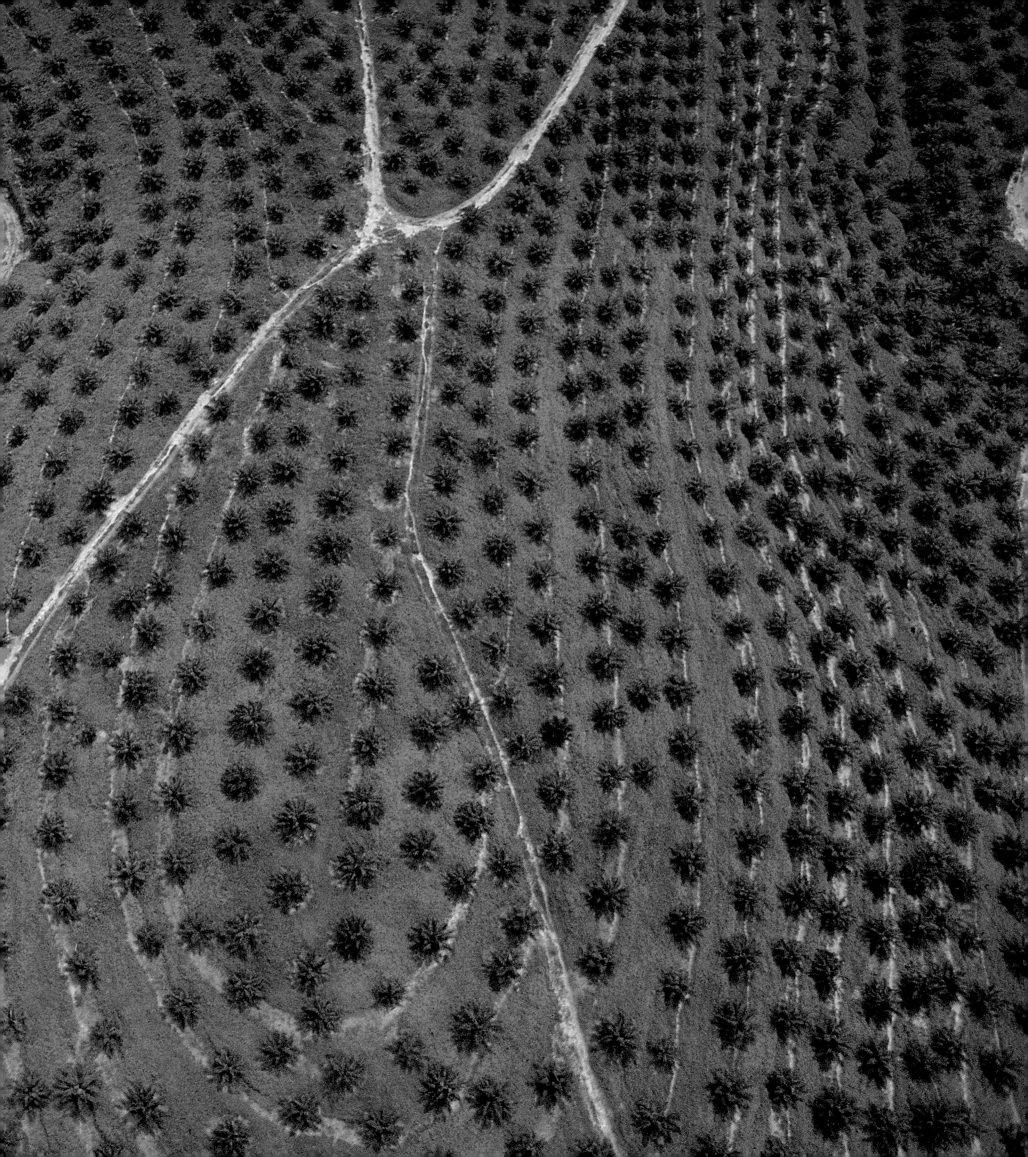

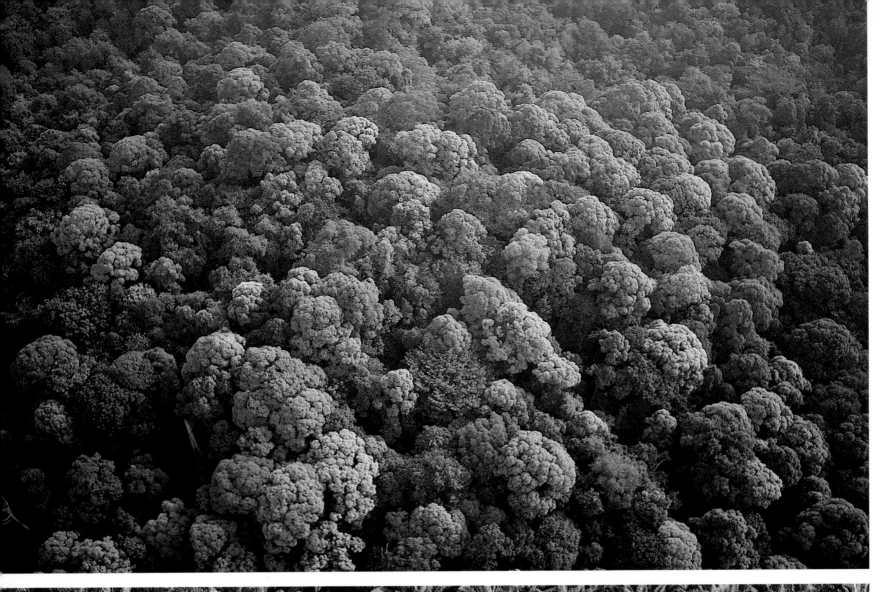

The very image of broccoli land: thick clusters of deep Malaysian jungle trees in clumps like a head of broccoli. Despite extensive development of the land, jungle still rules around 70% of Malaysia. One crop which competes for land is the oil palm, grown in neat patterned rows, below, or in contoured rows on hilly land, previous pages. Palm oil is one of the most popular cooking oils in the region and is an important export, but the tree also finds a place in stately gardens, prized for its elegant fronds.

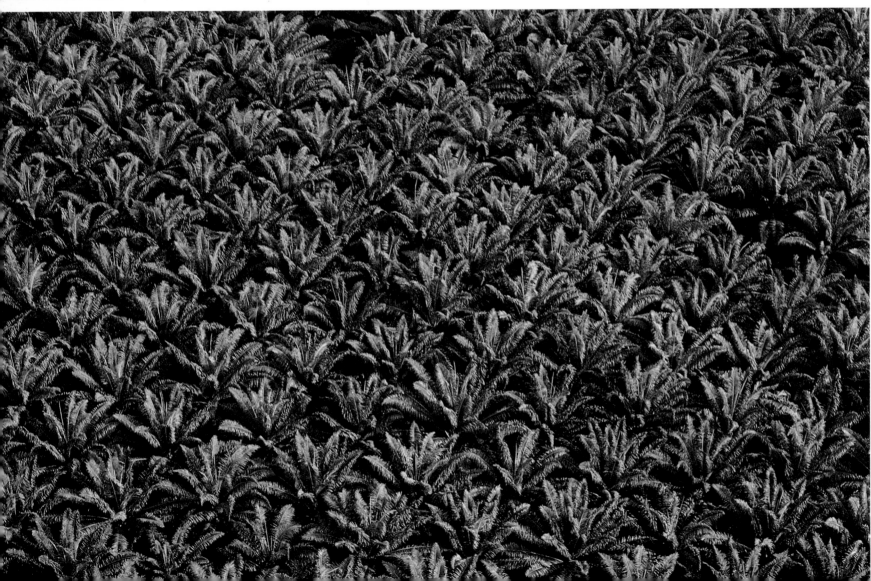

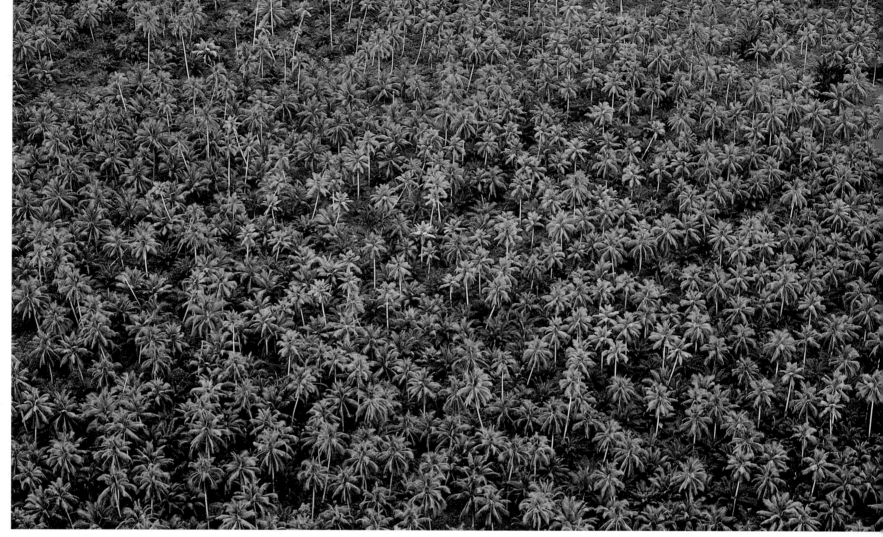

The coconut palm is a symbol of the tropics, and of the long beaches of Malaysia's East Coast. Every part of this versatile plant can be used, from the multi-purpose fruit to the leaf and trunk. New short hybrids can be plucked by anyone of average height. So far the Beruk —coconut-picking monkeys— have not launched an official protest at this threat to their liveli-hood. Another useful tree is an import from Brazil: the rubber tree is also grown on plantations. The scene (below right) looks like forest devastation, but it is actually a planta-tion in the course of being replanted.

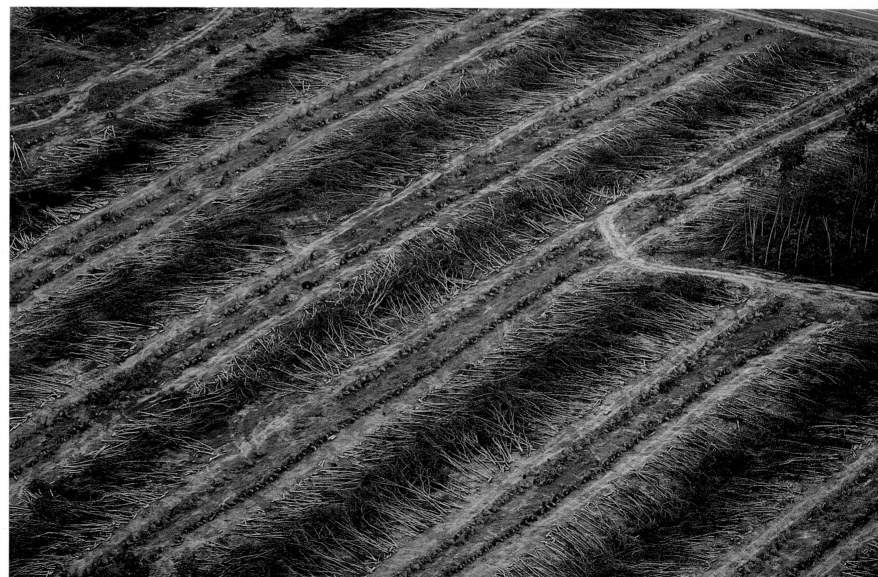

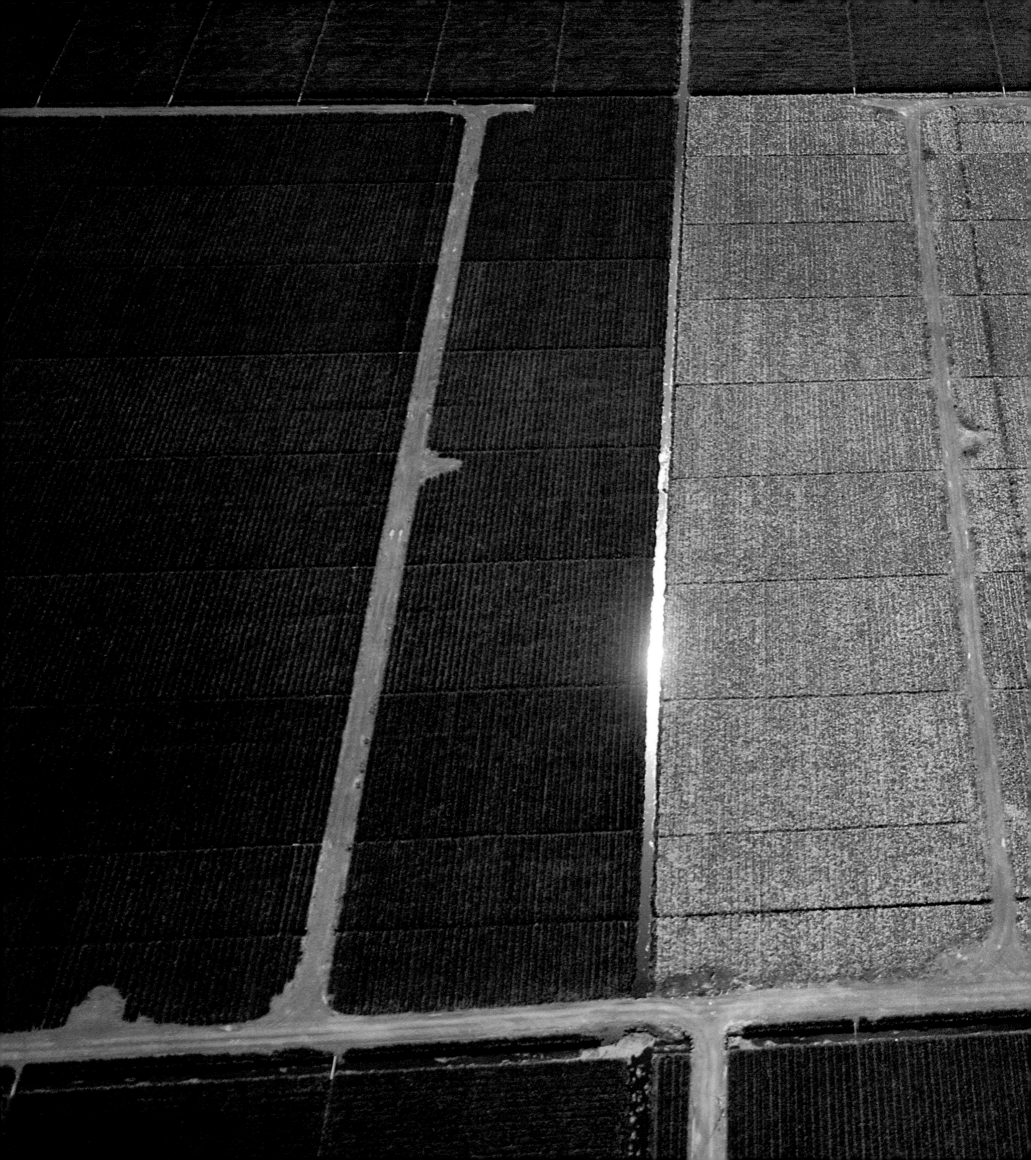

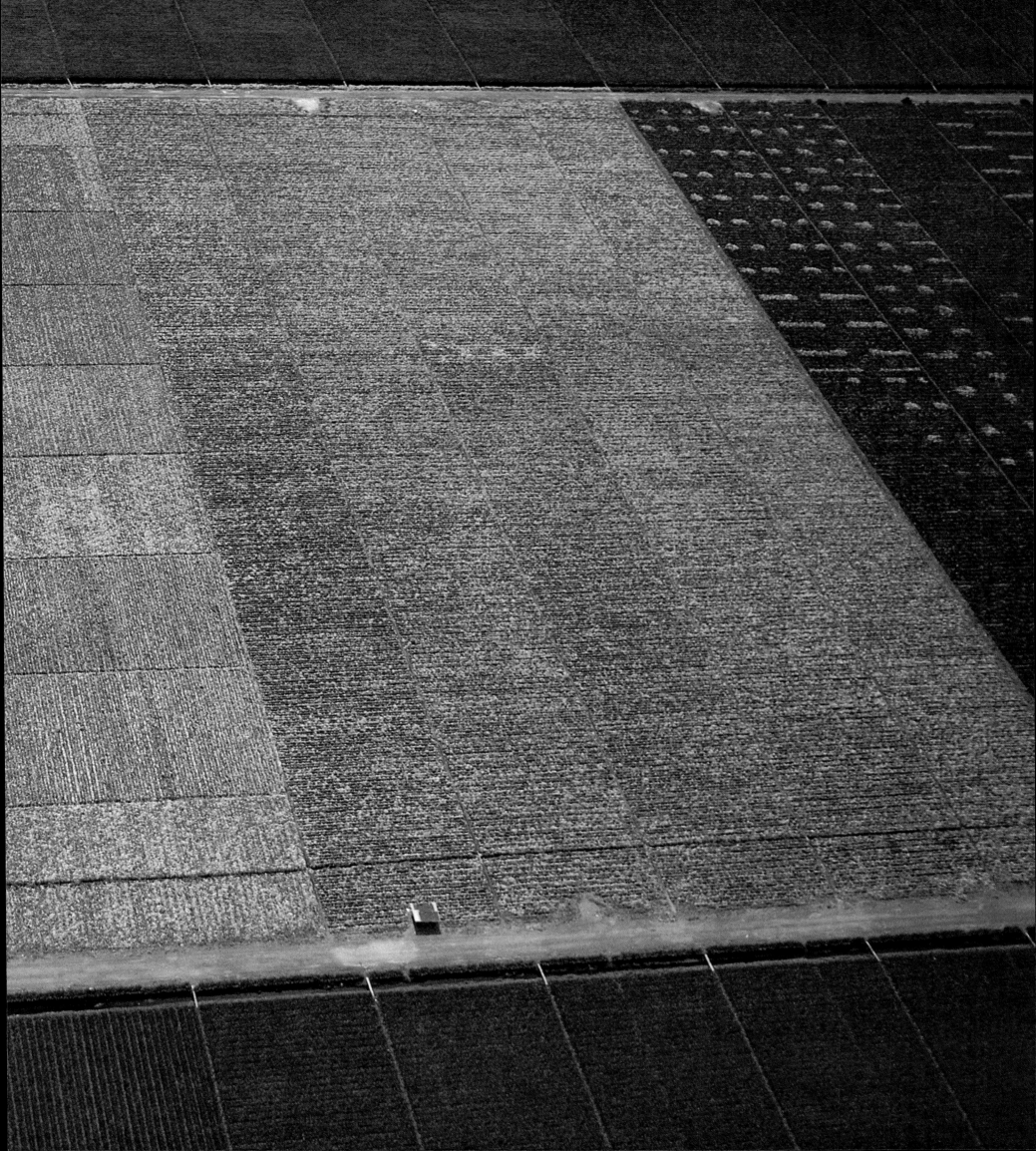

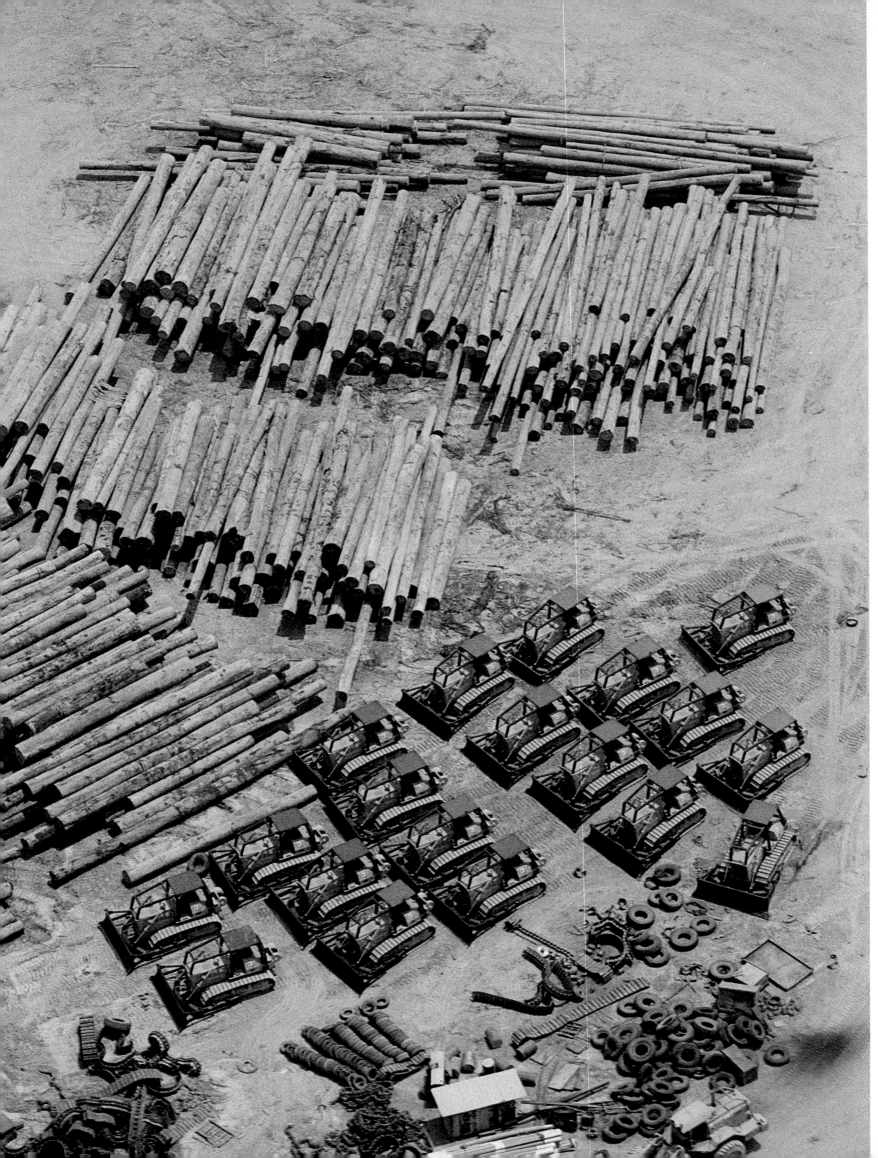

Irrigation projects have brought large-scale agriculture to Southern Johor, as in the photo of a field ready to be planted, previous page. This could well be a children's playground; it is actually big business. The bull-dozers may look like toys, but they are no pushovers, as proved by the multi-ton logs as neatly arranged as matchsticks. But rough terrain takes its toll, as seen in the number of spares in the yard.

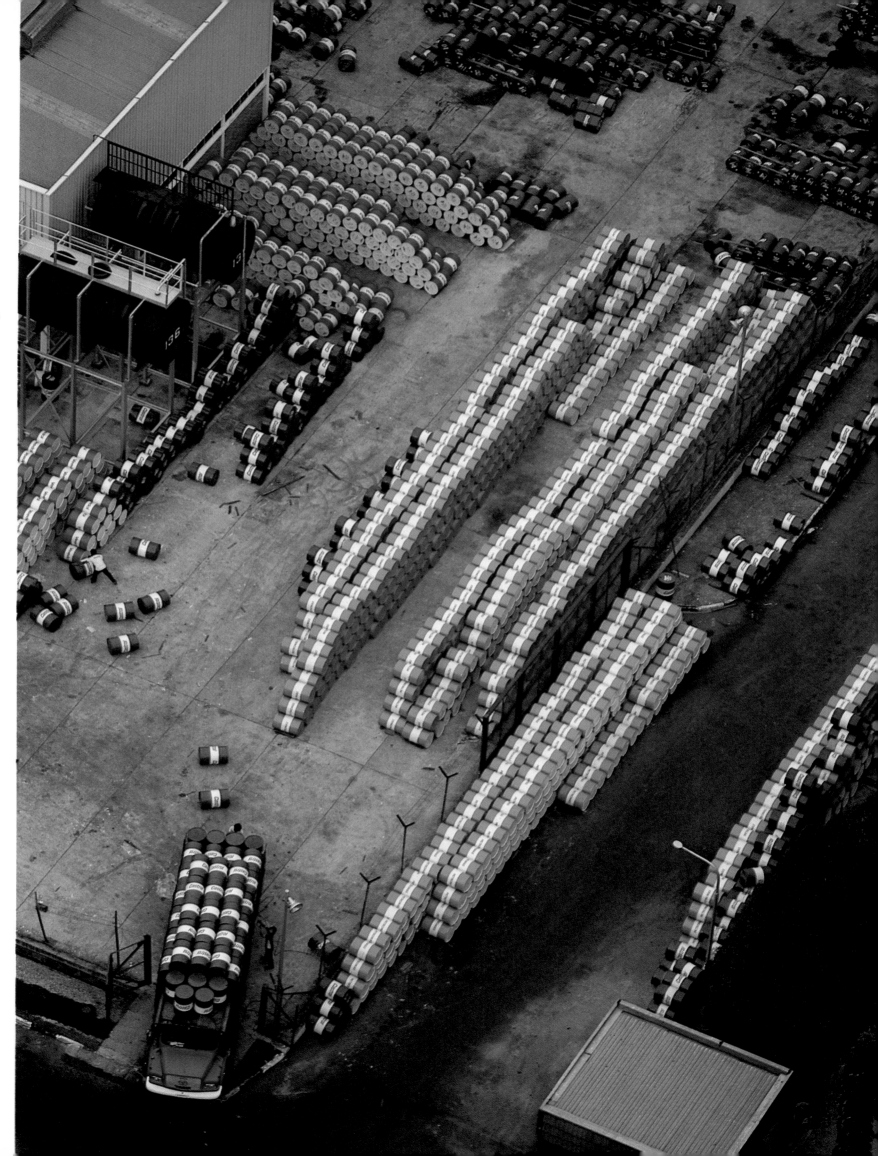

Industrial enterprise is interesting to analyse from the aerial view. From this vantage, day-to-day disorder recedes, to be replaced by the logic of a functional order, in this case in the storage and distribution of a well-known motor oil.

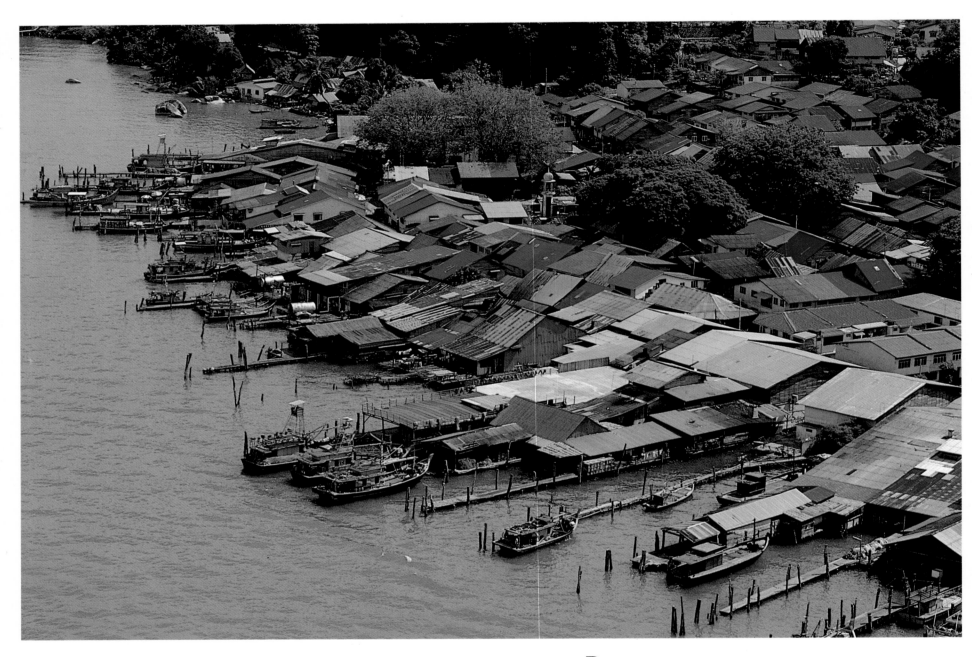

Pangkor island is a beautiful island made famous in Malaysian history by the signing of the Pangkor Treaty, 1873, between the British and Perak leaders. Fishermen in this village go in search of cuttlefish and anchovy; the roofs of their houses used to be of attap (coconut) fronds but zinc sheets now reflect the midday heat. Its day in the sun of local history assured, Pangkor island continues its peaceful, slumbering ways.

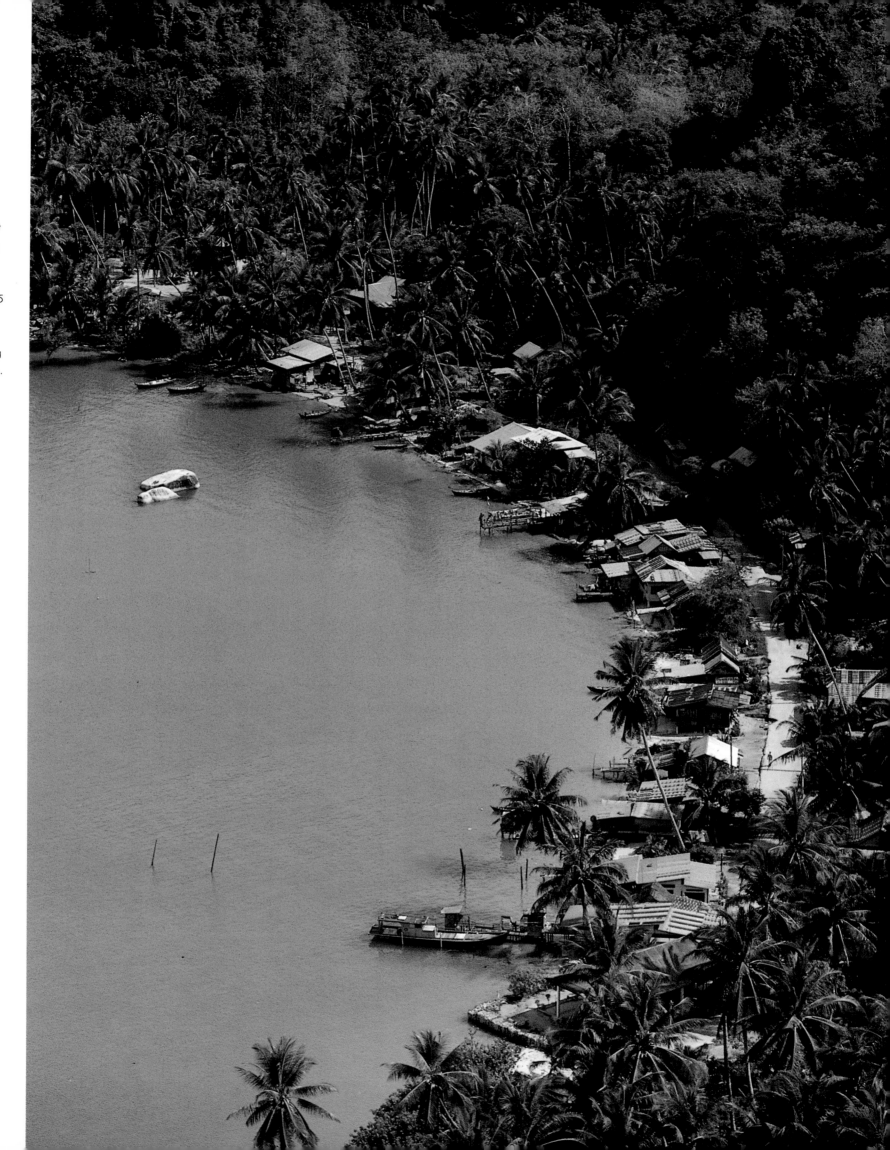

Resembling a giant jigsaw puzzle floating off in search of its match, the island of Pangkor Laut, some 45 minutes off Lumut in Perak state, is one of several islands making up the Pangkor Group. Pangkor Laut is home to one of Malaysia's most marvellous and scenic getaway resorts. On Pangkor Laut, the call of the wild has never been more pleasant.

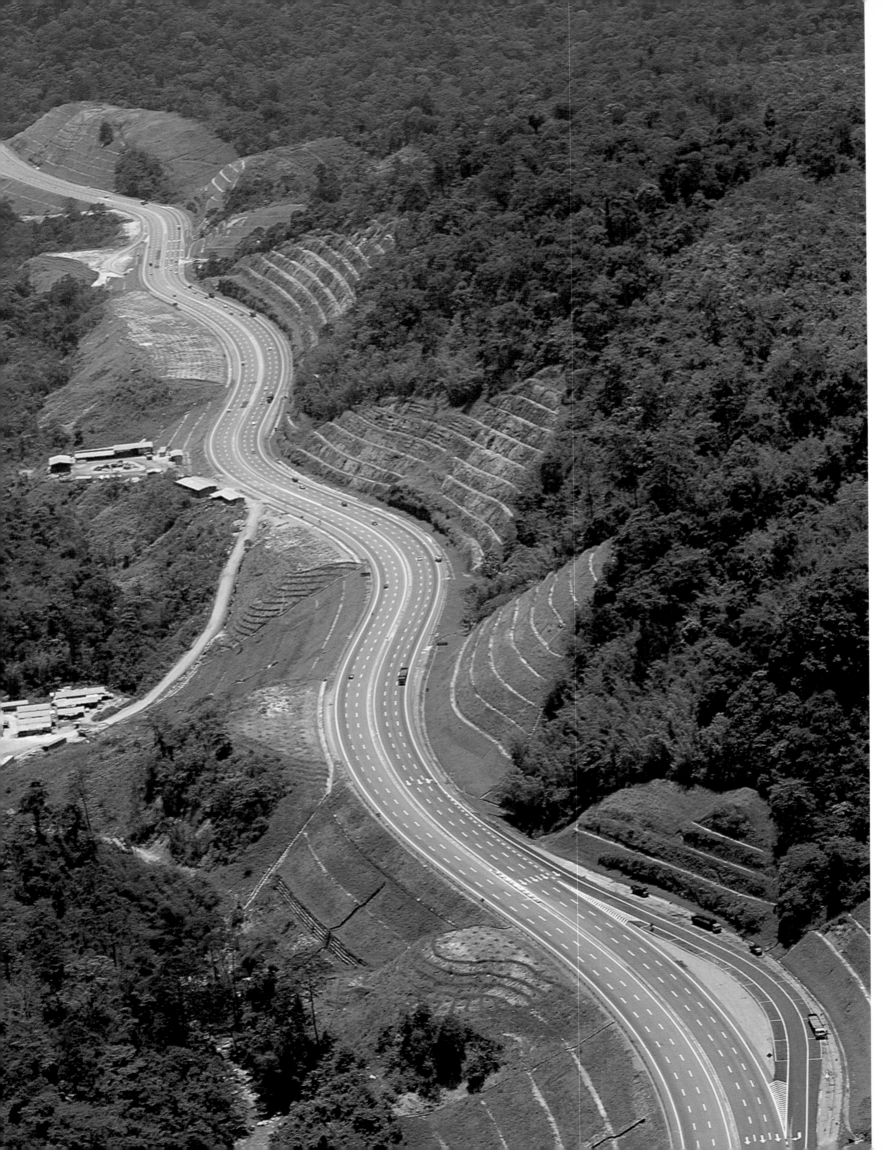

Genting Highlands, the hill resort nearest to KL, can be reached from the Karak Highway and then via an 18-kilometre four-lane highway which winds up to the resort at 1800 metres.

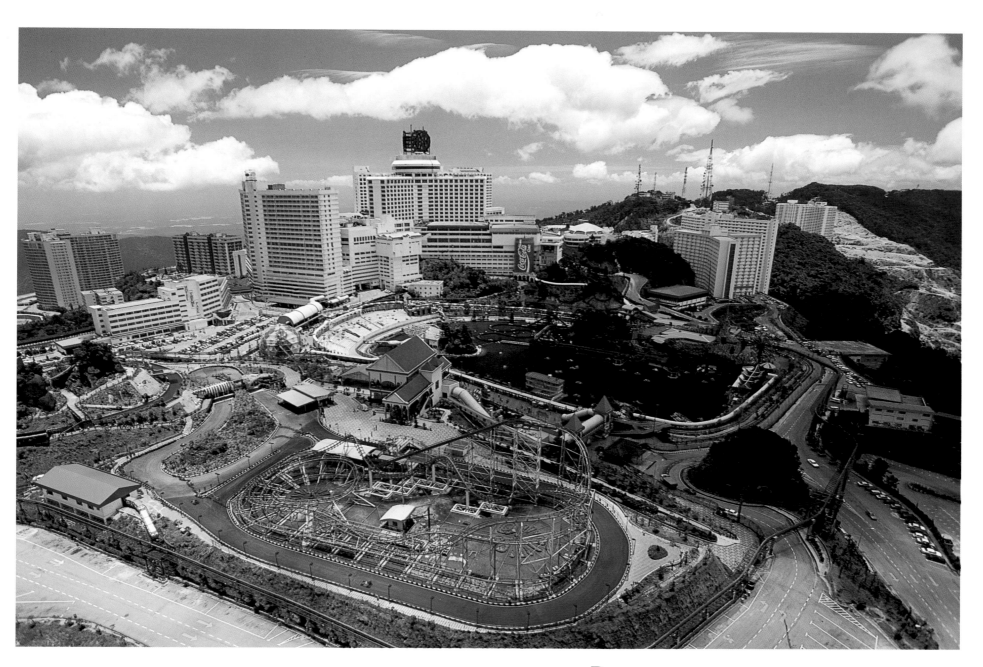

Bold brash and perched on the mountain top, the Genting Highlands Resort attracts tourists from Malaysia, Singapore and around the world. Its casino, its nightlife, the fresh cool air and magnificent views give it a special appeal. First opened up in the 1960s, the resort rests on a high point of the ridge of Gunung Ulu Kali. At night, and on clear days, the resort can be seen from downtown KL, beckoning from on high.

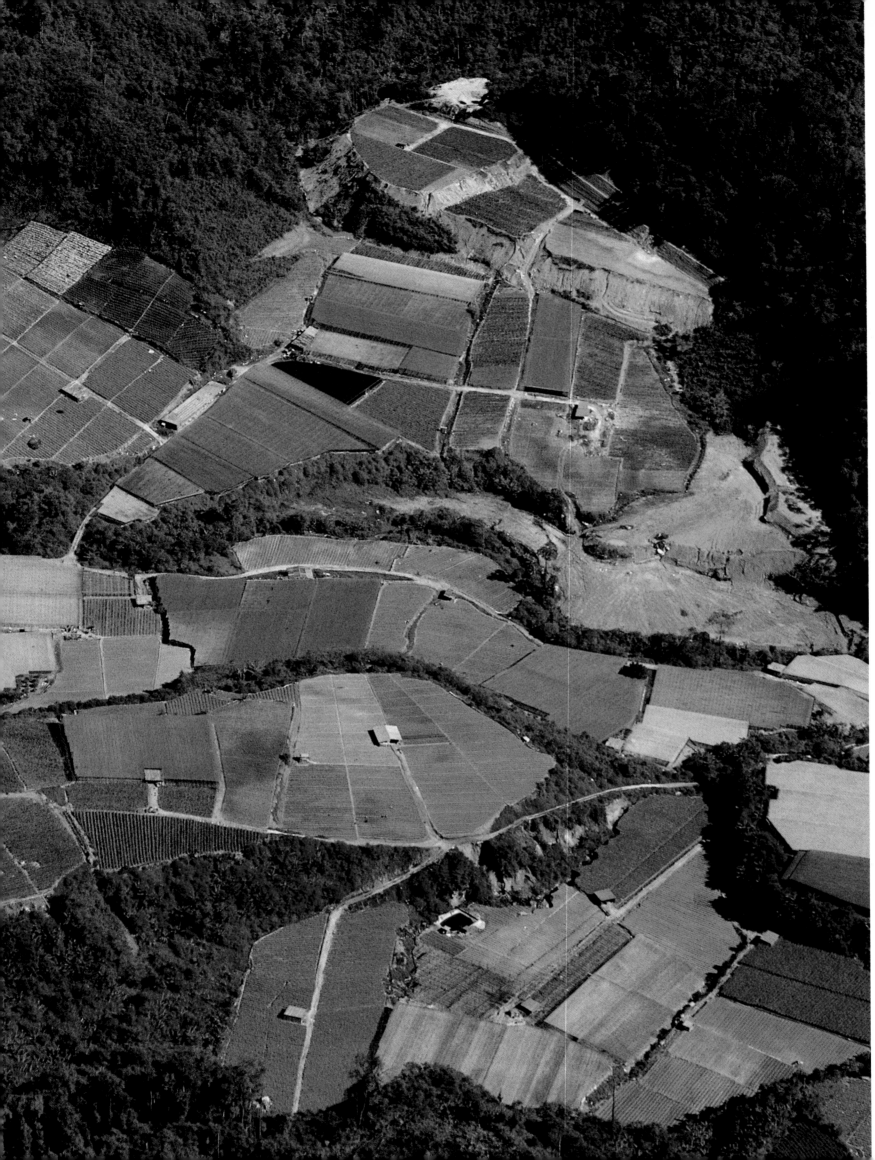

Cameron Highlands is one of the eight districts of Pahang state. Its cool and invigorating climate makes it ideal for flower nurseries and patchwork patterns of vegetable gardens. A popular colonial hill station, it looks like a small patch of England in the tropics, with many Tudor-style government guest-houses and hotels. Pahang became one of the four Federated Malay States in 1896.

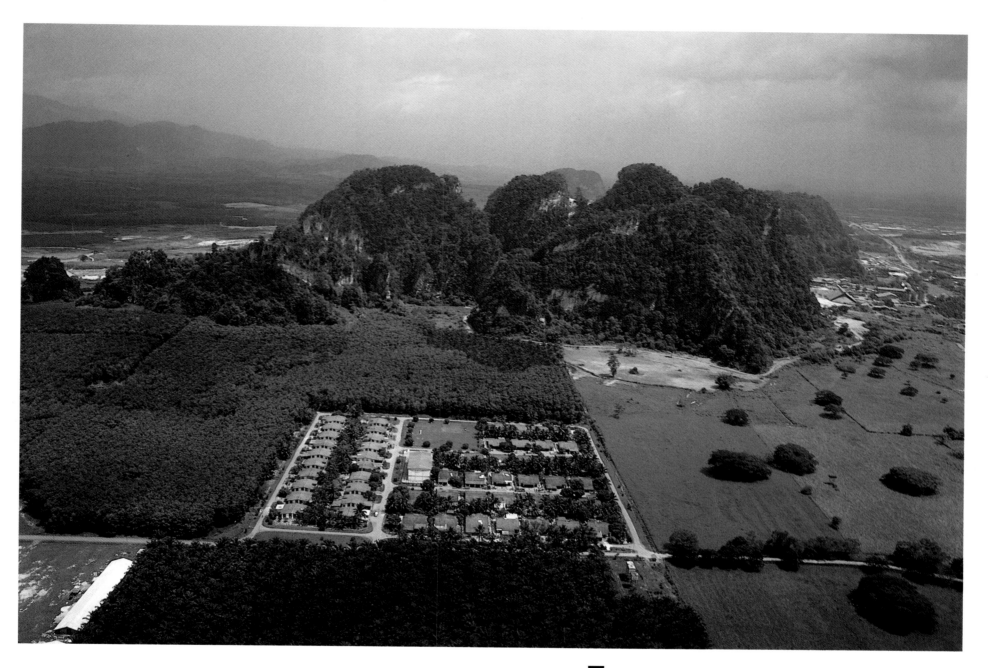

This particularly scenic outcrop of limestone hills and caves is part of a complex reminiscent of Guilin in southern China. A few miles from Ipoh, capital of Perak state, this area is a major tourist destination despite encroaching development. Perak is home to the the country's richest and largest tin lodes, although ironically 'perak' in Malay means 'silver'.

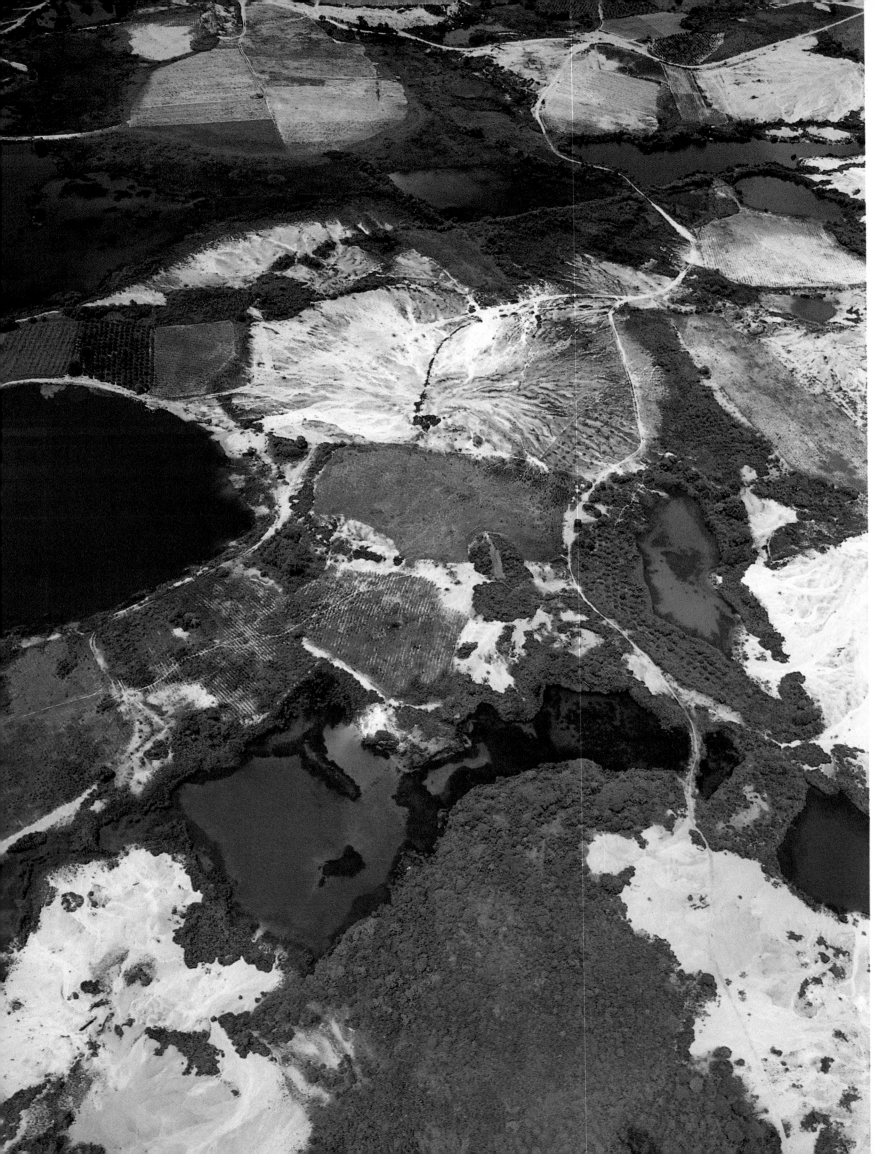

The search for tin in the states of Perak and Selangor did much to open the interior of the Malayan Peninsula, and still today Malaysia and Bolivia dominate the world's tin industry. Craters and pools remain after tin-bearing sands have been dredged of their share of the metal, but the energy of the tropical flora means that nature begins to rehabilitate the exhausted tin fields quickly.

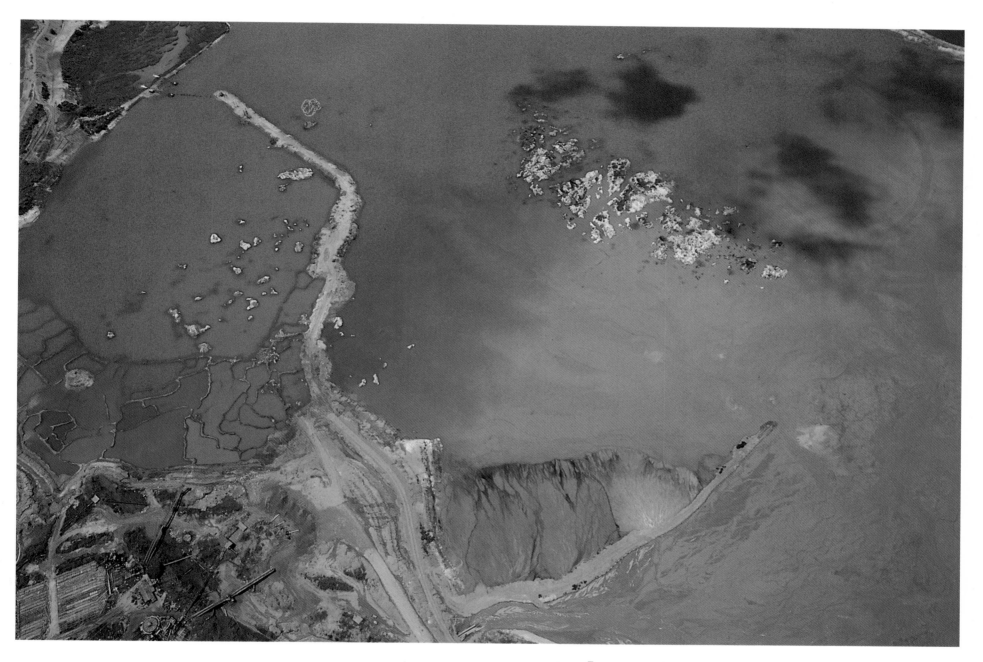

Like a crazy neon version of the dark side of the moon, the fresh remains of open-pit tin mining make for an eerie aerial spectacle. Locals believe that furious malignant spirits lurk beneath the waters, and when children drown in these relatively shallow depths, they whisper of the vengeance of nature.

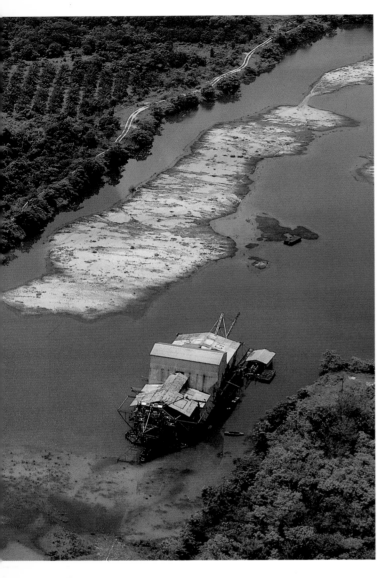

A disused floating dredge rests in a pool in an old tin mine, the land already coming back into productive use to grow oil palm. A low-lying landscape of mines, agricultural villages, and shady row after row of rubber trees on large plantations makes the drive north from Kuala Lumpur through Perak to Ipoh and further north to Penang a pleasant one. North-South road links are now being expanded and improved, for this corridor through the most densely populated part of Malaysia is really the main backbone of the Peninsula.

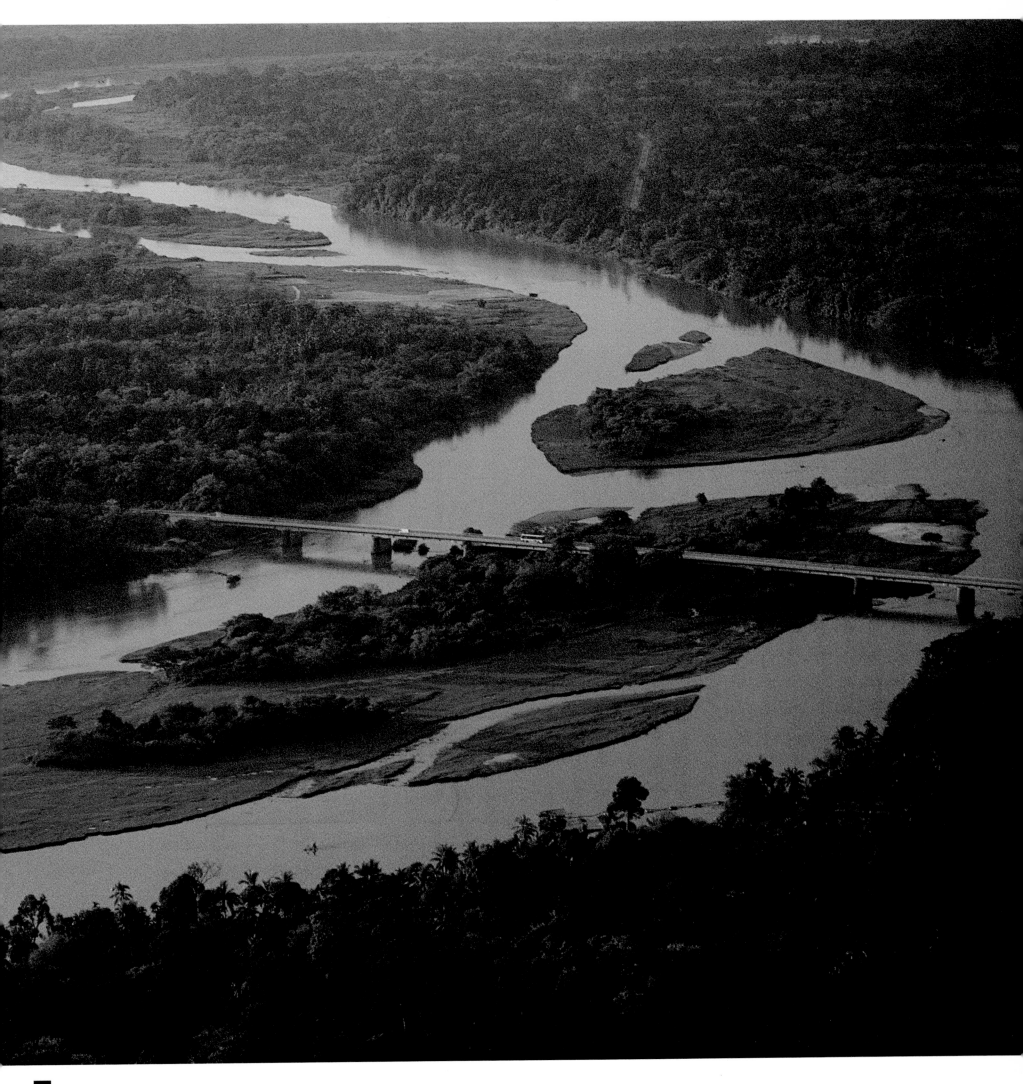

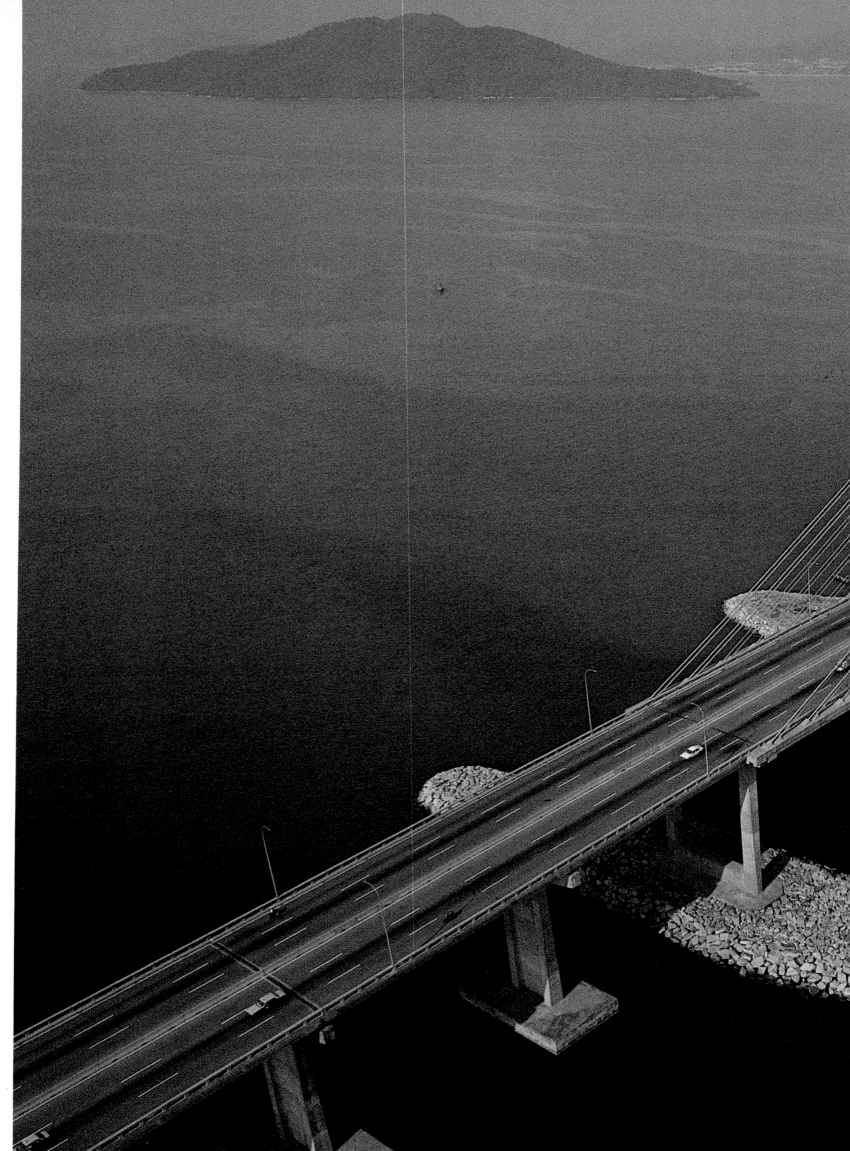

Since the opening of the Penang Bridge, in August 1985, Penang is no longer completely an island. This tremendous bridge, its pylons delicately suggesting the lines of a mosque's minarets, measures seven kilometres long, and joins Penang with Province Wellesley, or Seberang Prai, the band of land on the peninsula that belongs to the state of Pulau Pinang.

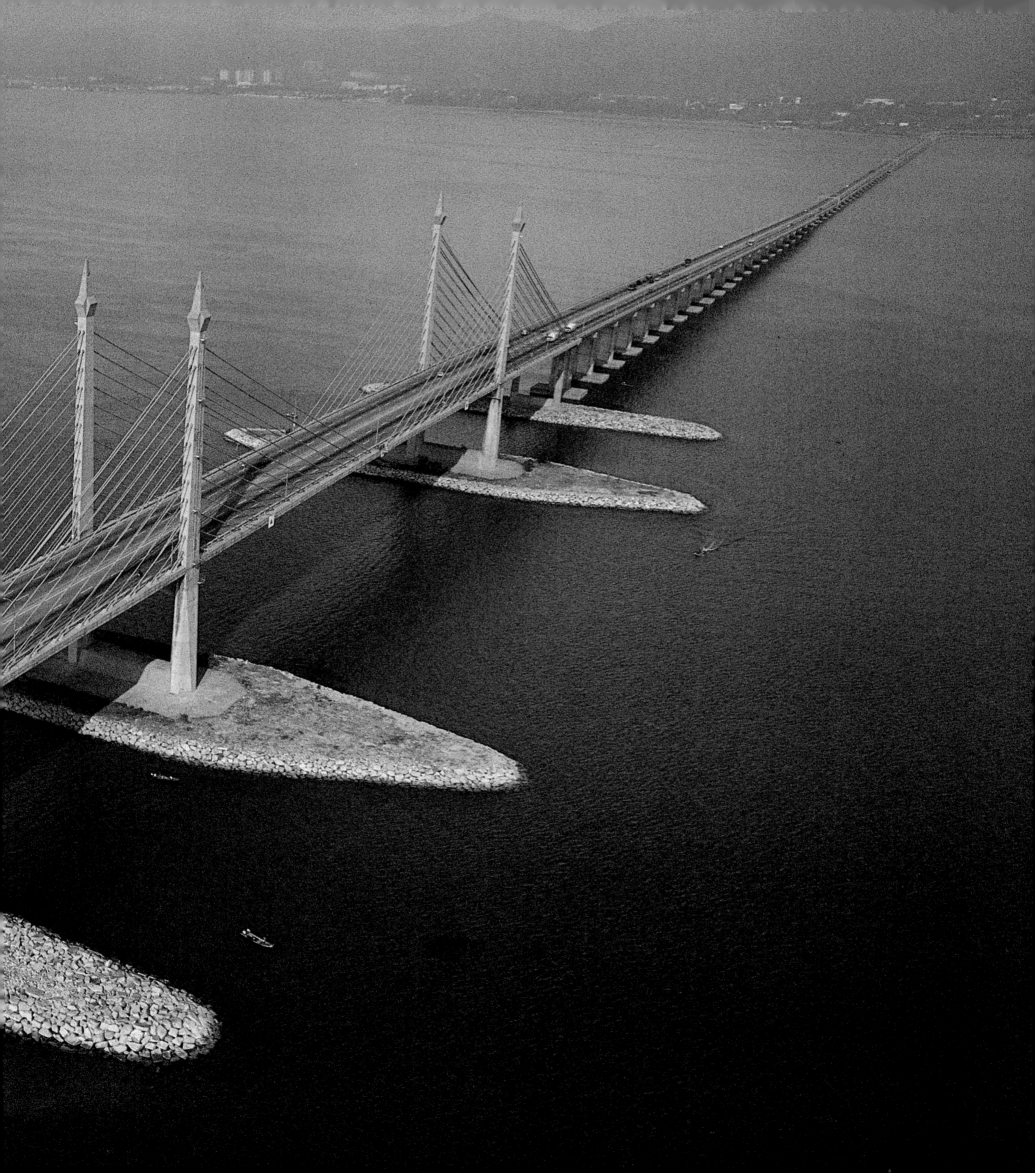

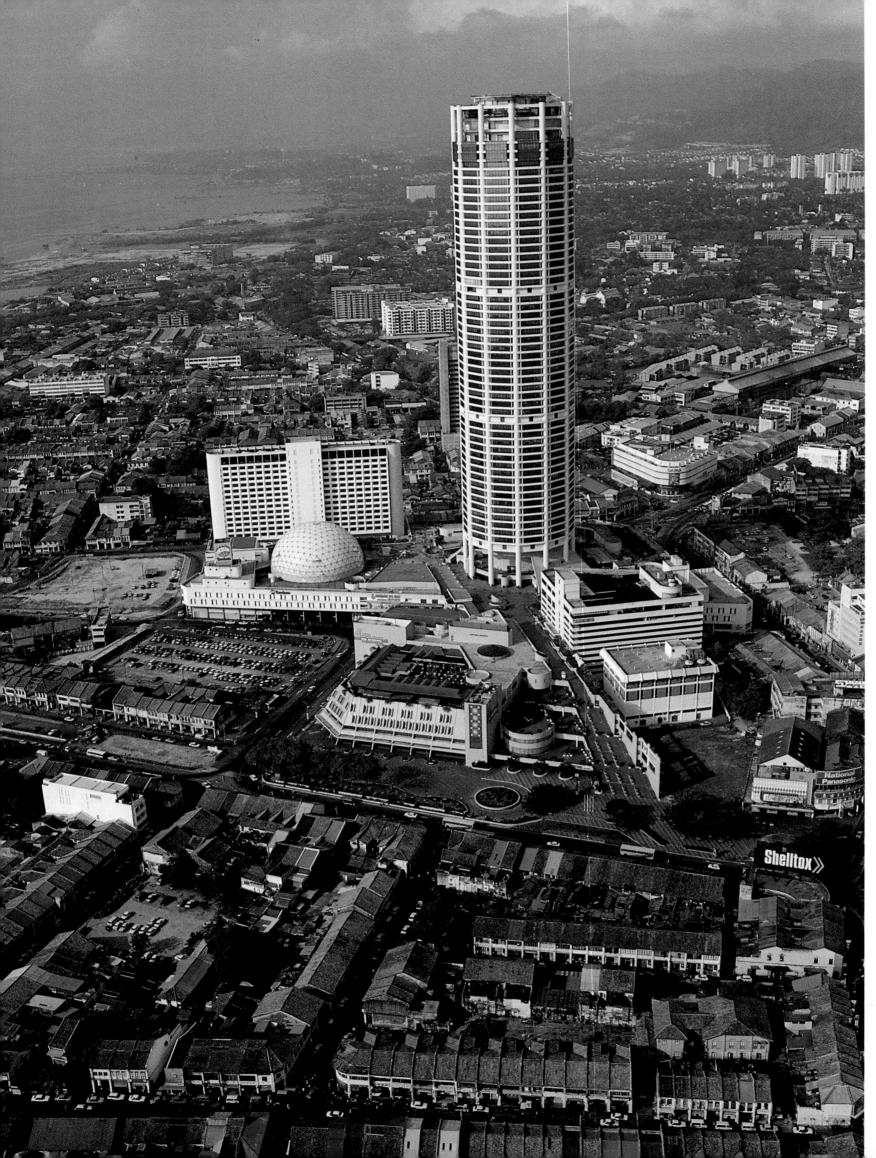

The pride of Georgetown, capital of Pulau Pinang, must be Komtar, a stunning monolith towering nearly 60 storeys above the din and bustle of old Penang town. While it is a disruption of the urban fabric of the town, the rationale is that it concentrates all development in one spot, allowing the rest of the city to preserve its traditional feel. Shops and major department stores occupy the lower levels, with offices above. The adjoining geodesic dome is used for meetings and exhibitions.

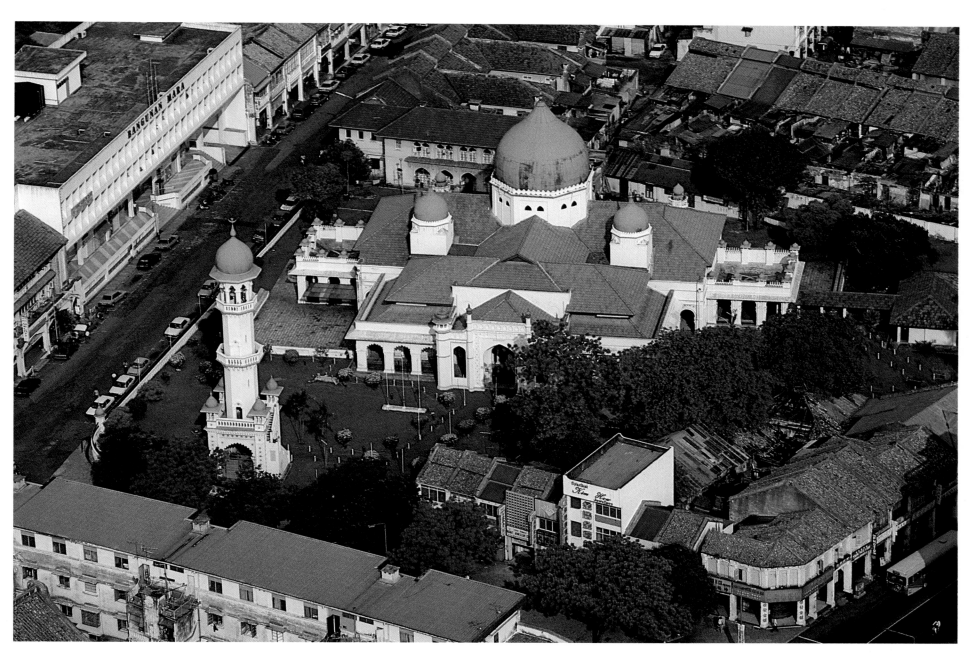

The history of
Penang mirrors that of
commerce and industry
of Malaysia. Francis
Light recognised the
potential of the island
as a naval and trading
base for the East India
Company. Barely
inhabited in 1786, it
prospered quickly,
luring adventurous
tradesmen and entre-
preneurs from India,
China, Burma and
Indonesia. The mosque
is a fine example of
the contribution of
Indian Muslims, who
carved out a profitable
niche for themselves
here.

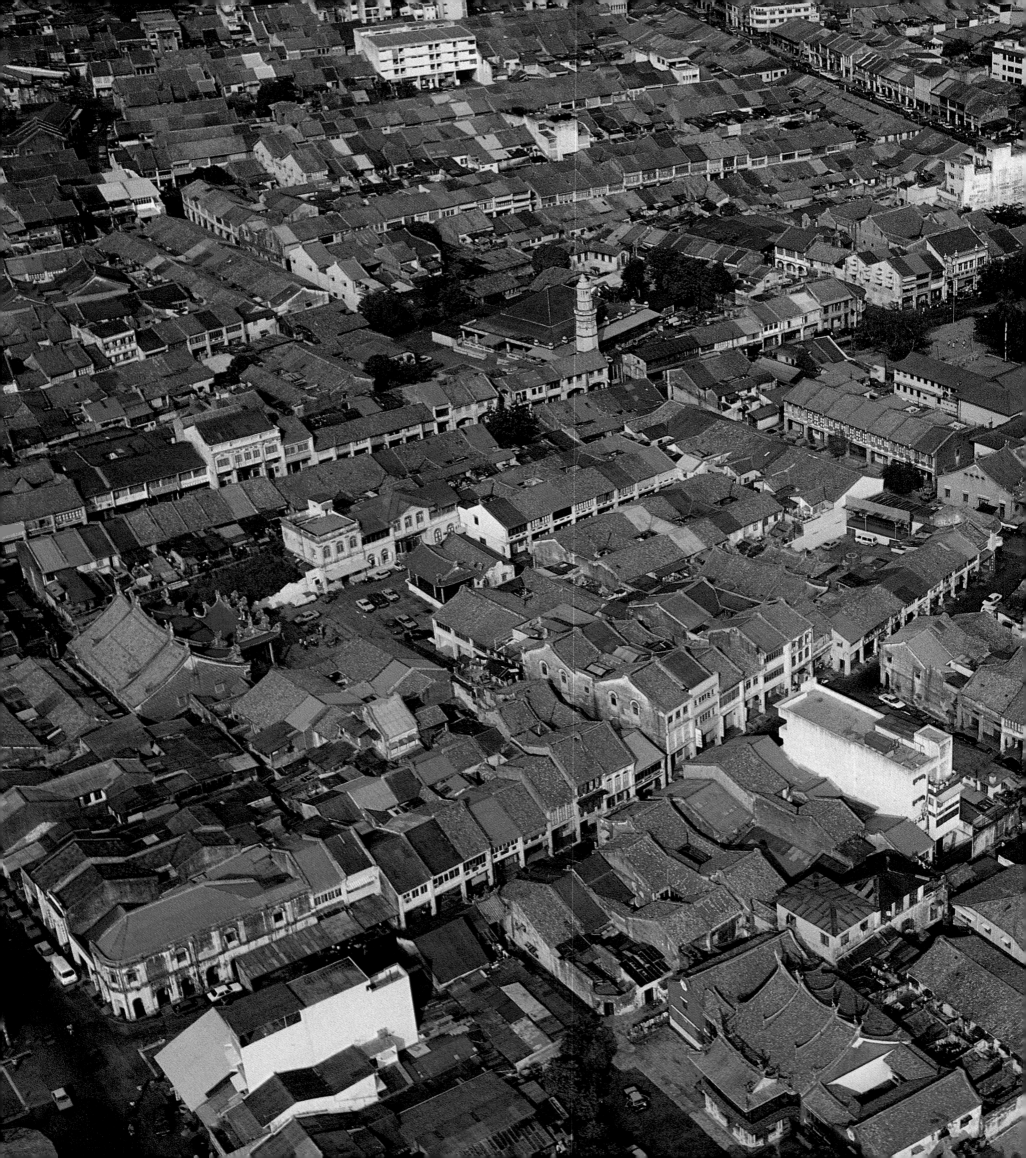

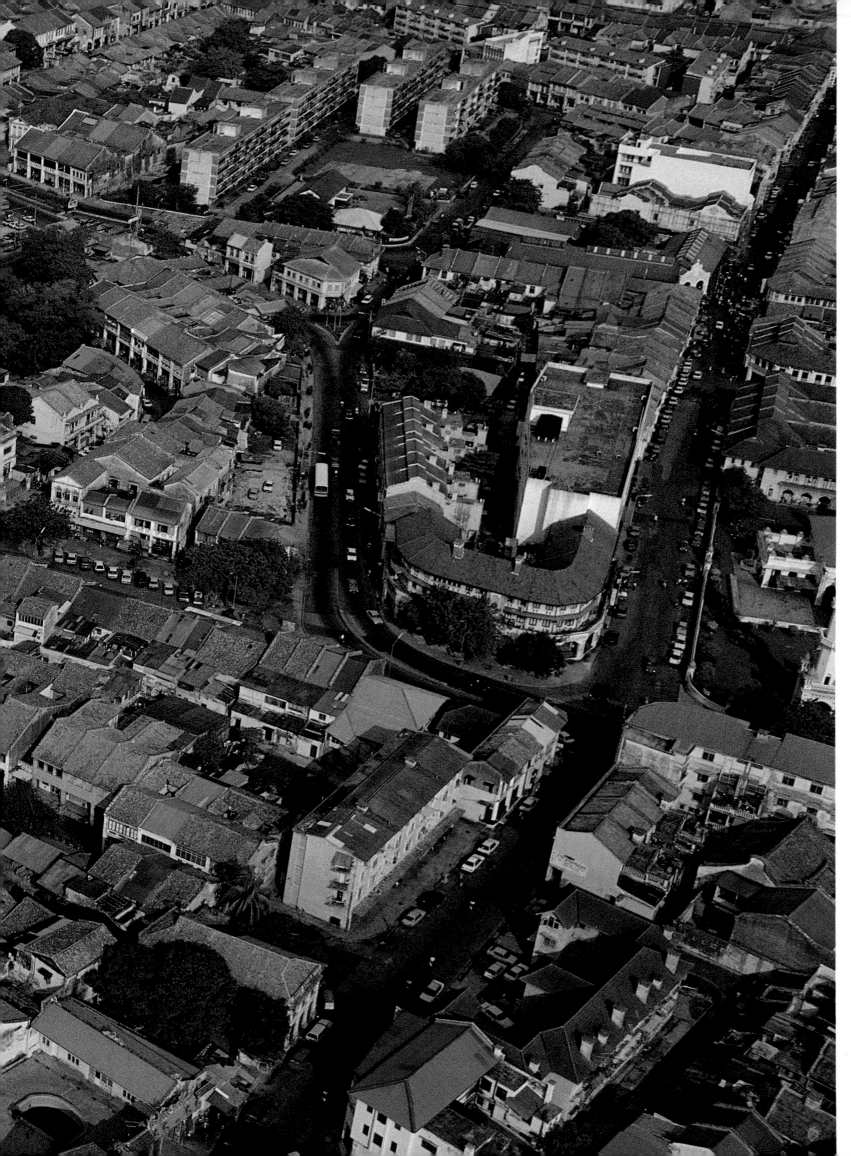

Despite the ever-nearing approach of the 21st century, Penang still basks softly in the afterglow of its glory years. Prospering since it was founded, the city boomed during the 1920s, on fortunes made in rubber and other commodities. The thick clusters of tile roofs are seemingly unchanged since then, and are a reminder of the once-bustling entrepot trade.

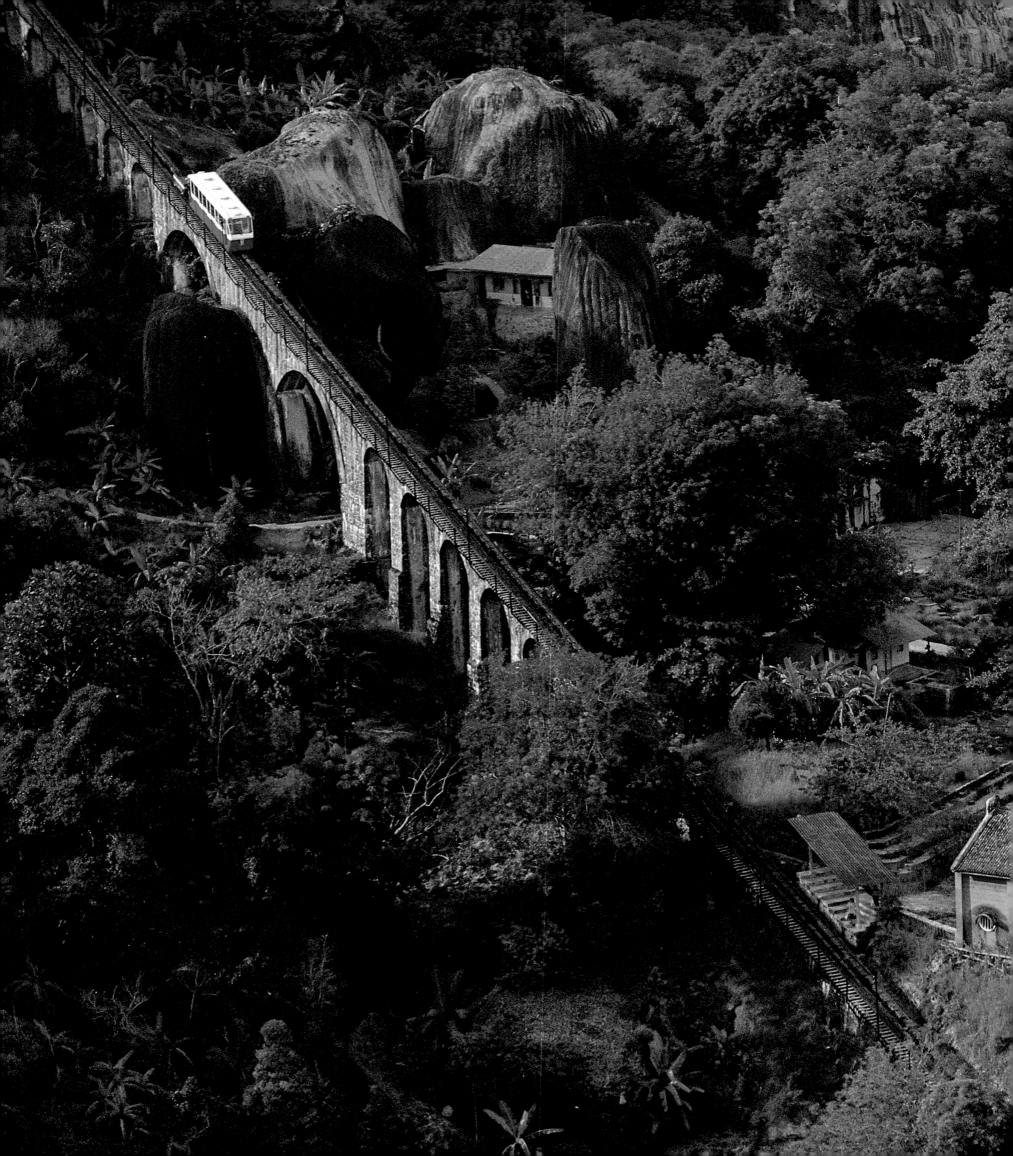

The funicular railway to Penang Hill was built by a Swiss engineer in the 1920s. The train may now have new carriages, but it is still a charming way to reach the coolness of the hill-station summit. The Hill is currently occupied by a few old mansions and rest houses, and offers wonderful views over Georgetown and across the straits to the mainland of Seberang Prai and the peaks of Kedah. This tranquility may change: plans have been announced to develop part of the Hill into a recreational centre and theme park.

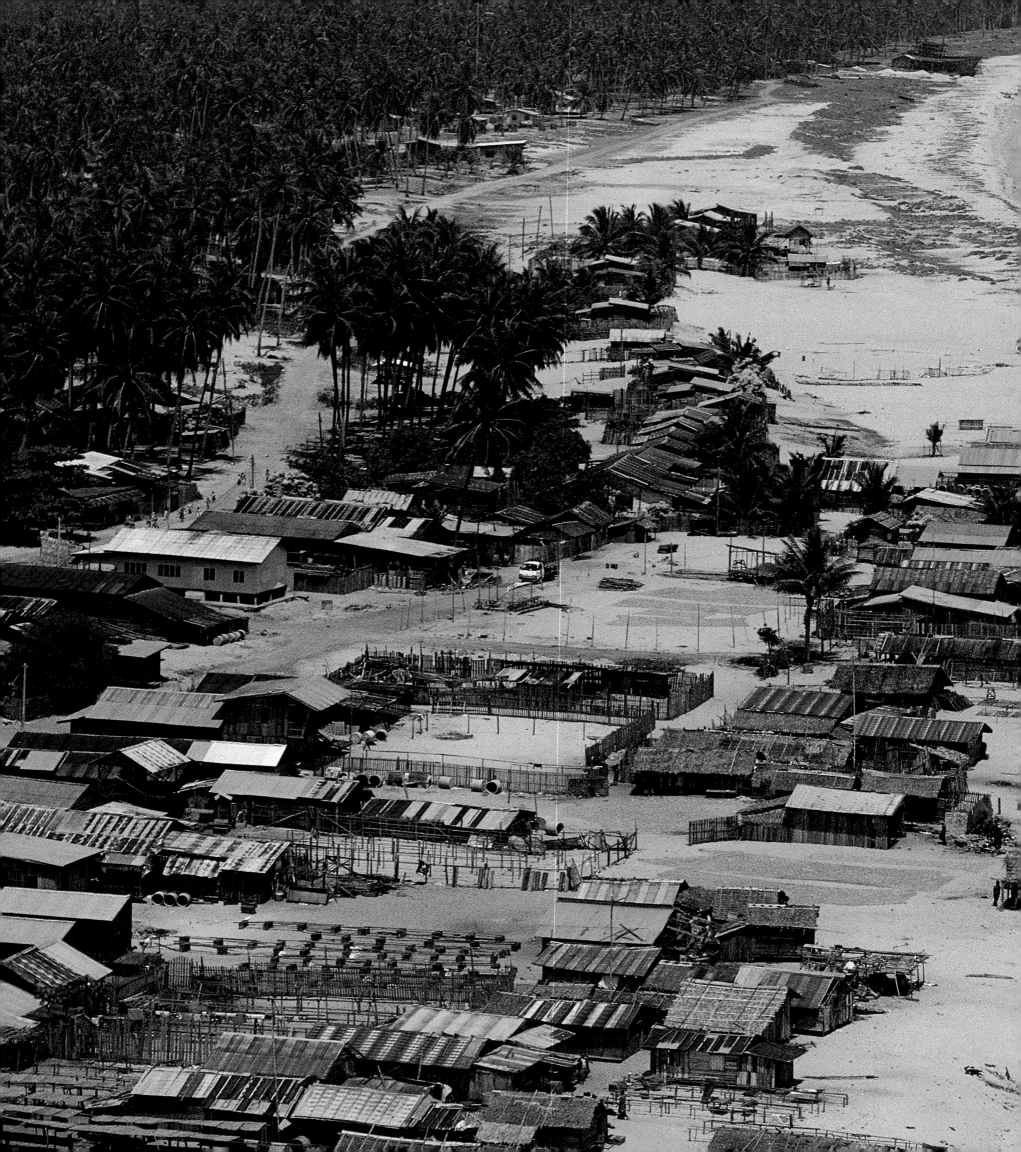

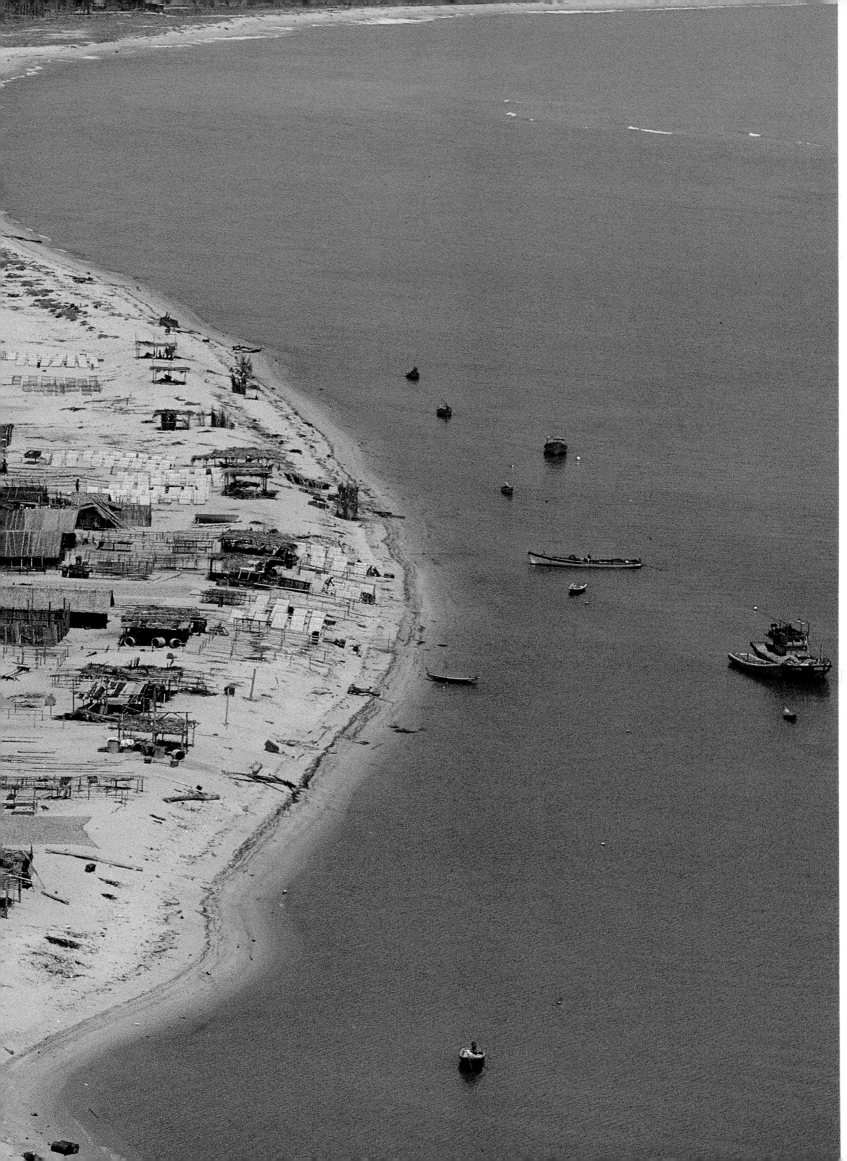

Previous page: this simple and beguiling stretch of 'no-man's land' is atypical of the East Coast. A dark-coloured river runs almost parallel resulting in a saline estuary rich in flora and fauna. Two different worlds, fresh and sea water, are only a lap away. Kampung Kuala Besut, this page, is a village of fishermen where the permanent odour of fish drying in the sun permeates the air. The beach of fine sand, and the coconut palms provides a picturesque setting.

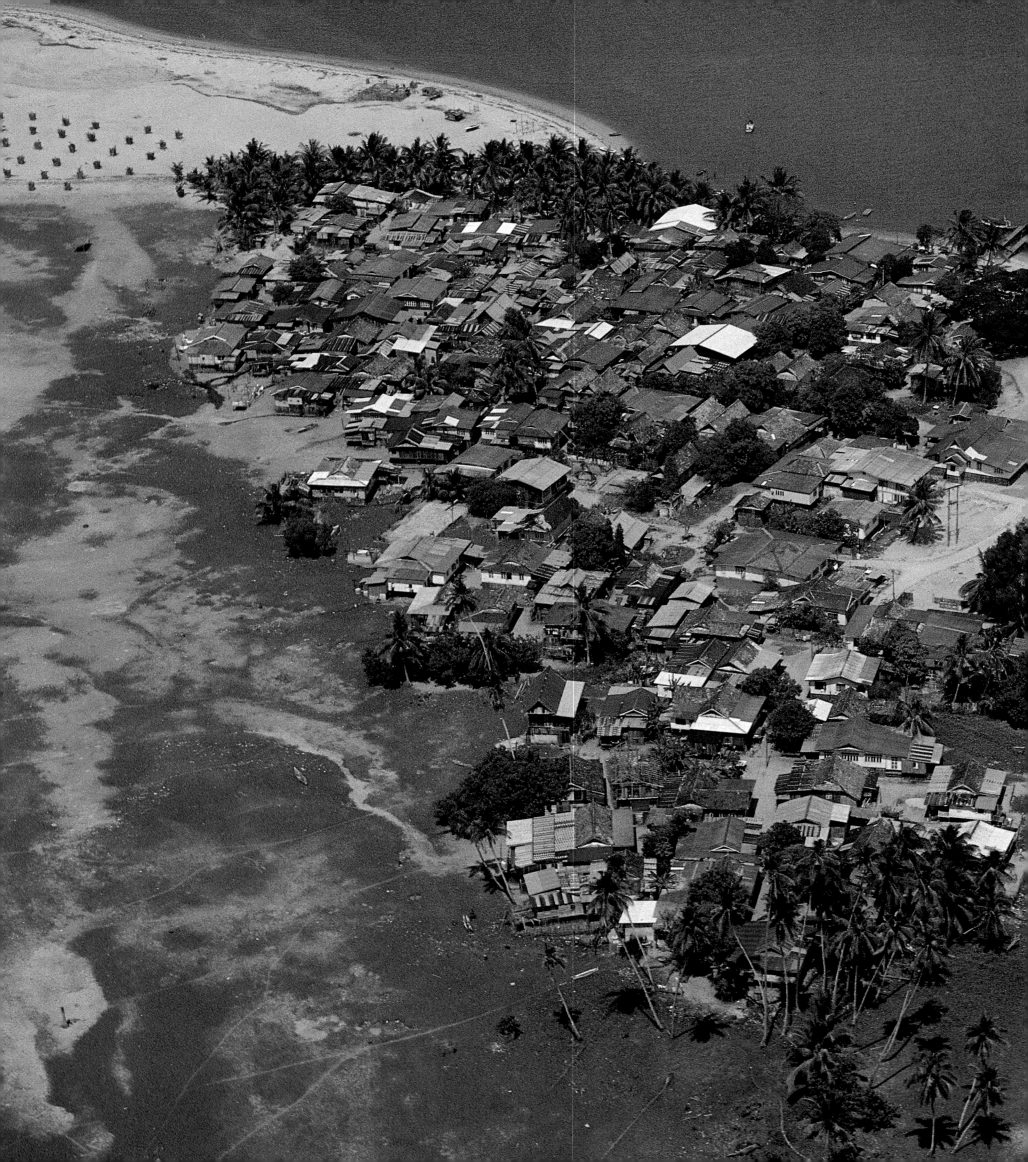

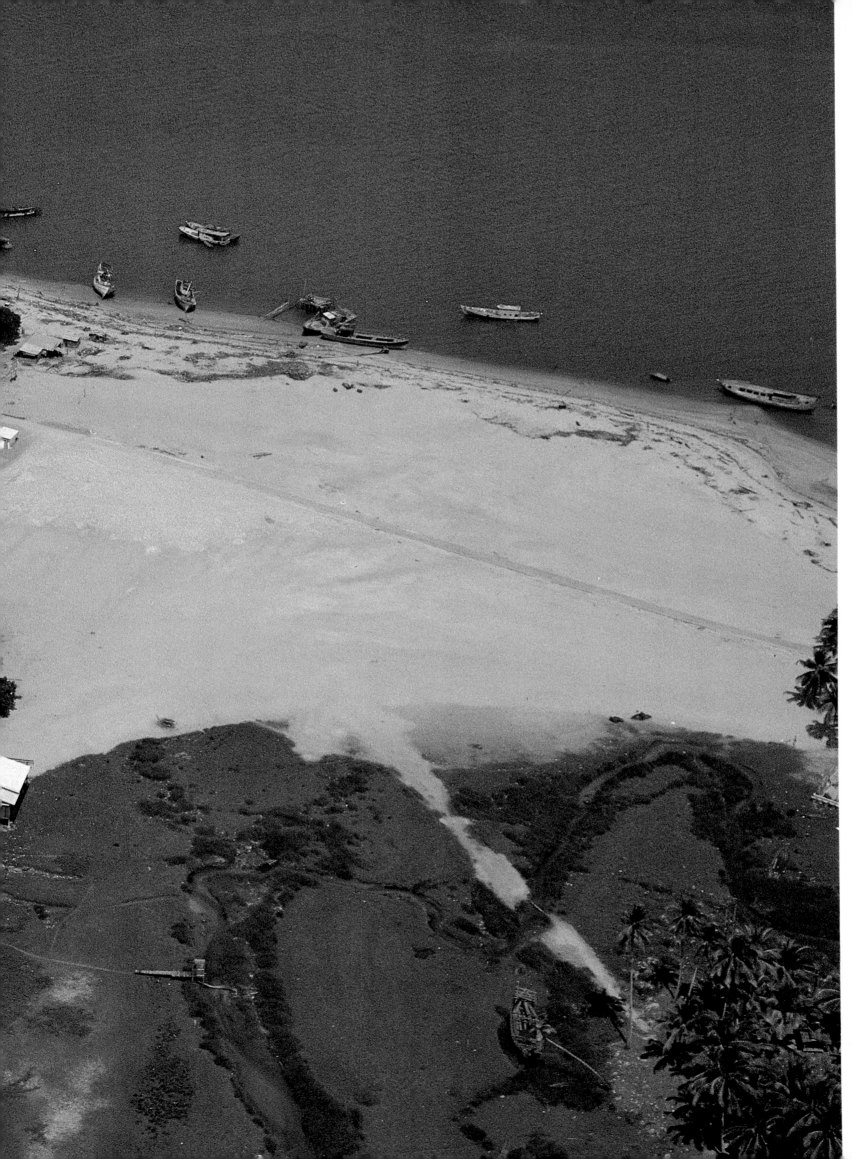

Idyllic villages like this dot Terengganu's coastline. Although assumed to be a peaceful backwater state, Terengganu has long been an important area of Malay settlement, and was the first Islamic state on the peninsula, a full hundred years before the founding of Melaka as a stone inscription at Kuala Berang bears testimony. Both Terengganu and Kelantan were obliged to send the 'Bunga Mas' to Siam prior to British domination.

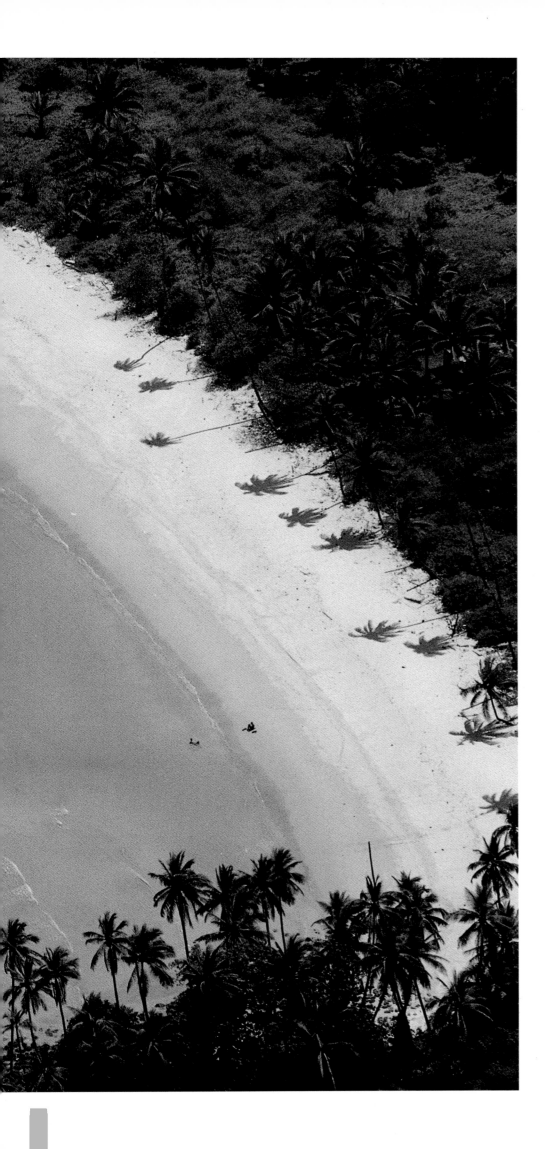

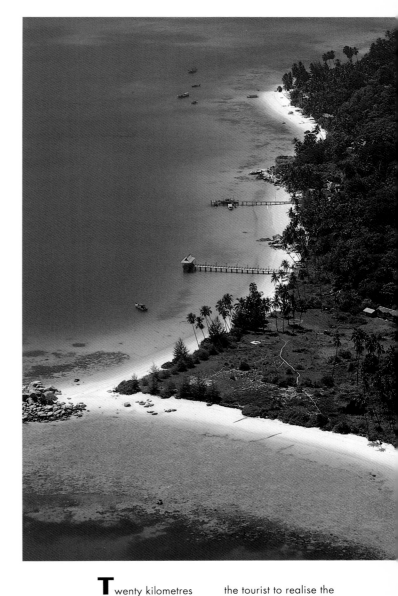

Twenty kilometres off the East Coast of Terengganu, the islands of Perhentian Besar and Perhentian Kecil make a superb refuge. The shallow seas and rich coral reefs around the islands have prevented them from being heavily fished, so their spectacular sea life is available to snorkellers and scuba divers. There are basic amenities here, but it is still possible for the tourist to realise the greatest touristic dream of many: a deserted beach, all to themselves. Fishermen from the mainland ferry travellers and divers out to Perhentian for their own deserted island experience.

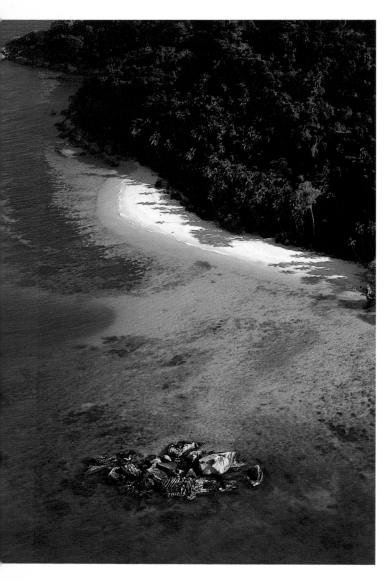

Tioman island, and the islands near it, off the Johor port of Mersing, are a popular getaway for holiday-makers. The diving is excellent, the coral sand of the beaches is fine, interspersed here and there with boulder-rimmed coves. The islands offer a mix of sophisticated resorts complete with golf clubs, inexpensive beachside chalets, and isolated getaways. Tioman has long been attractive to travellers; it was a watering spot for Ming Dynasty traders from China, and bits of Ming blue-and-white, well-eroded by the action of sea and sand, can occasionally be found on the shores.

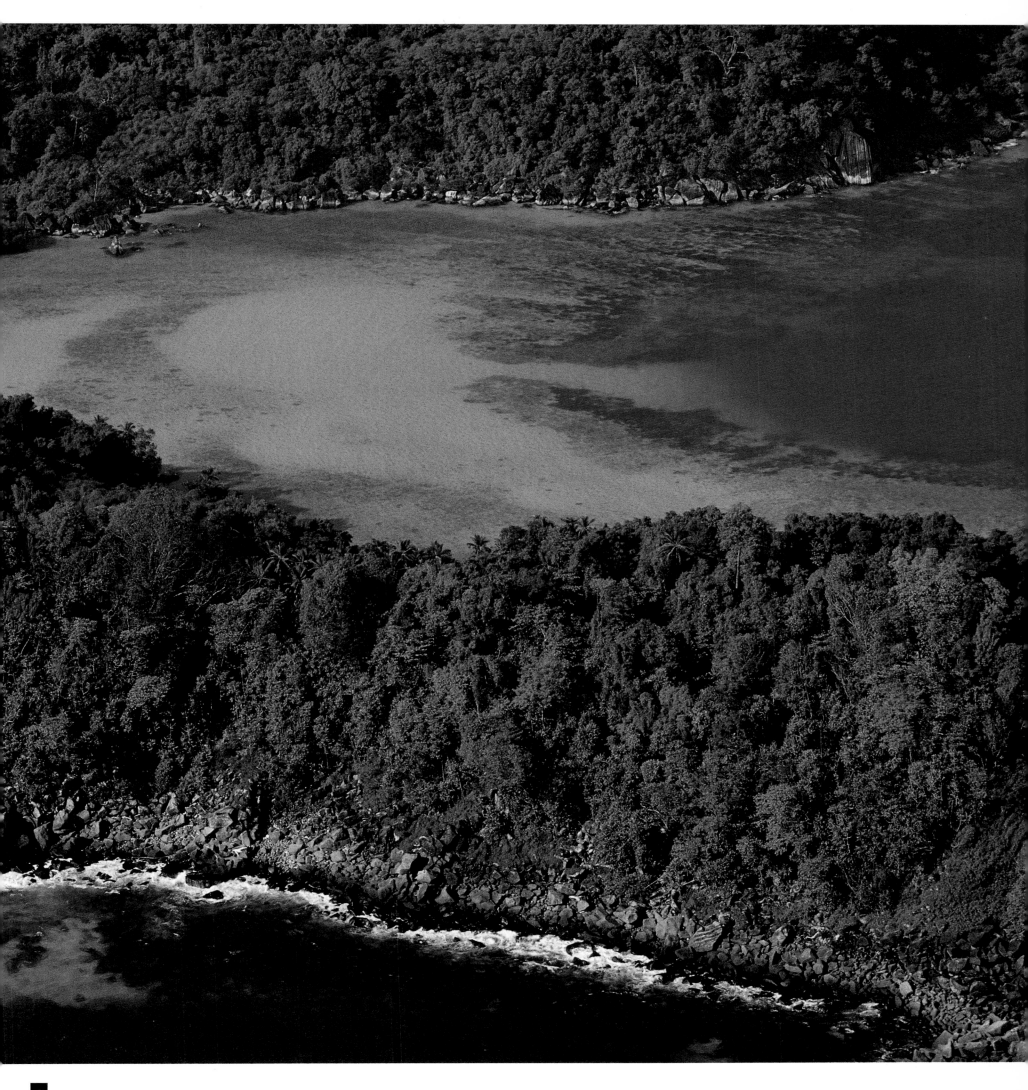

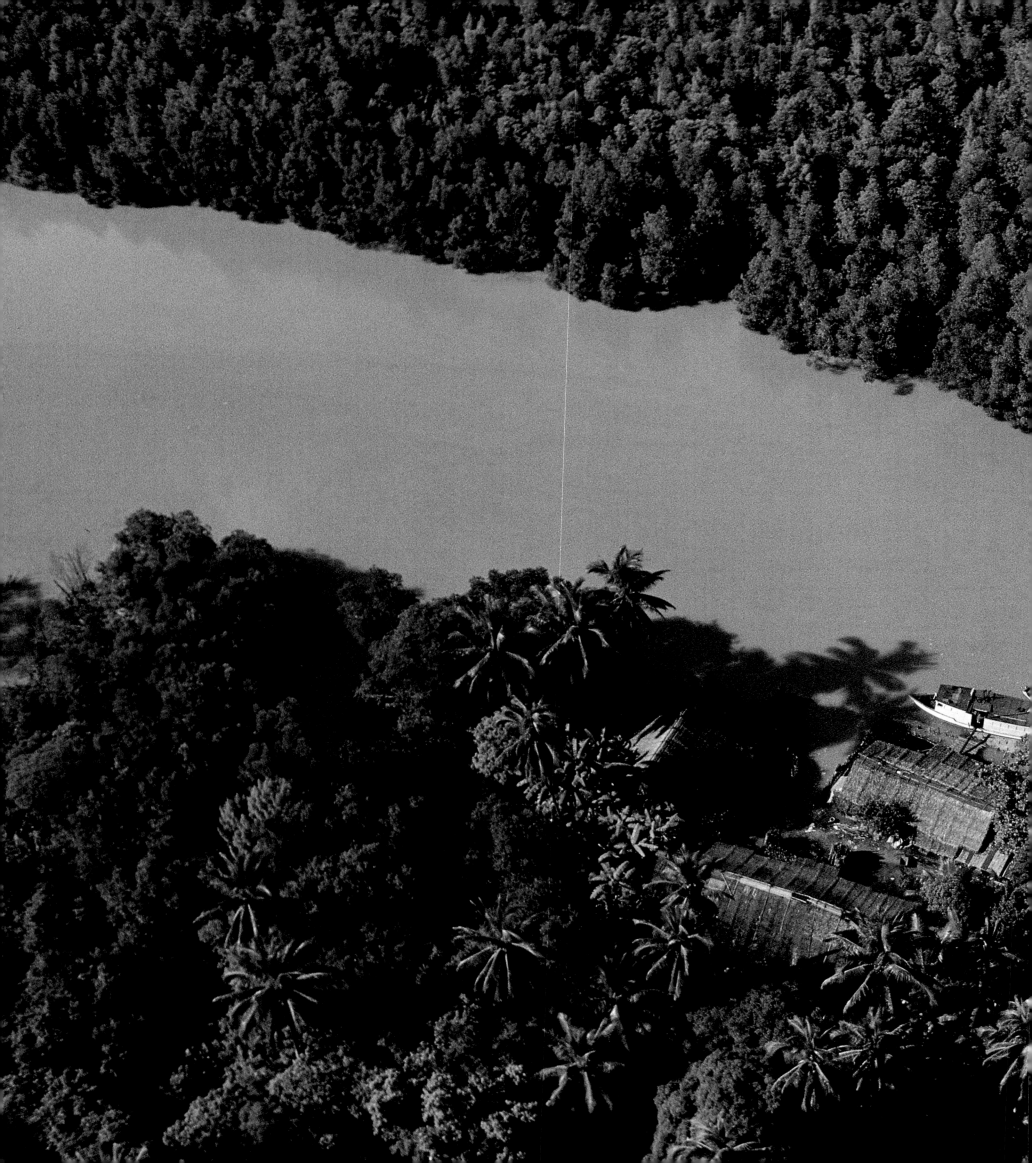

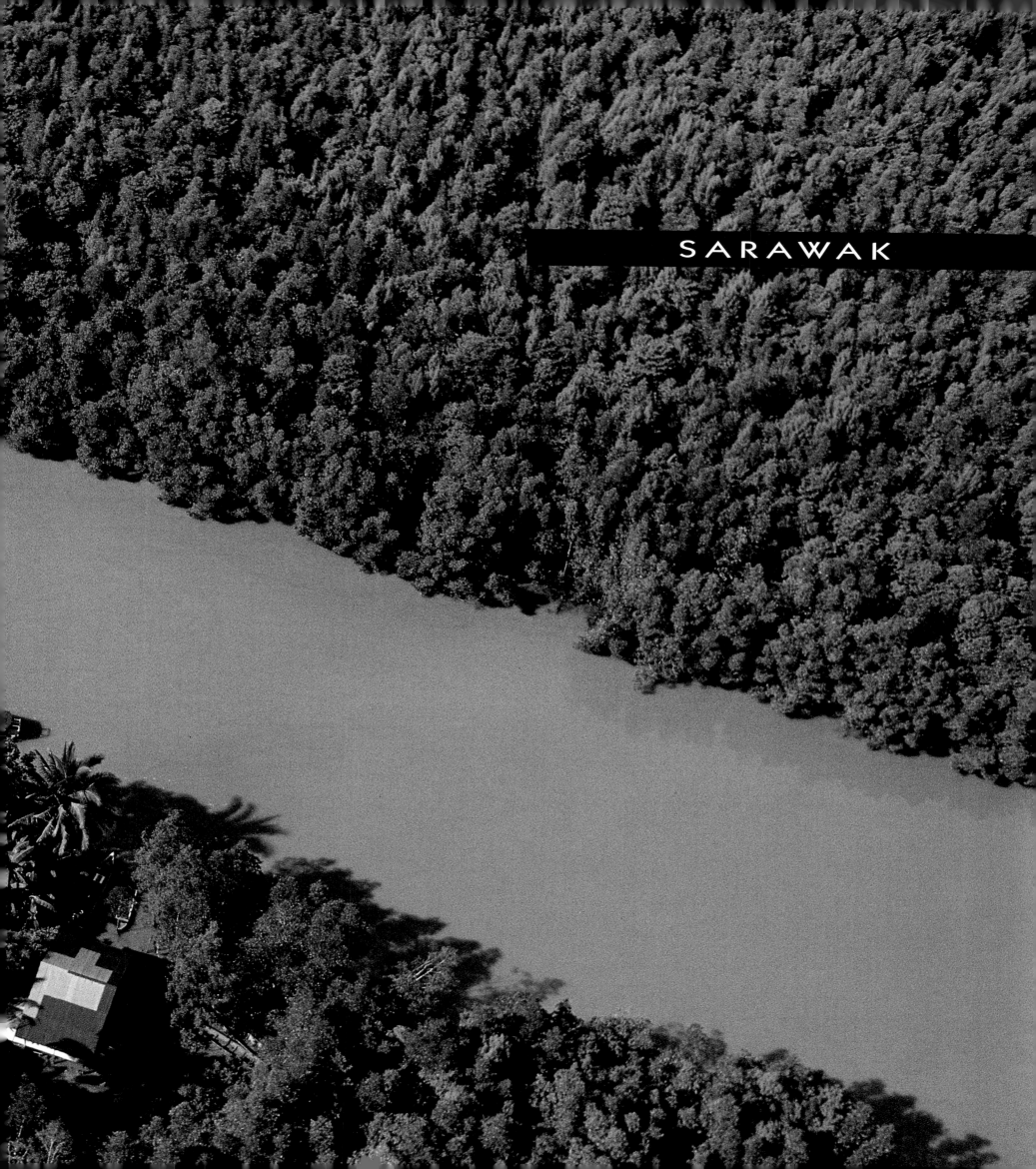

SARAWAK

The history of Sarawak could have been lifted straight out of a Hollywood epic box-office hit. In the 19th century, a cast of several thousand headhunters and pirates set into action a swirl of events peppered with enough adventure and intrigue to satiate any would-be Cecil B. de Mille. The dynasty of the White Rajahs was a classic case of being in the right place at the right time. When the English swashbuckling adventurer James Brooke docked in 1839, Sarawak was in the throes of a rebellion against the Brunei sultanate. As a token of appreciation to James Brook for quelling the uprising, the grateful Pengiran Mahkota of Brunei granted Brooke the territory between Tanjung Datu and Samarahan river in 1841. James Brooke 'crowned' himself with the title 'Rajah', becoming the first white man to rule a large territory in the East in his name and not on behalf of a European monarch.

He moved decisively to consolidate his personal private kingdom in the East by curtailing Malay and Iban sea power and by forging a strong government. When Charles, his nephew and heir took over the mantle in 1868, Sarawak stretched further, to Tanjung Kidurong. Rajah Charles Brooke continued his uncle's expansionist policies at Brunei's expense. With the annexation of Lawas in 1905, Sarawak acquired its present-day boundaries. His eldest son Rajah Charles Vyner Brooke acceded in 1917 and ruled Sarawak as absolute potentate though he granted Sarawak a written constitution in 1941. The Japanese arrived the same year, putting events on hold and the Rajah only reassumed his rule five years later. British pressure and his belief that the state could not recover and progress on its own resources turned Sarawak into a British Crown Colony. This antagonised the Malays and others against the cession, coming to a head in 1949 with the assassination of the second colonial governor. Tunku Abdul Rahman, Malaysia's first Prime Minister, proposed in 1961 that Sarawak join Malaya in a new Federation of Malaysia, together with Singapore and Sabah, and thus gain her independence. The Federation was born on the 16th of September, 1963 despite Indonesia's armed opposition which ended only in 1966.

At 123,986 square kilometres, Sarawak is by far the largest state in Malaysia, nearly equivalent to the eleven states of the Peninsula. Its multi-ethnic population of 1.6 million is a fascinating blend of Iban (around 30%), Chinese (30%), Malay (21%), Bidayuh or Land Dayak (8%), Melanau (6%) and other indigenous peoples making up a total of 23 recognised ethnic groups. Sarawak's island, Borneo, is a geological relic of Sundaland, a now-submerged arm of continental asia. The Peninsula and Borneo were joined as recently as 10,000 years ago, during the last Ice Age, and so their flora and fauna closely resemble each other. Sundaland has surfaced and again receded at various times, and this has contributed to the mostly sedimentary character of

Sarawak's geology. The most valuable mineral found here is oil. Other commercially viable deposits are bauxite and coal, with gold and antimony, both once very important to the economy. Along the coast and offshore, especially near the towns of Miri and Bintulu, Sarawak's landscape is dotted with oil fields and the structures of the liquified natural gas industry.

Over 75% of the state is still forested with some of the world's most diverse vegetation; luxuriant tropical rainforests, swampy marshlands along the coast and soggy, damp, moss-layered forests with dwarf vegetation occurring at altitudes over 1000

Malaysia is not a member of OPEC, but it is an exporter of oil. These storage drums are near the Sarawak town of Miri. Previous pages: a windless day on a river near Gunung Gadang.

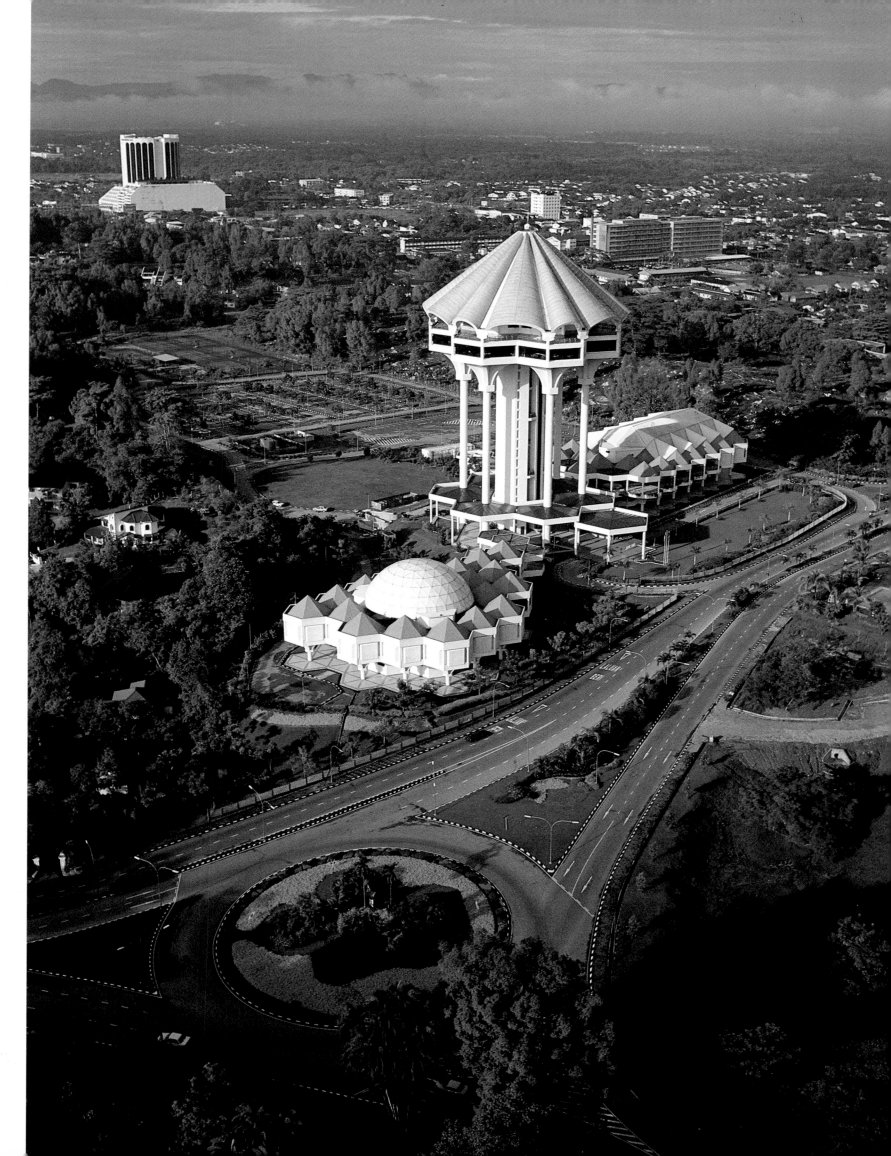

Kuching's space age City Hall is a masterpiece of funky futuristic architecture. The building functions as a meeting place, banquet hall, conference room, and exhibition complex. In front is the structure holding Malaysia's only planetarium. Some have noted the similarity of the main tower to a parachute in full descent.

Express river boats tie the main cities and towns of Sarawak together. Fast and streamlined, they have a shallow draught, and are often called upon to navigate tricky rapids.

metres. Unique in the world are Sarawak's heath forests, where conifers rule supreme. This low-lying type of forest, seen in its most extreme form in the Bako National Park on the coast just south of Kuching, grows up over impoverished or poorly-drained soils, and is festooned with low, gnarled vegetation.

From above, Sarawak is one lumpy green blanket criss-crossed with brown veins. The rivers are the country's longest and most navigable. The Rajang is navigable up to Kapit 160 km inland. Other imposing arteries include the Baleh, tributary of the Rajang, the Baram (400 km), the Batang Lupar (288 km), the Limbang (196 km) and the Sarawak (113 km). The main towns are all along these mighty conduits of commerce and transport, including Sibu, which is the terminus for the long-distance boat lines going up the Rajang. Because development has come so recently to much of Sarawak, and because communications are still dependent on the sometimes capricious rivers, some of the riverine settlements still have an adventurous air of the frontier about them.

Kuching, home to 306,000, is the nerve centre of Sarawak, and the seat of the state's government and administration. Kuching means 'cat' in Malay, and though the popular story has the name chosen by the Rajah, it is likely to have been the traditional name for the area for some time, inspired by the cats' eyes trees. For all its modernity, new developments and impressive government buildings, the city can still evoke the time of the White Rajahs, especially Rajah Charles Brooke. The Astana with its private jetty and pair of formidable towers was built in 1870 by Charles as a bridal gift to his wife, the Ranee Margaret. It is now the official home of Sarawak's Head of State. Also Charles' handiwork is Fort Margherita, built in 1878 and named after his beloved wife. The flag mast has seen the banners of many masters: the colours of the Brooke family's escutcheon, the Rising Sun, the Union Jack and now the Malaysian Flag. The Fort's new role in these rather more peaceful times is as the police museum.

The Round Tower is another fort commissioned by Rajah Charles though its actual purpose is a bit obscure. Down the road towards the river is the Square Tower, an odd edifice of solo tower, slit windows and parapets, a bit of Medieval England transported to the tropics. Kuching's architecture is a bewildering hodge-podge of lurid orientalia, classical Palladian, British colonial and Modern, as if the master planner couldn't decide on the overall theme and opted for a bit of everything. The Court House is acknowledged as one of the most magnificent in Malaysia, with a clock tower, an obelisk to Rajah Charles Brooke and intricate native motifs on its doors and grills. The General Post Office, with its ten Corinthian columns, looks as if it would be more at home in Athens' Parthenon. Learned souls will make their way to the Sarawak Museum, one of Asia's finest. Completed in 1891, its facade is Normandy but the interior houses Bornean art and crafts, and a natural history collection started by the famous naturalist Albert Wallace, circa 1855. The old and new wings provide a rich insight into Sarawak's heritage. The gaudy red Tua Pek Kong Temple is Kuching's oldest dating back to the 1860s. A grand new Sarawak State Mosque now supercedes the 1968 one which was designed by the renowned architect Sami Mousawi and still stands regally on 100 acres, on the site of an earlier wooden mosque built in 1852. A little bit further from Kuching, by the foot of Santubong Mountain is Sarawak's Cultural Village, a living, open air museum highlighting the various ethnic cultures.

Some of Sarawak's most arresting, spell-binding and magical sights are completely unavailable to the aerial view. They are even too bashful and demure to be seen from on the ground. One has to go underground, in fact, to appreciate them. The Gunung Mulu National Park is only a compact 544 square kilometres, but within its boundaries is one of the most spectacular and extensive limestone cave systems above and below this earth. The Sarawak Chamber, Lubang Nasib Bagus ('Good Luck Hole') is the worlds largest natural chamber at 600 m long, 450 m wide and 100 m high, cavernous enough to garage 7500 buses! Deer Cave has the largest passage known to us at 100 m wide and 120 m high with an eerie 190-m waterfall pouring through the roof after a rainstorm. The longest cave system in Southeast Asia is Clearwater Cave which winds at least 51.5 km into the mountain. The much publicised British-Malaysian Mulu Expedition of 1980 did a great deal of work surveying the caves, and to date over 26 caves with 159 km of passages have been surveyed. Yet this is believed to constitute only 30% of the cavern system!

A little of Mulu's magic is visible from the air, as the limestone that is tunnelled through underground yields bizarre shapes and forms above ground as well. Huge forested hummocks and sheer cliffs mark the Mulu landscape, but the most exciting spectacle above ground here is the sight of the desolate, weirdly shaped pinnacles protruding perversely along Gunung Api's slopes. These formations—knife-sharp, intensely eroded spurs of limestone loom as much as 45 m above the treetops. The second highest peak in Sarawak is Gunung Mulu, at 2376 m Covering the mountains, caves, valleys, heath and flatland are, at the last count, 1500 species of flowering plants including 170 orchids and 10 species of pitcher plants. Traversing the surface are 68 species of mammals, 262 species of birds including all 8 species of hornbills, 74 species of frogs, 47 fish types, 281 forms of butterflies and 458 kinds of ants. Inside the Deer Cave are several hundred thousand Free-tailed bats, one of the twelve bat species which form black clouds at the cave entrances each evening. These zones are home too for three species of swift, for scorpions, earwigs, and monstrous crickets. Underground, confined to a gloomy subterranean existence are 25 invertebrates including a rare scorpion and White crab, living fossils saved from extinction by the caves specialised mode of existence. Other bizarre life forms may be in the caves, yet to be described by scientists. In other parts of Sarawak, like at Nias Caves, now part of a 3102-hectare National Park, flying cave dwellers provide locals with an excellent source of income: bats and swifts provide the materials for the guano and birds nest industries. The red variety of birds nest now commands over M$300 per kilo.

The entire rugged, sandstone peninsula by the Bako river 37 km east of Kuching is Bako National Park, 2742 ha of plunging cliffs, eroded headlands, sandy bays, sea arches, sea stacks, bizarre and coloured rocks from diffused iron depositions. The main feature here is the 100-metre high sandstone plateau that holds a unique sort of peat forest. Bako's extensive mangroves are home to the Proboscis monkey, Silver-leaf monkeys, Long-tailed macaques, two-metre long Monitor lizards, mud-skippers, and even inquisitive and playful otters.

Birds have always played a crucial role in the myth and symbolism of the peoples of Sarawak, the Land of the Hornbills. Despite their dominion, the birds-eye view only begins to reveal the secrets of this natural haven.

The Goddess of Mercy Temple, prominently located in Kuching, honours Guanyin, a Buddhist deity very popular among the Southern Chinese who migrated to Sarawak.

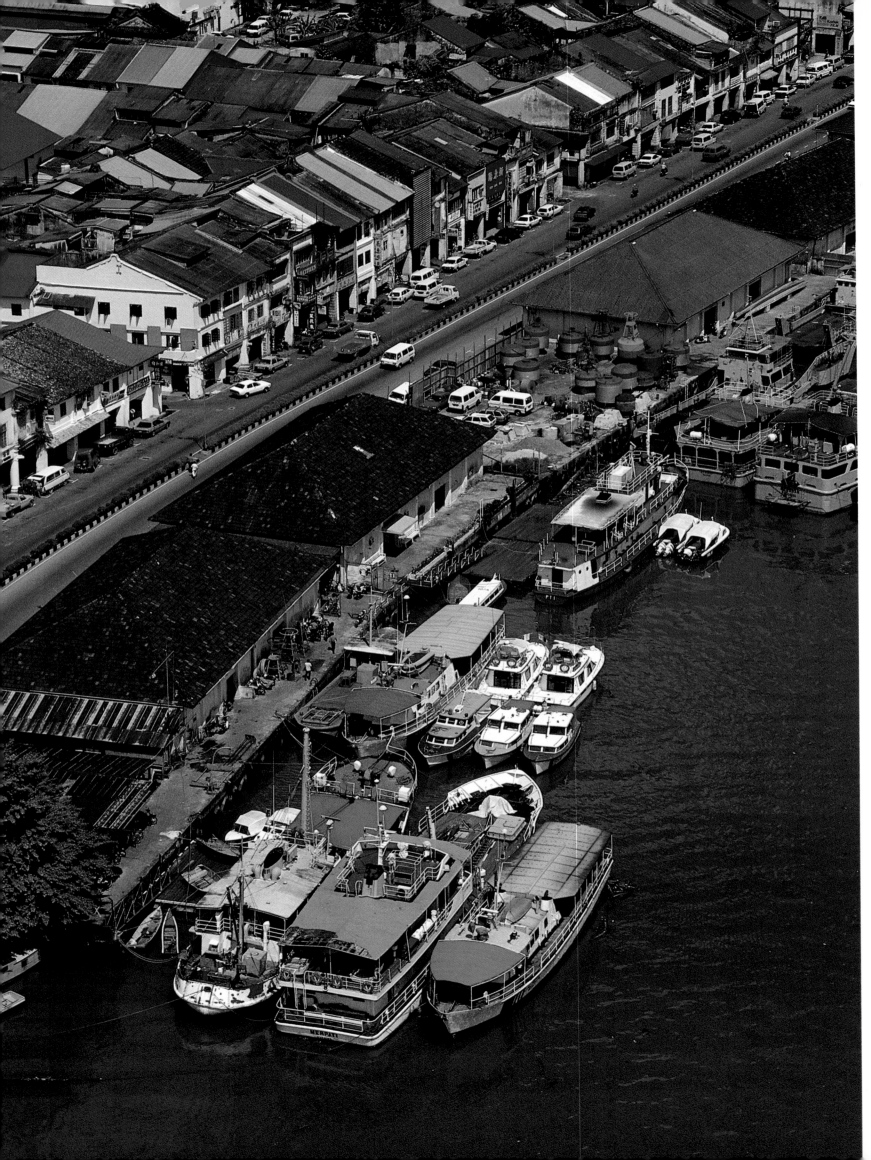

The Sarawak River, Kuching's lifeline, remains an active seaport, communicating with the sea some 50 kilometres downstream. The port is mostly used for goods carried to and from the interior. In Sarawak towns and settlements not directly on the sea hug the river, which still serves as the principal means of transport for this rugged state.

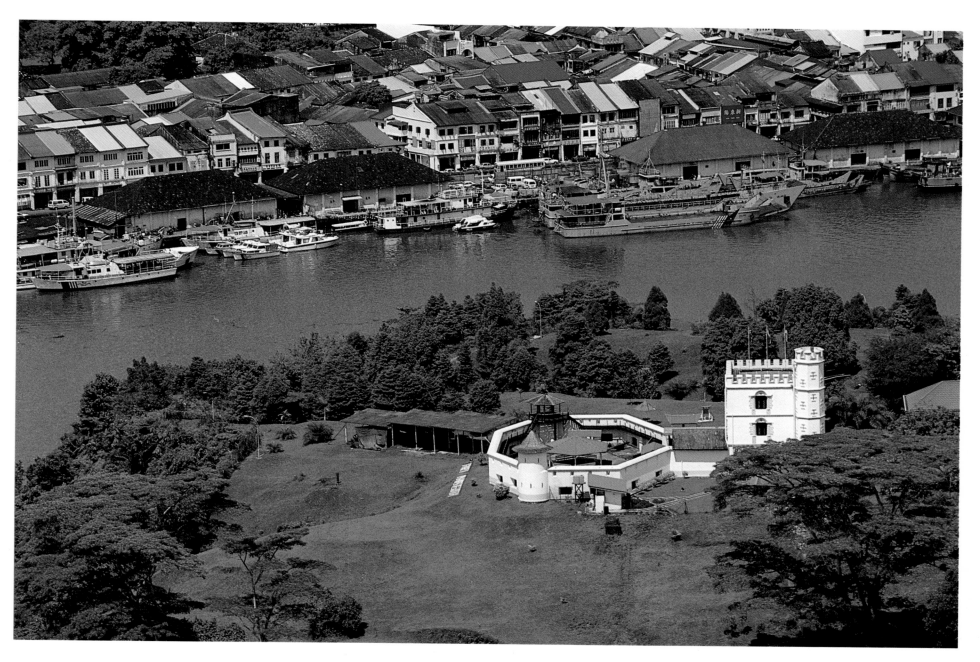

Down by the Sarawak River is Fort Margherita, an odd-looking building erected for Charles Brooke, resembling an English medieval fortress transplanted to the tropics. It originally served as a prison, and has served as a fortress in its time, though some suggest that its true purpose was to amuse the Rajah's wife Margaret, who had been reading a little too much Sir Walter Scott. Today, in more peaceful times, it serves as a Police Museum.

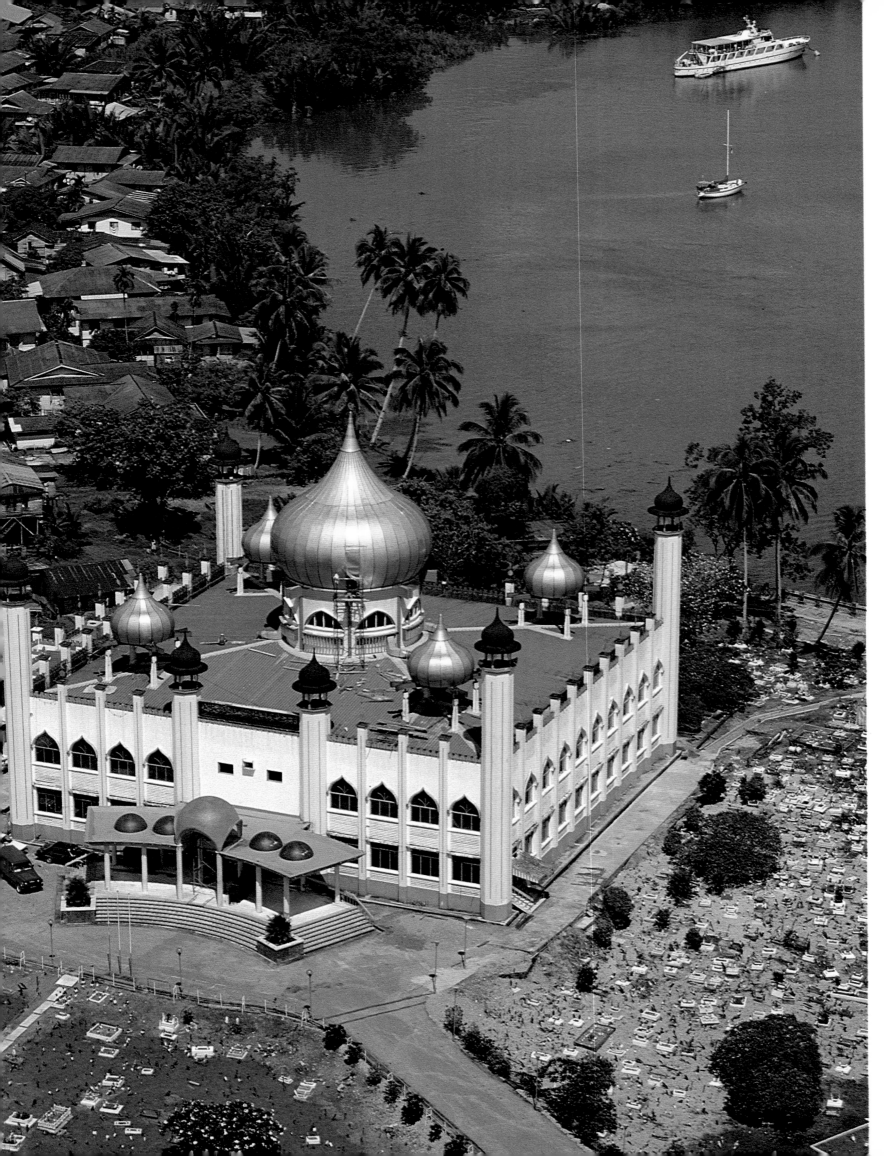

The Sarawak
State Mosque was
completed in 1968,
on the site of an
earlier wooden
mosque built in 1852.
Commanding a view
of the river, and
surrounded by a small
graveyard, the mosque
has since been super-
seded by a new,
grander mosque,
which was completed
in 1990.

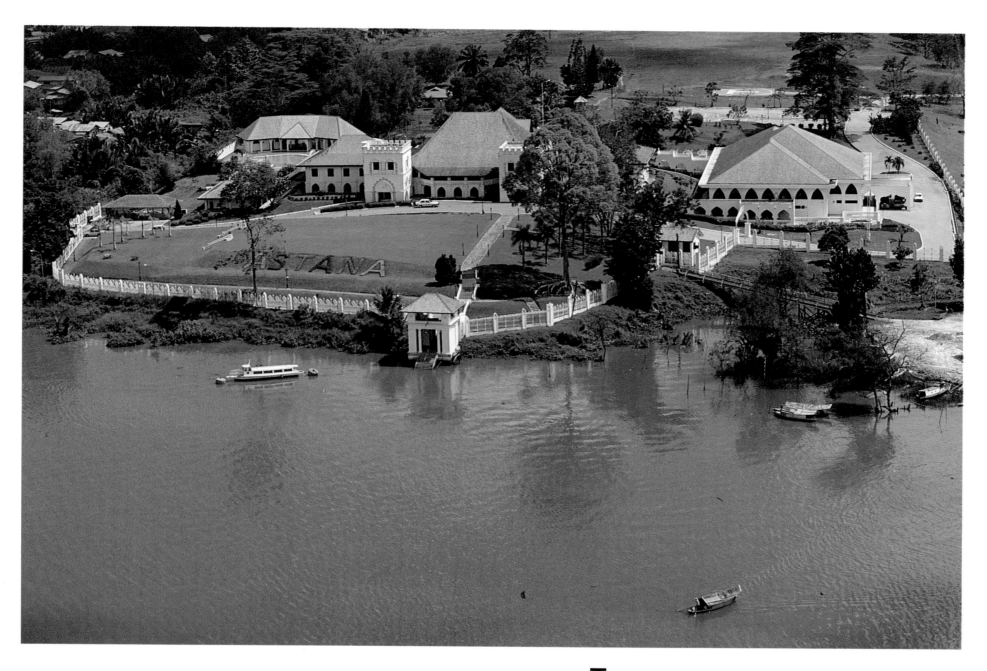

The Astana was built in 1870 by Rajah Charles Brooke, the second White Rajah, as a wedding present to his wife, Ranee Margaret. Margaret prided herself on good relations forged with the women of Sarawak. It has its own private jetty, and the two imposing towers serve as lookout points. The Astana is now the official residence of Sarawak's Head of State.

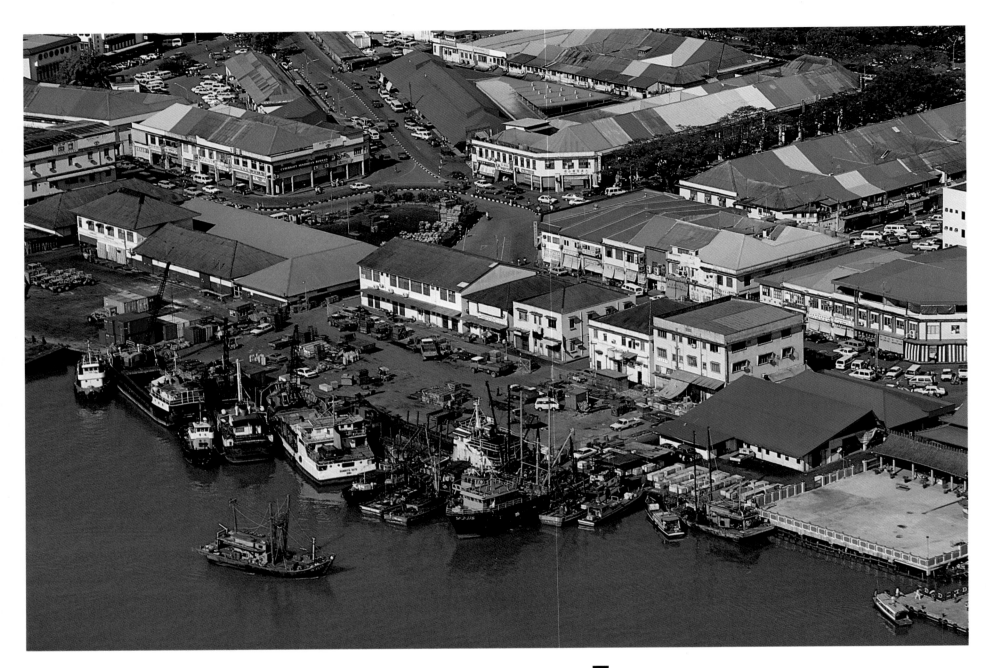

Throughly modern Miri is Sarawak's second largest city, on the coast east of Kuching, near the border with the oil-rich independent Sultanate of Brunei. Miri was one of the first areas in Borneo to be exploited for oil; Sarawak's first oil well was drilled here in 1910. The centre of the industry in Sarawak has now shifted south to Bintulu, where natural gas fields are currently being tapped.

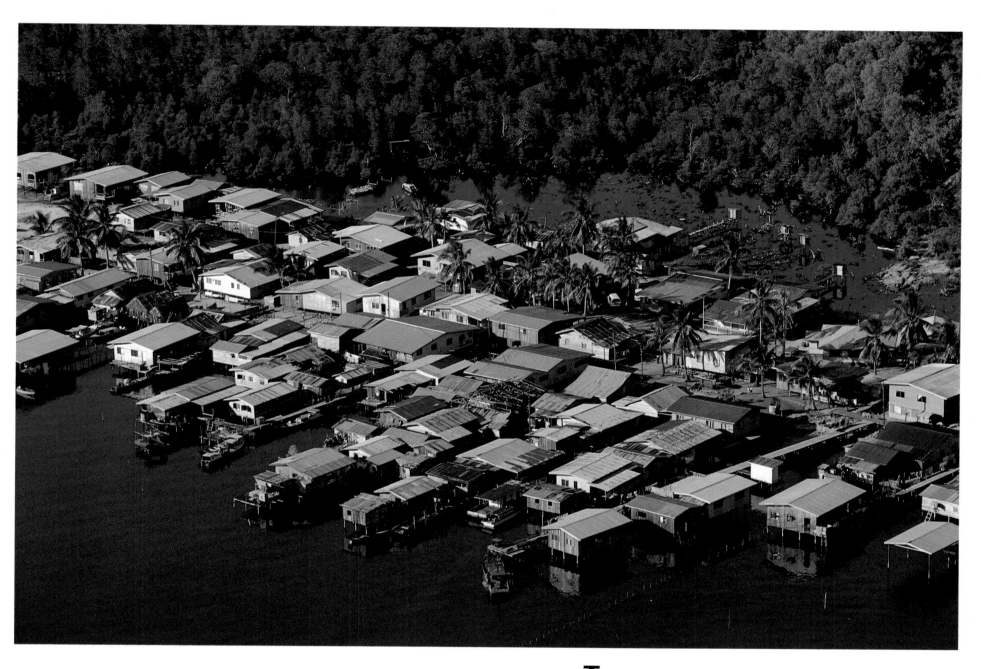

This study in blue and evening light is a scene from the water village outside of Miri. Many towns in Borneo (and Kalimantan) have a *kampong air,* or water village, built on stilts and piles over the protected waters of an estuary or rivermouth. The tides serve to tidy up the yards, and the lapping of the water on the house piles adds a degree of coolness and quiet to the environment.

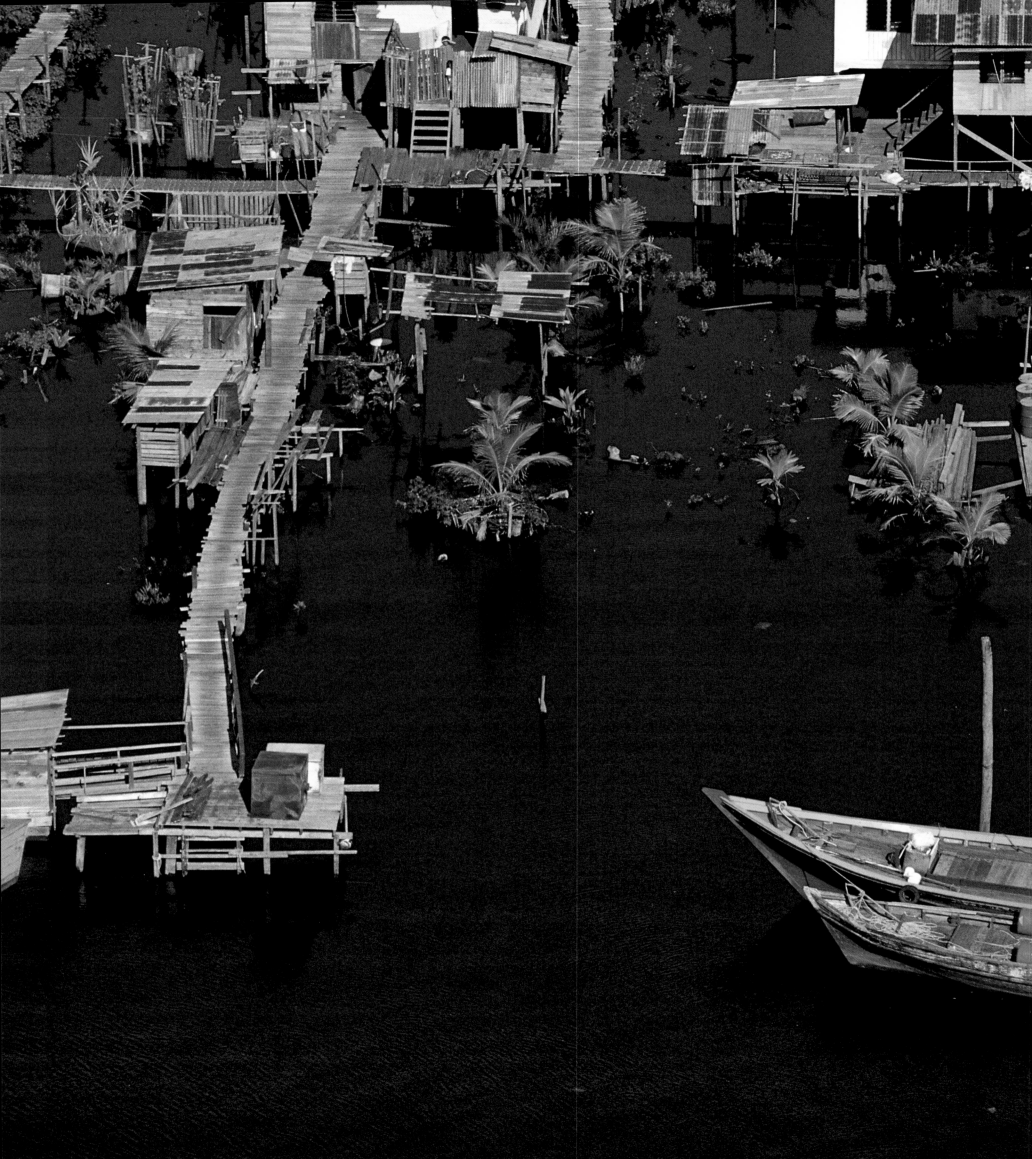

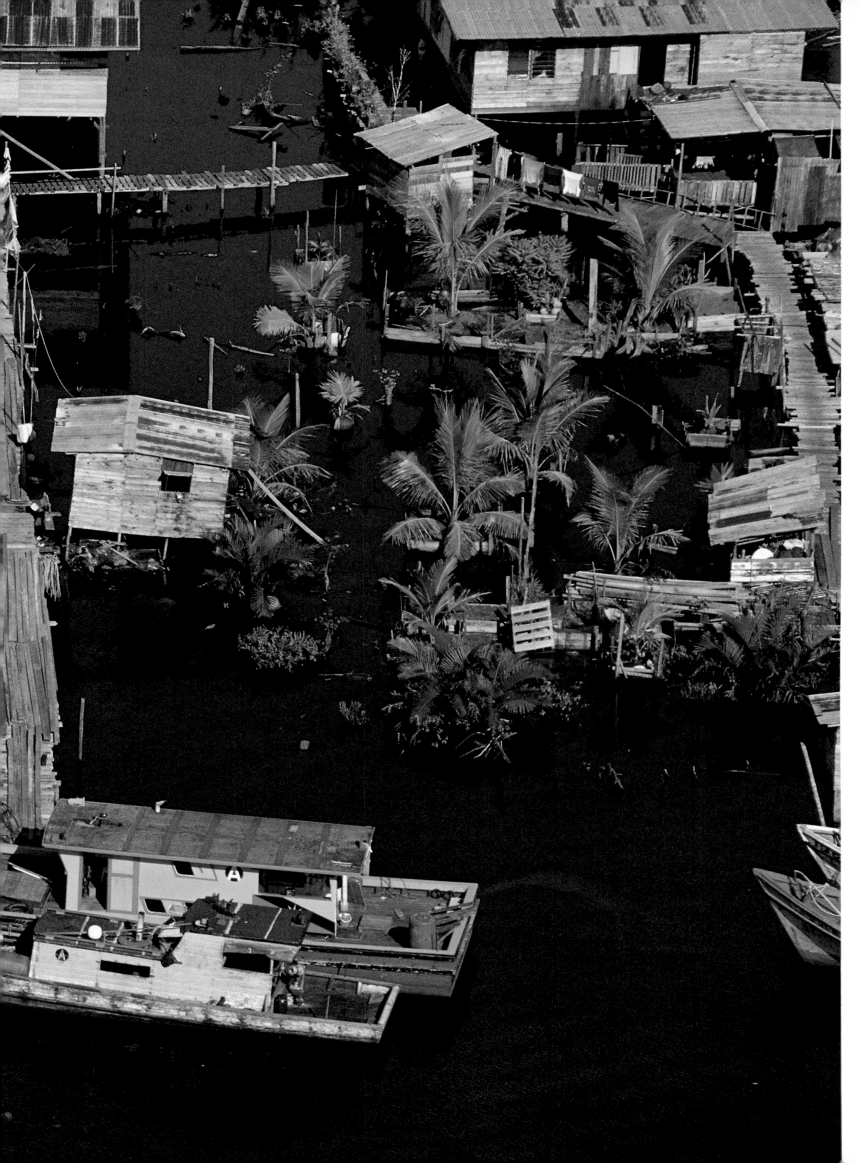

Cool reflections and a brightly coloured coastal fishing boat make for a pleasant scene outside of Miri. This town is a good base from which to begin trips up the Baram River to Marudi, and towards the Mulu Caves.

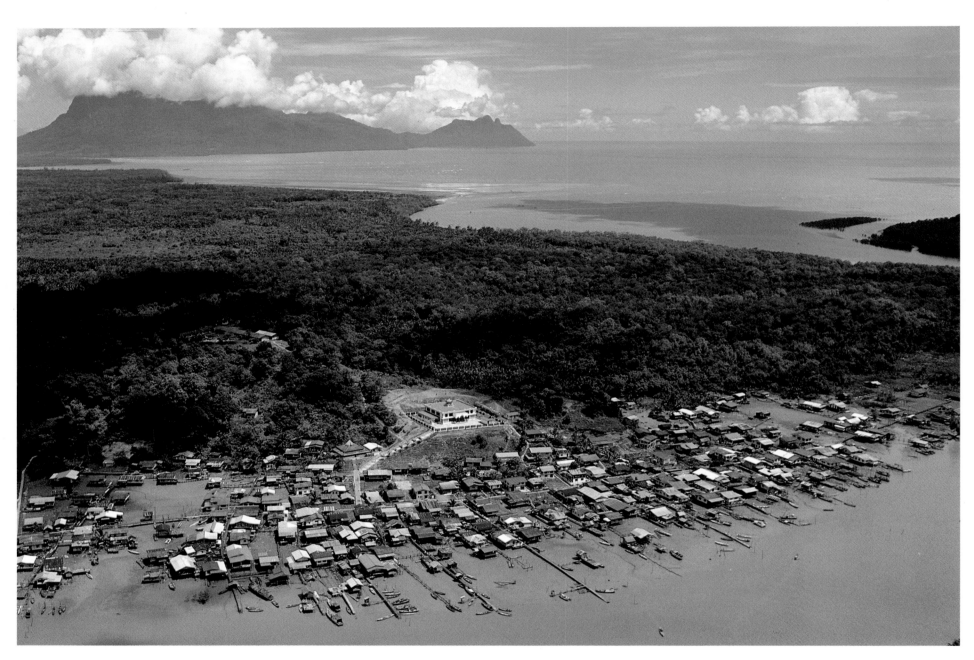

Bako Village, displaying its new mosque, tends towards the river. The village is the entrance point to the Bako National Park, which occupies a peninsula of rugged sandstone in the Sarawak River delta. The dramatic shape of Santubong Mountain, capped in cloud, dominates the views. The mountain has served as a landmark for navigators making for the Sarawak River for at least a thousand years.

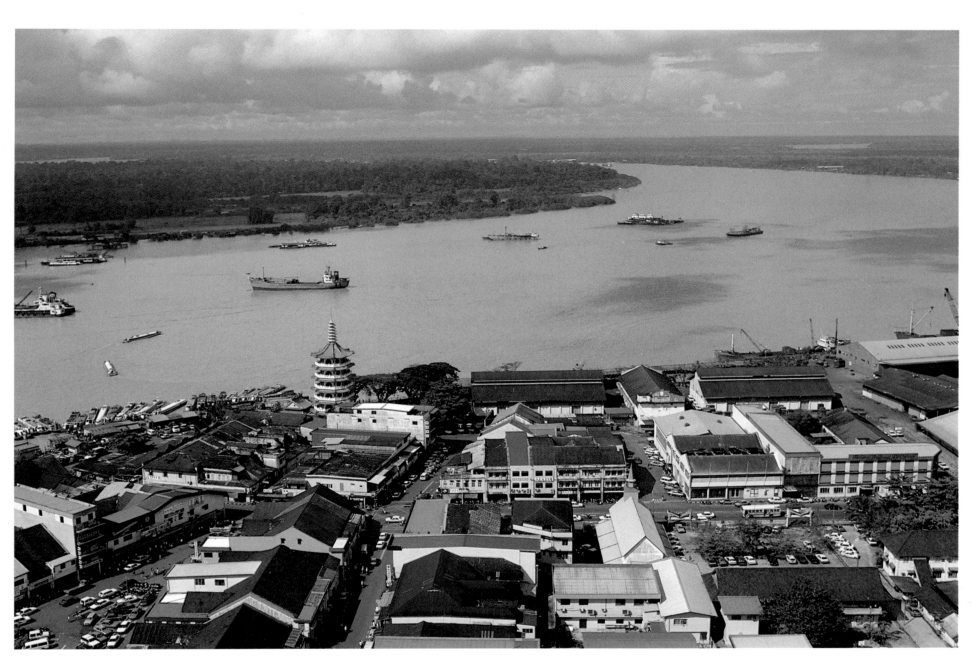

Sibu city is the main port for the Rajang River, Sarawak's longest. The capital of Sarawak's Third Division, the city is the terminus for boats plying their way upriver to the towns of Kapit, and —water levels permitting— beyond to Belaga and the upper reaches of the Rajang. The Baleh, a tributary of the Rajang, is also served from here.

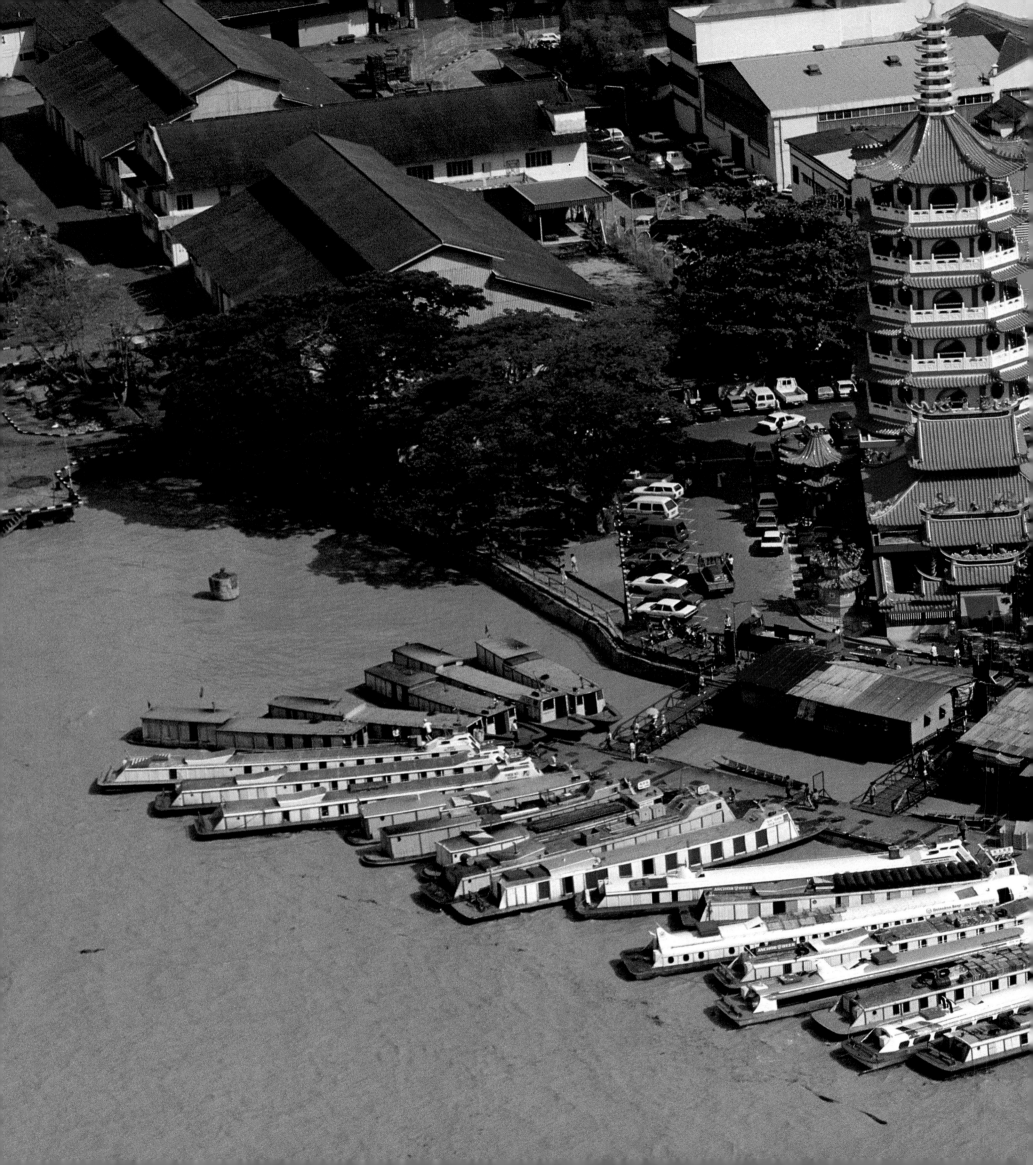

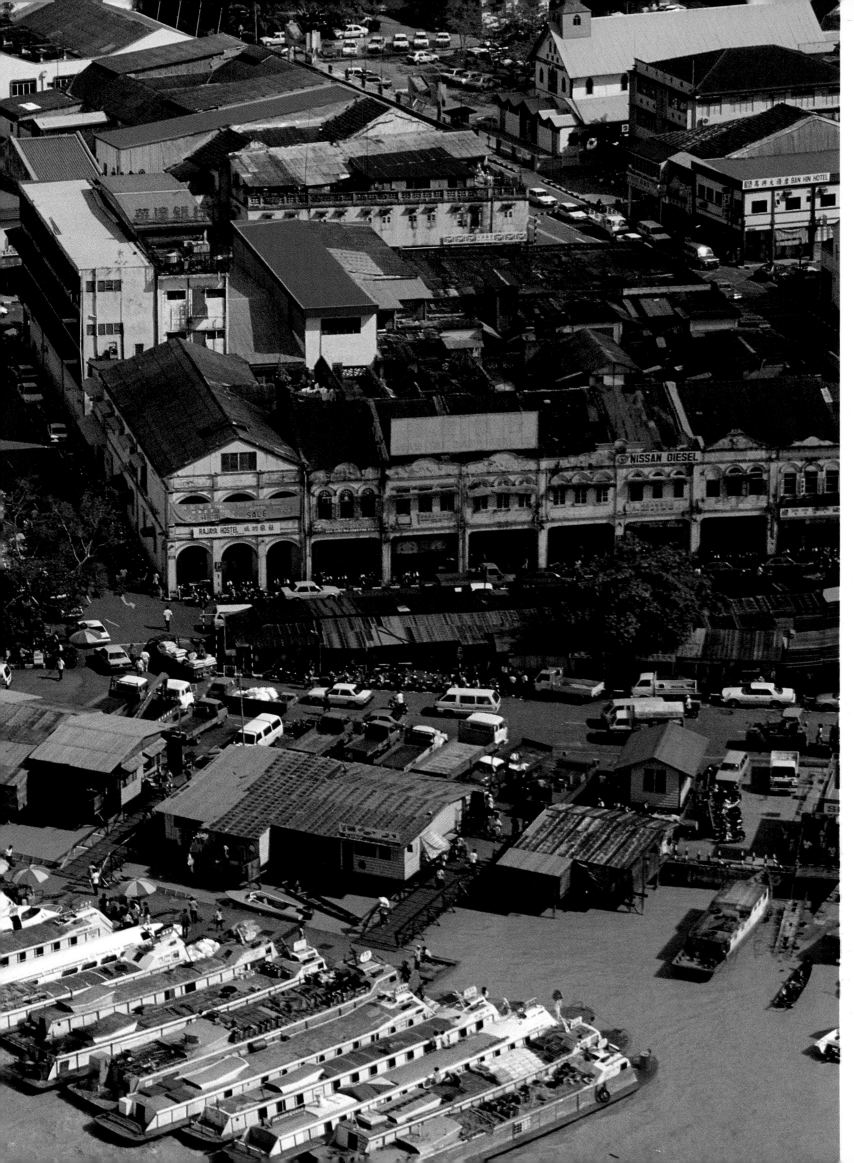

An array of stream-lined long-distance express river boats seem to be paying homage to Sibu's landmark, the pagoda built as part of a Chinese temple. These boats can make it all the way upriver to Belaga. The express boats are often equipped with video sets and air-conditioning. Traffic on the river might be light, but the boats have steel-lined hulls to contend with possible hazards floating just below the waterline.

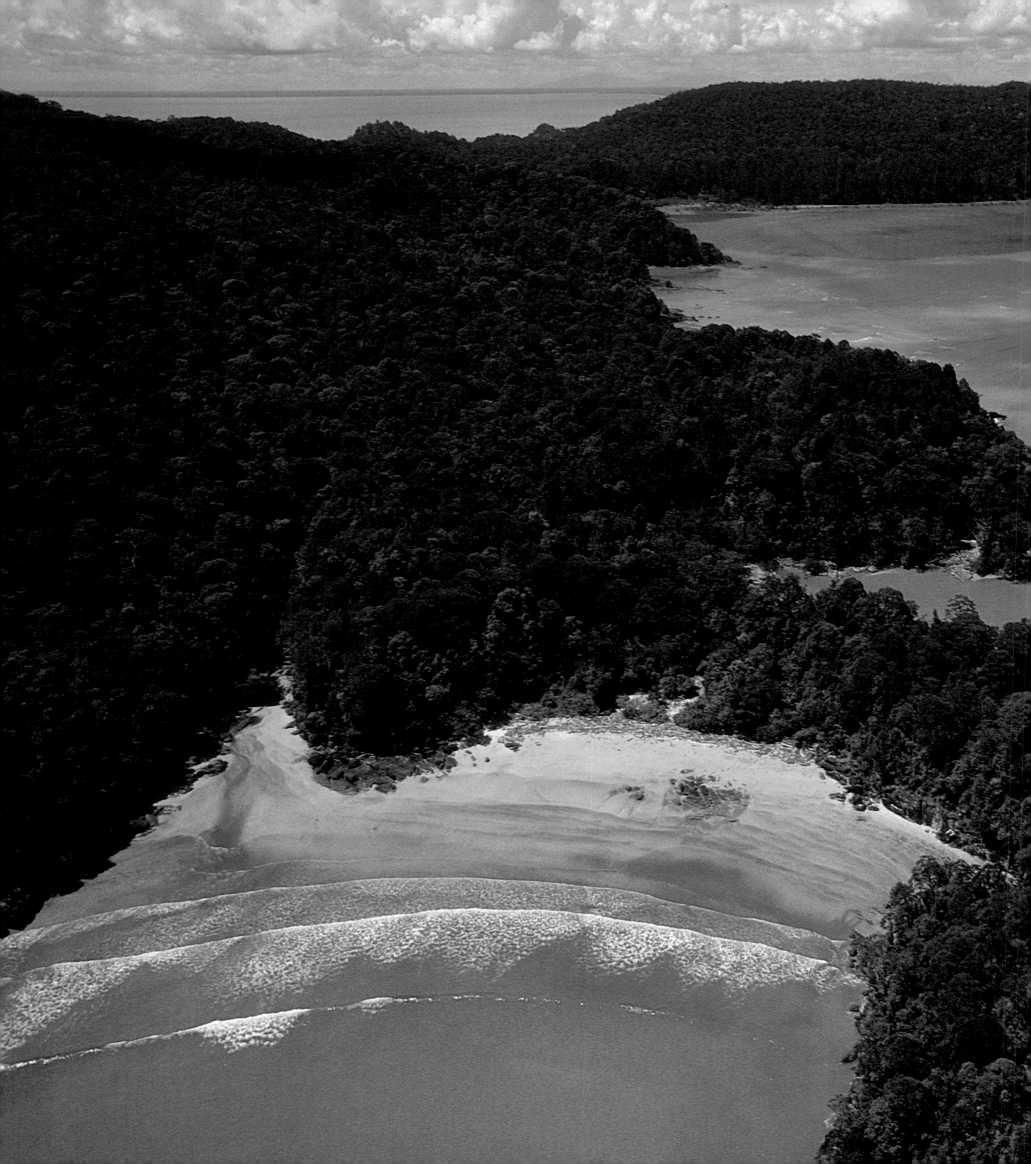

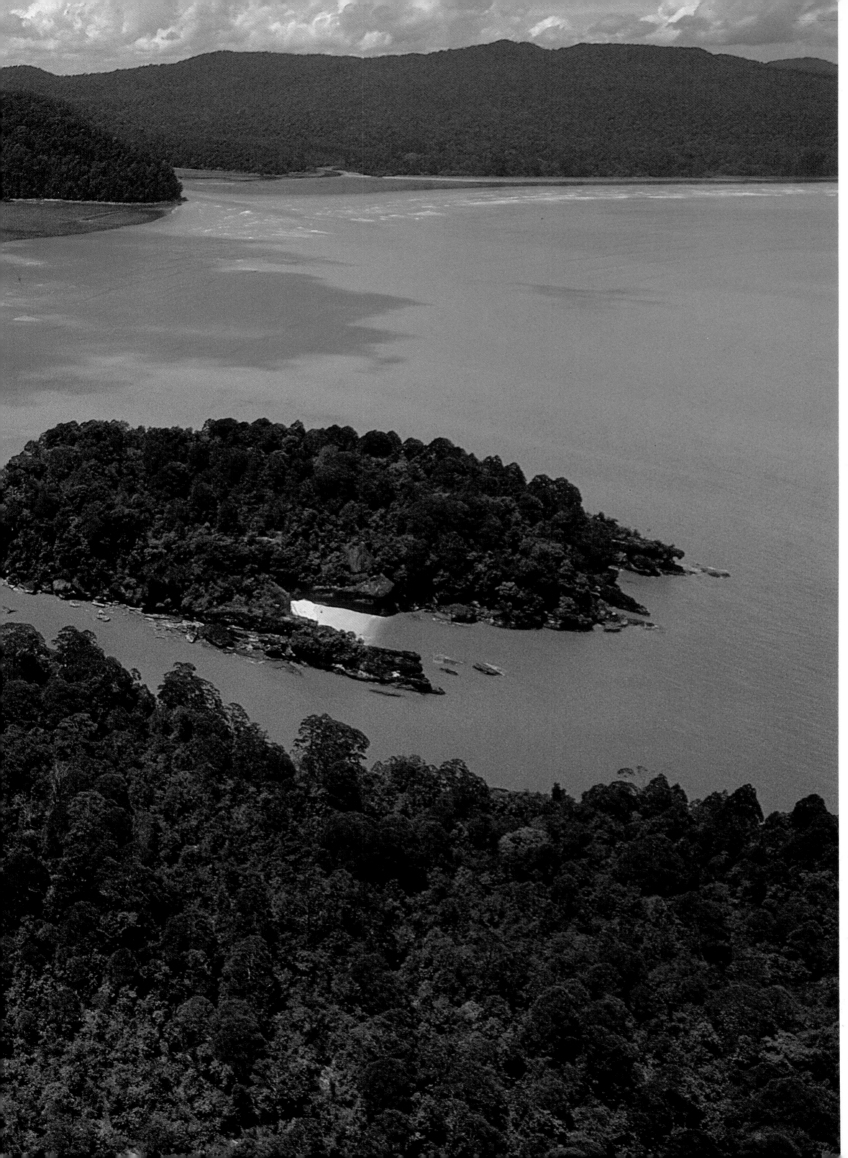

Bako was Sarawak's first National Park, gazetted in 1957. Situated in the Sarawak River delta, Bako preserves 2728 ha of coastal and mangrove habitat. The flora ranges from lush dipterocarp forest to near-barren *padang* of tall grass and scrub, with a sprinkling of carnivorous plants. The rare Proboscis monkey is found here; the Long-tailed macaque enjoys its protected status when it raids visitors' unattended picnic baskets.

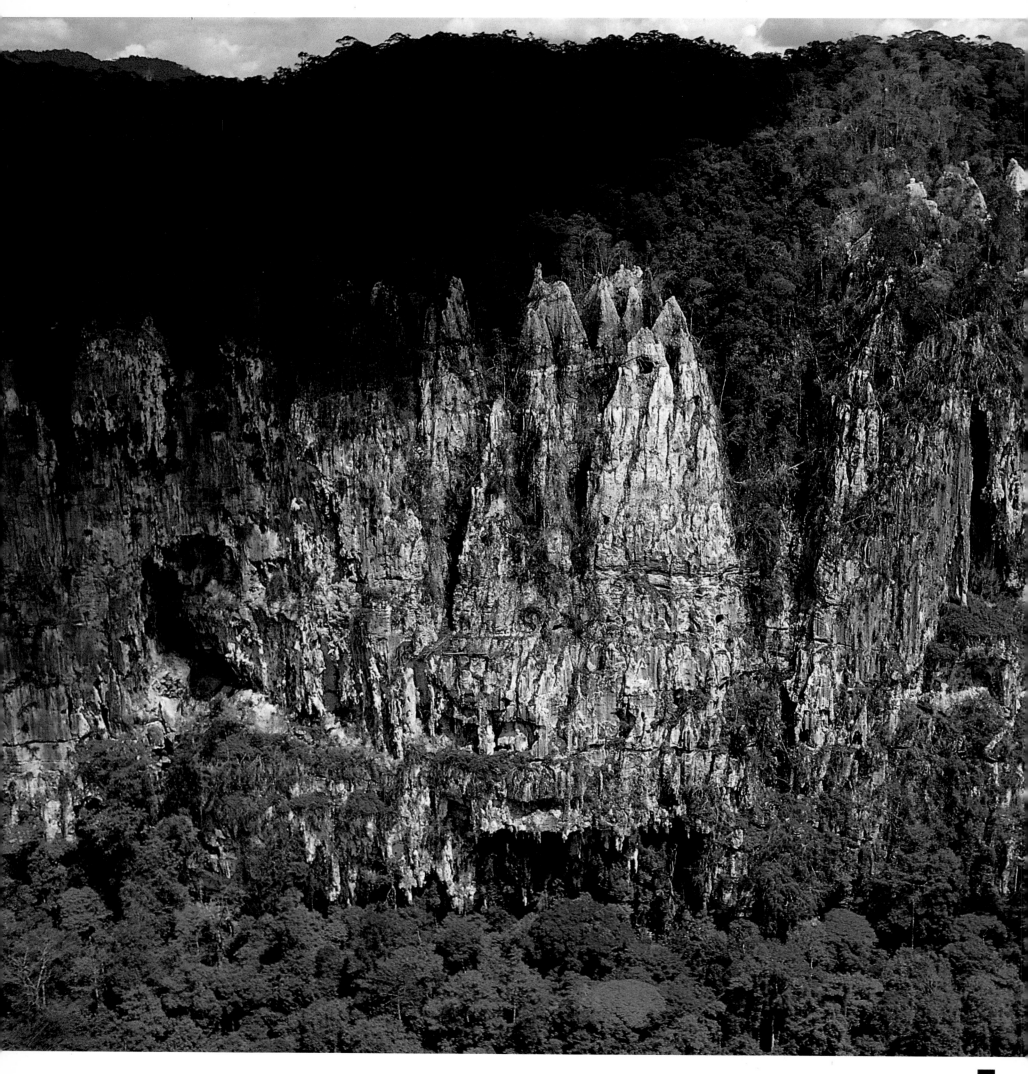

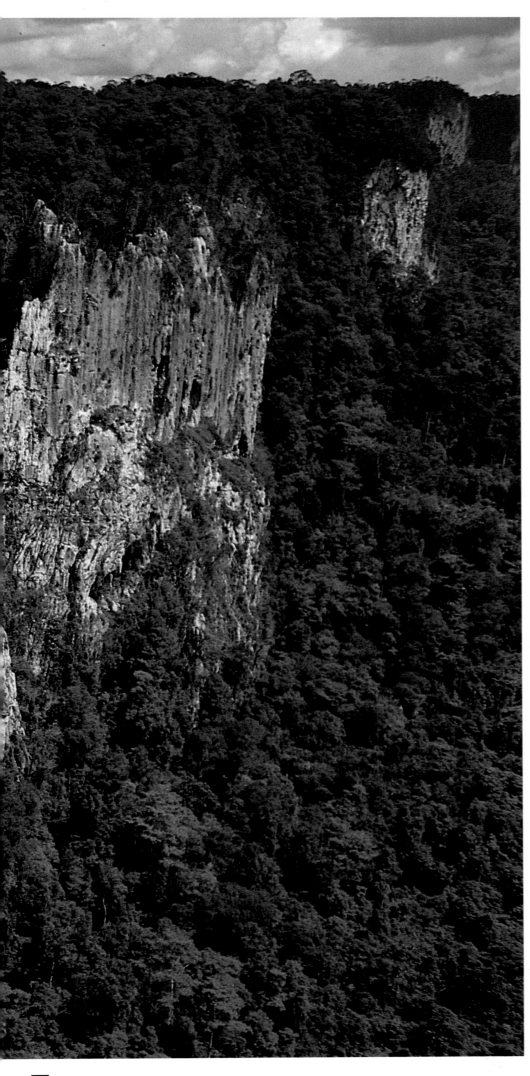

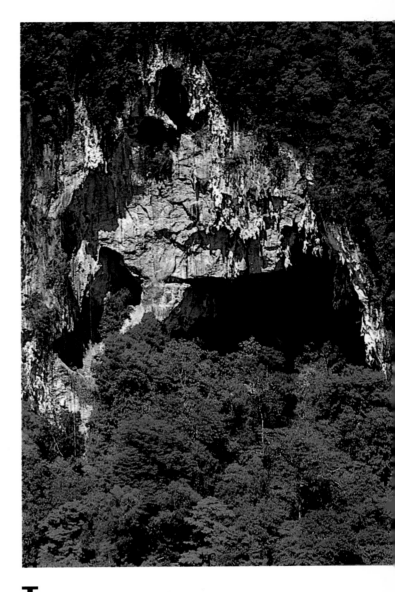

The massive boulder of limestone that is Niah sits in the lowland swamps like a huge sponge riddled with innumerable caves. The Niah Caves have long been known to the local inhabitants, who were curiously reluctant to discuss them; it is only after World War II that the Sarawak Museum seriously investigated and explored this prehistoric burial site. Niah Man, a human fossil 35,000 or more years old, was found in Niah Great Cave. The collection of bird's nest still goes on in the caves, but under the authority and strict control of the Sarawak Museum.

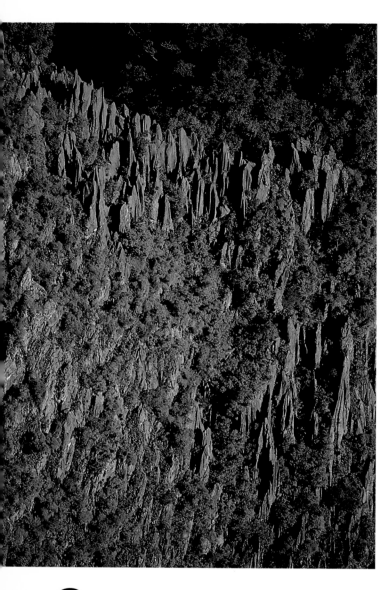

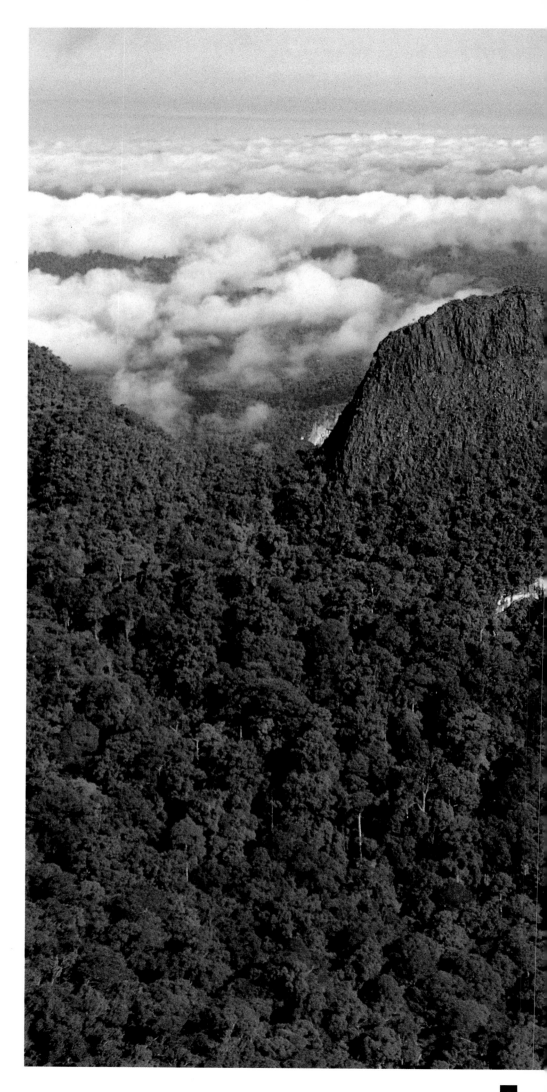

Gunung Api, a 1750-metre limestone mountain, has ruled over the forests of the Mulu National Park for over five million years. This area has long remained isolated by virtue of its rugged limestone terrain. One feature that attracts visitors are the knife-sharp pinnacles rising up 45 metres high two thirds the way up the slope of Gunung Api. Deep ravines and impossibly steep mountain slopes form the outer surface of a honeycomb of limestone that holds the Mulu Caves, a cave complex that rivals any in the world.

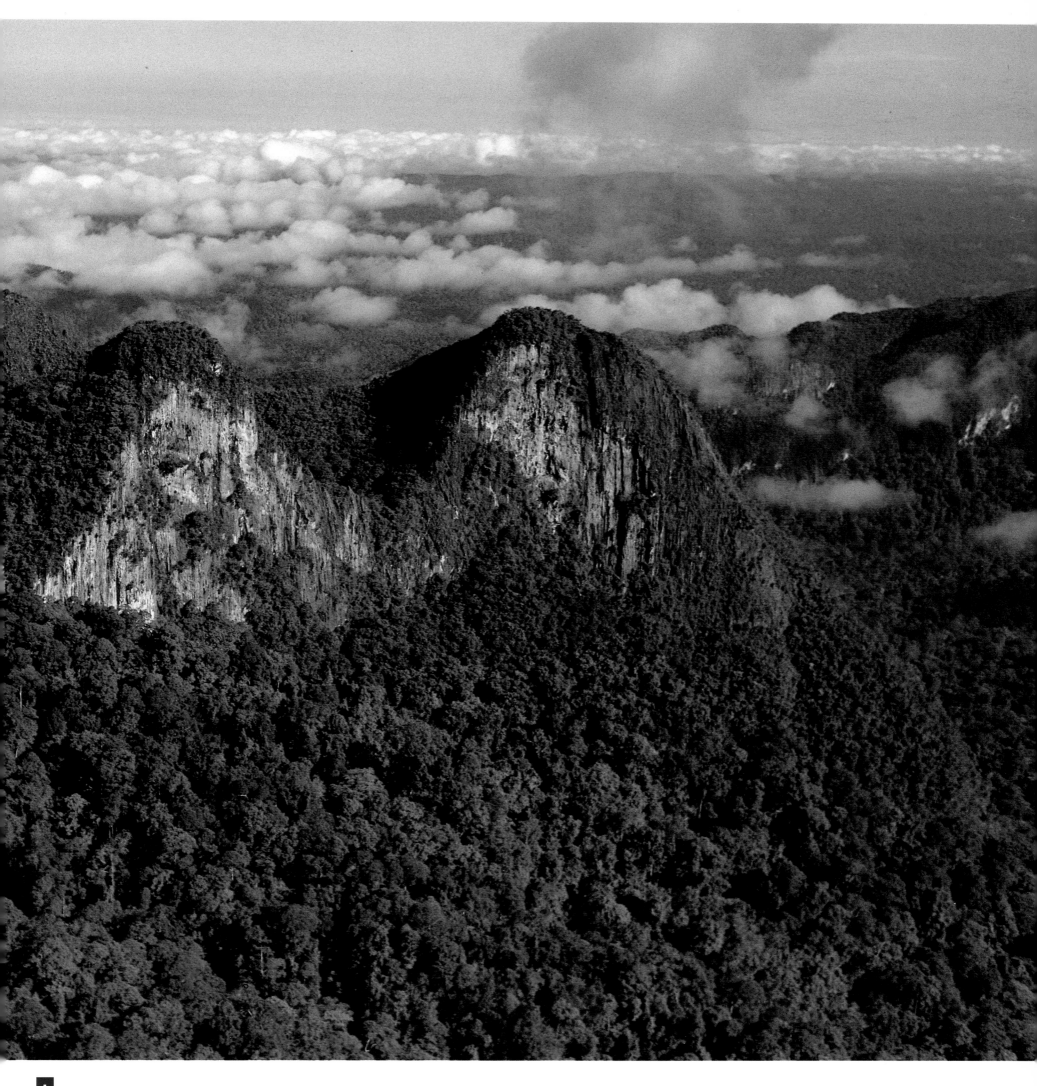

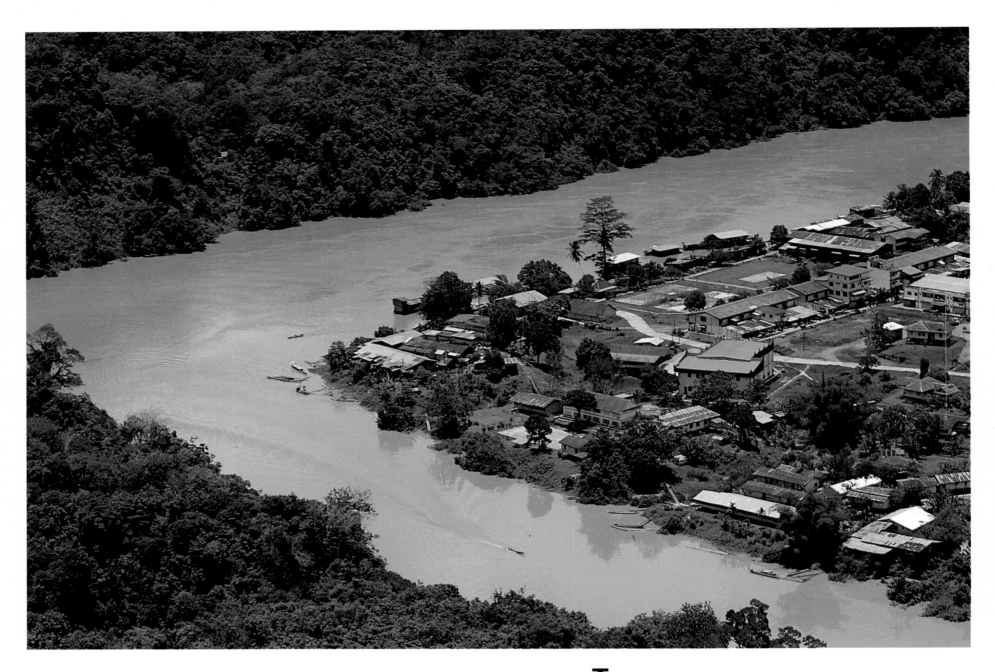

Townships like Belaga are the focal points of wide, mountainous tracts of Kapit division. Belaga used to be one row of shophouses where natives bartered jungle produce for a few commodities like cloth, salt, beads and jars. Now a school caters to a young population hungry for education, and a District Office and Hospital serve the far-flung community. Transport is still uncertain and expensive; Belaga may be reached by air, by boat, or very laboriously on foot.

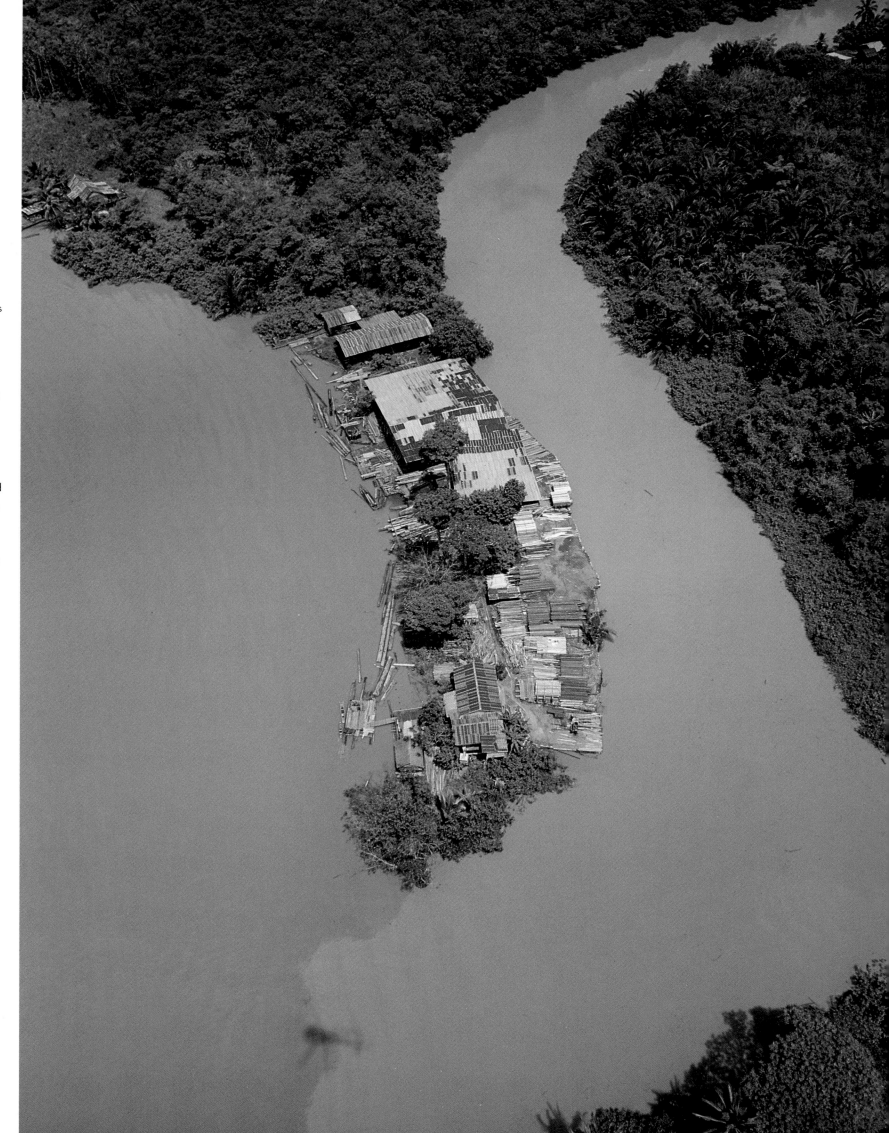

Gushing rapids mark the zones where Borneo's mighty rivers drop from the high plateau into the wide lowland plain. Log rafts and silted water are common sights here. In the past, nearly all of Sarawak's lumber was exported as round logs. This is changing as timber processing in the State is encouraged. A local industry provides jobs for skilled and semi-skilled labour, and so helps to distribute better the value of forest products between the primary producers in Sarawak and the processors and sellers in the end markets, mostly in Japan and East Asia.

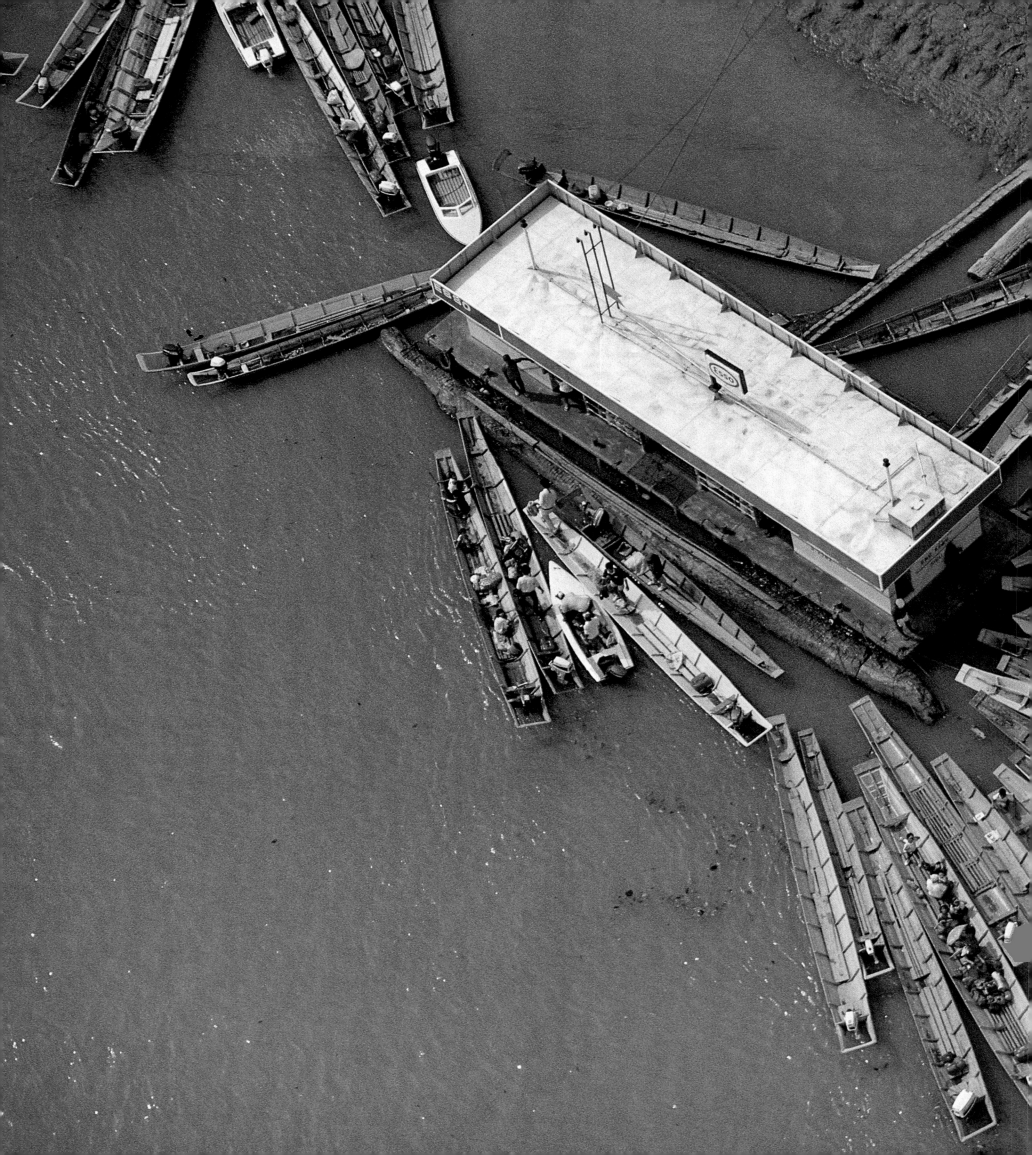

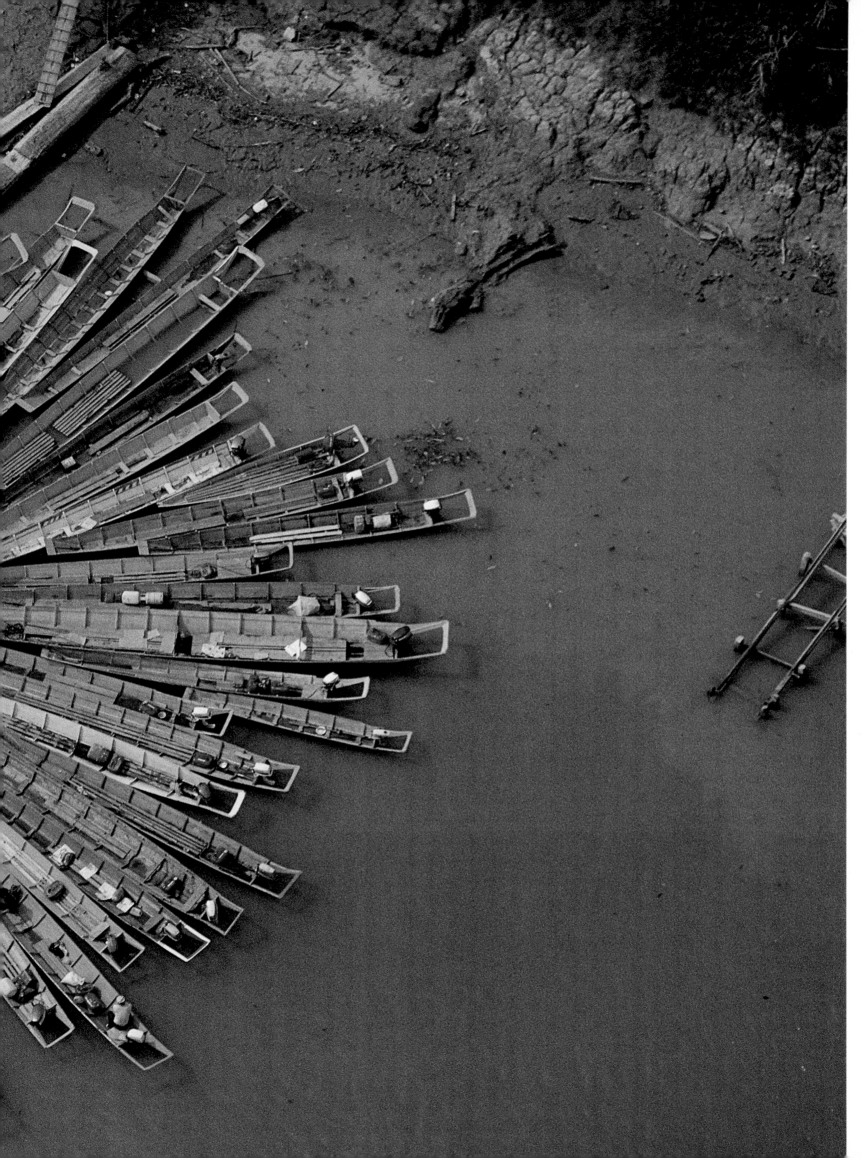

Like bees drawn to a pot of honey, these elongated speed-boats call at an Esso 'offshore' petrol station, for fuel and to catch up on local news. Once oar-driven, boats and sampans are nowadays fitted with motors for speedy access.

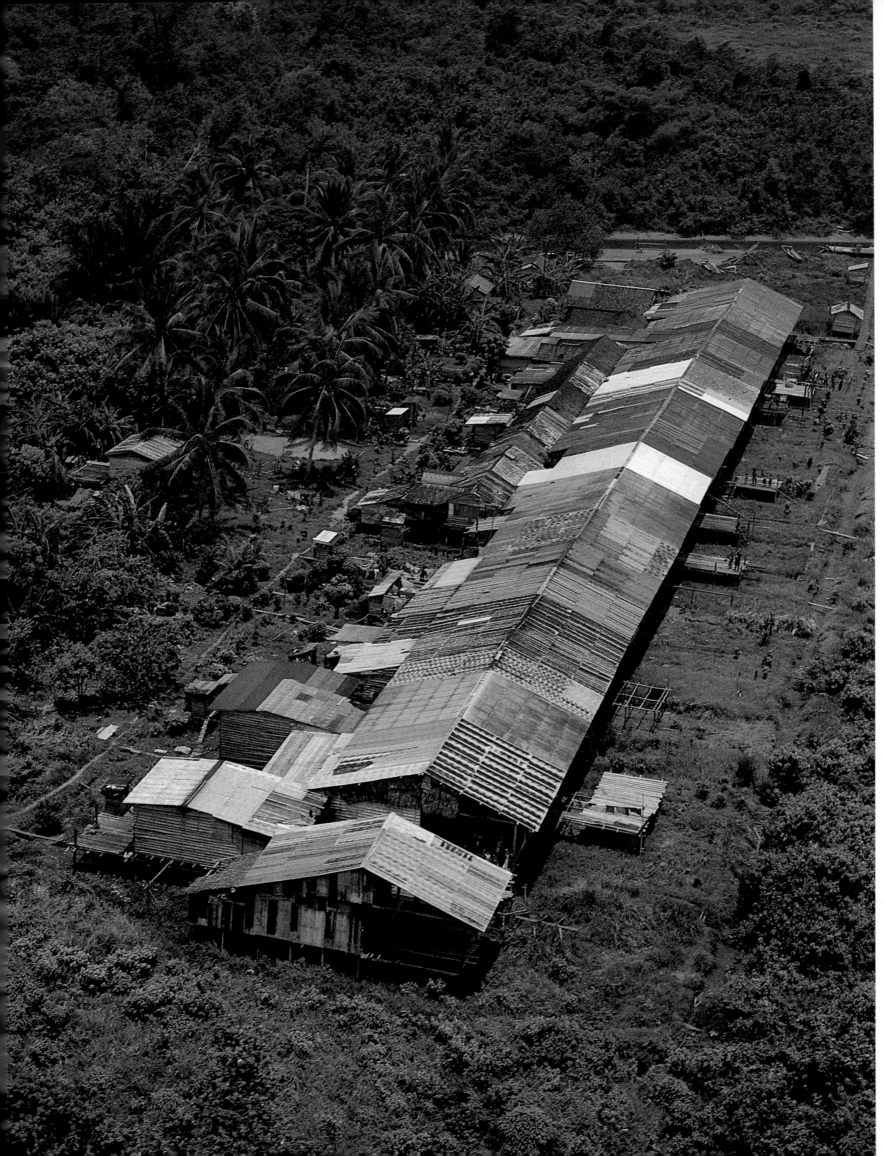

This longhouse, fairly near the coast between Sibu and Miri is roofed in zinc, supplemented with the occasional touch of attap under the eaves. Relatively few longhouses with ironwood tiles remain. Though the basic longhouse form is common to many of the indigenous groups of Sarawak, the internal layout of the longhouse can vary. Typically though, a shared verandah runs the entire length of the house.

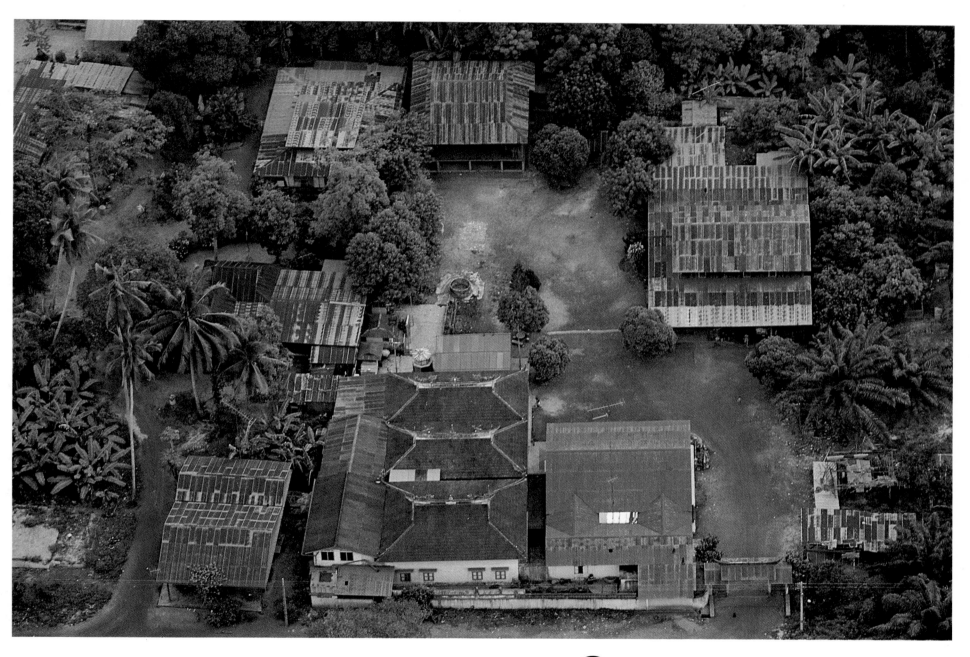

Oxidized zinc roofing also colours this view of a Chinese temple or clan house, though the roofridge ornaments of dragons and longevity gourds can be discerned. The use of such ornaments, and upturning eaves, is one indication that Southern Chinese and Southeast Asian house styles may share a common ancestor.

For centuries Bareo has been a place apart. Before Malaysia Airlines' sturdy Twin Otters were put into regular service, the traveller paddled upriver from Miri for one week, then walked through rugged mountain territory for another to reach this highland valley. This isolation has made the Kelabit an independent people with proud traditions. They share the remarkable artistic skill of most indigenous Borneo peoples, and they developed a sophisticated system of irrigated rice culture.

The ricefields of Bareo look brown and uninviting between the seasons. A month after this photo was taken, the nursery will be prepared, and the sluice gates on the stream opened to flood the earth. The newly sprouted rice seedlings are planted into the soft mud by patient back-breaking labour. Carefully tended bunds permit the regulation of the water level. Far, far downstream from these ricefields is the winding delta of the Rajang, shown on the following pages, developing a classic oxbow near the seaside town of Sarikei.

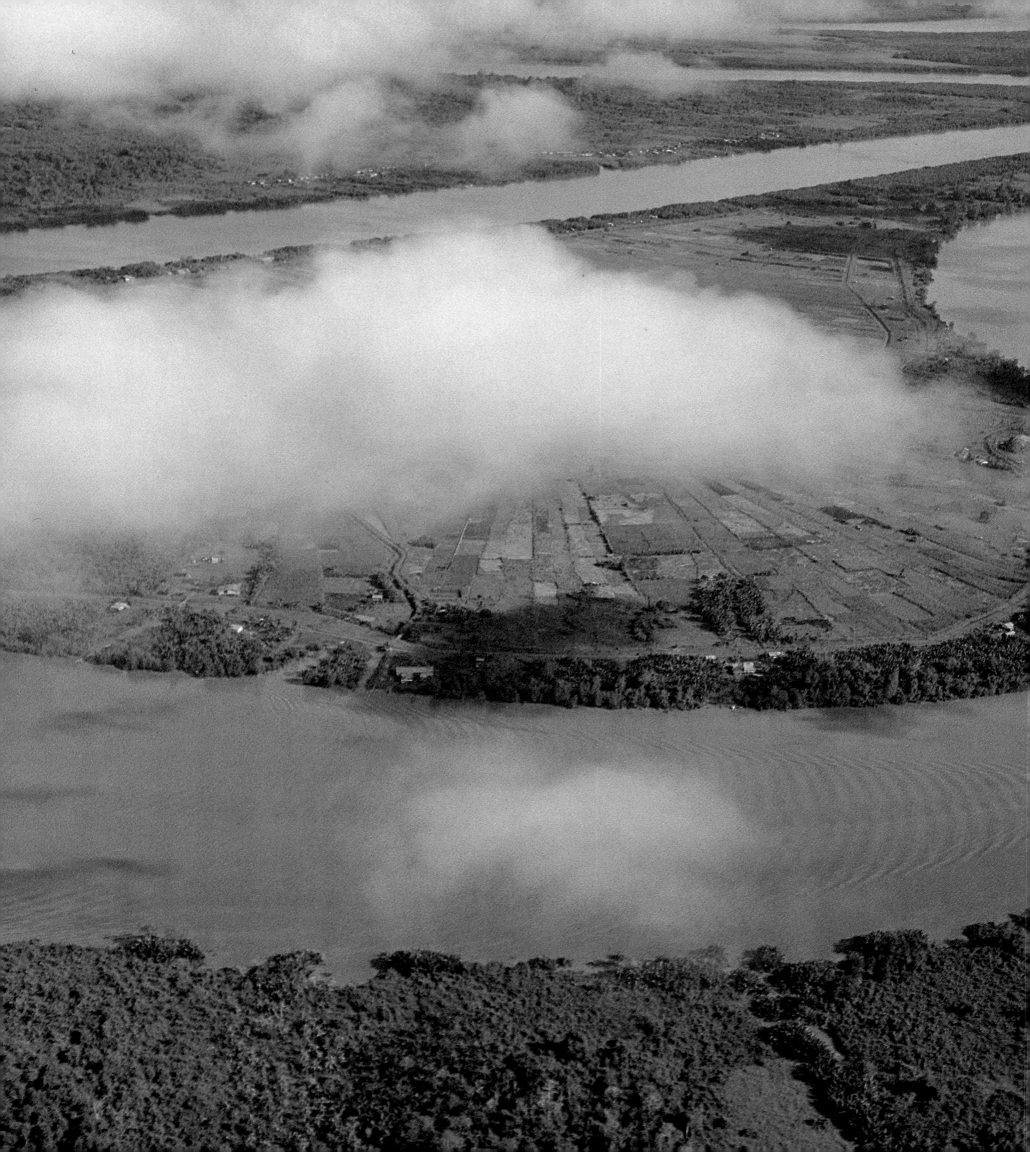

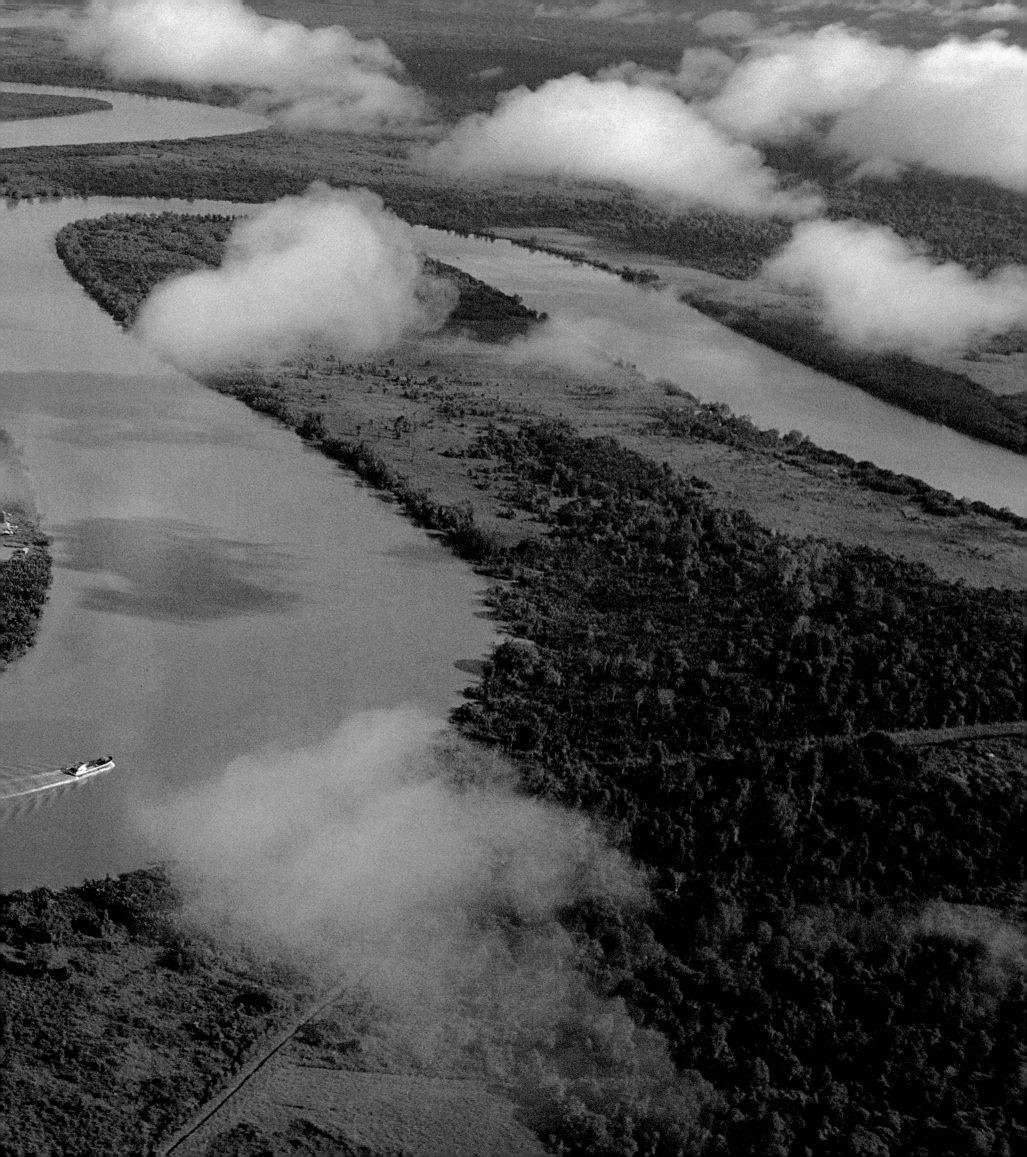

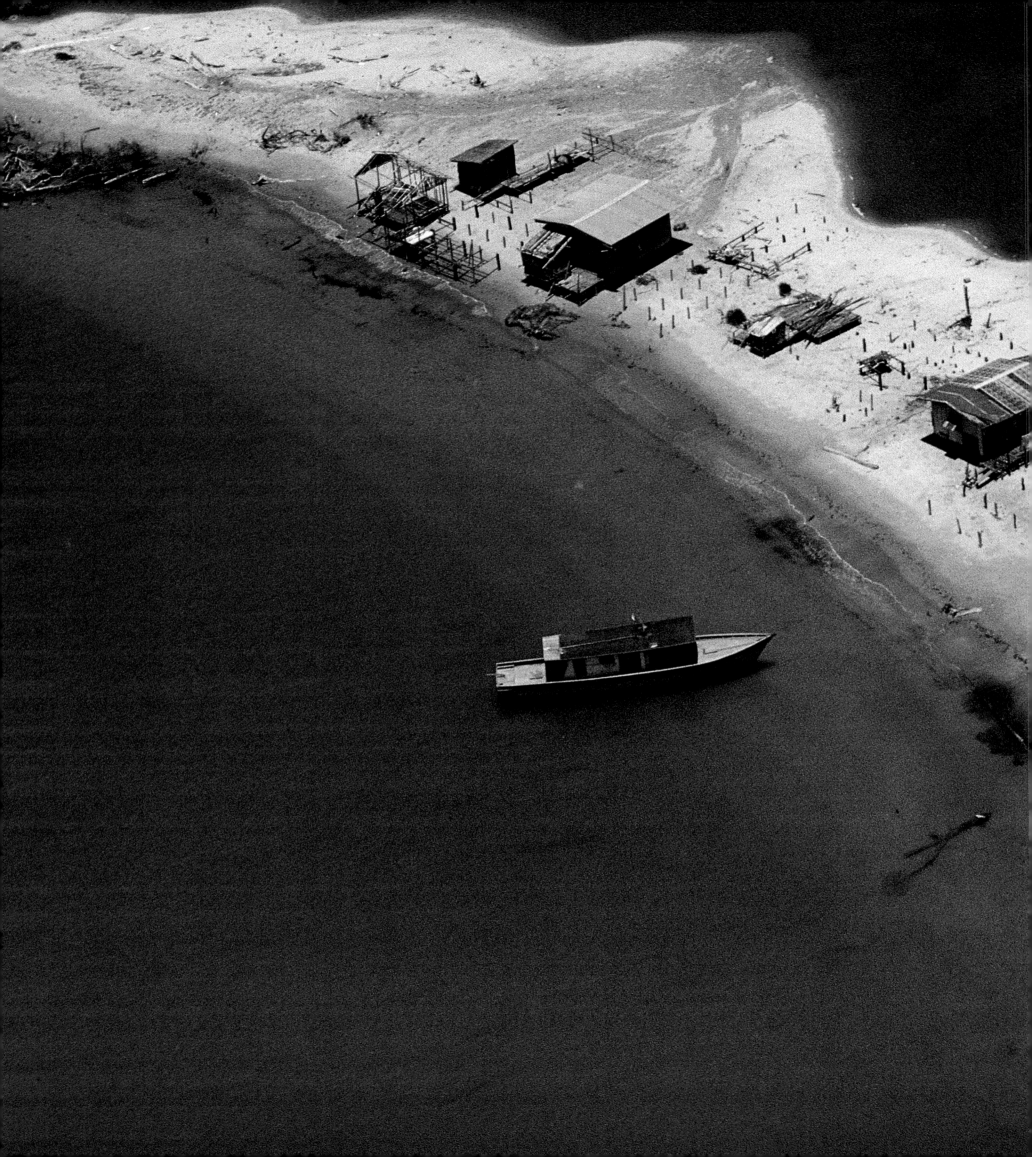

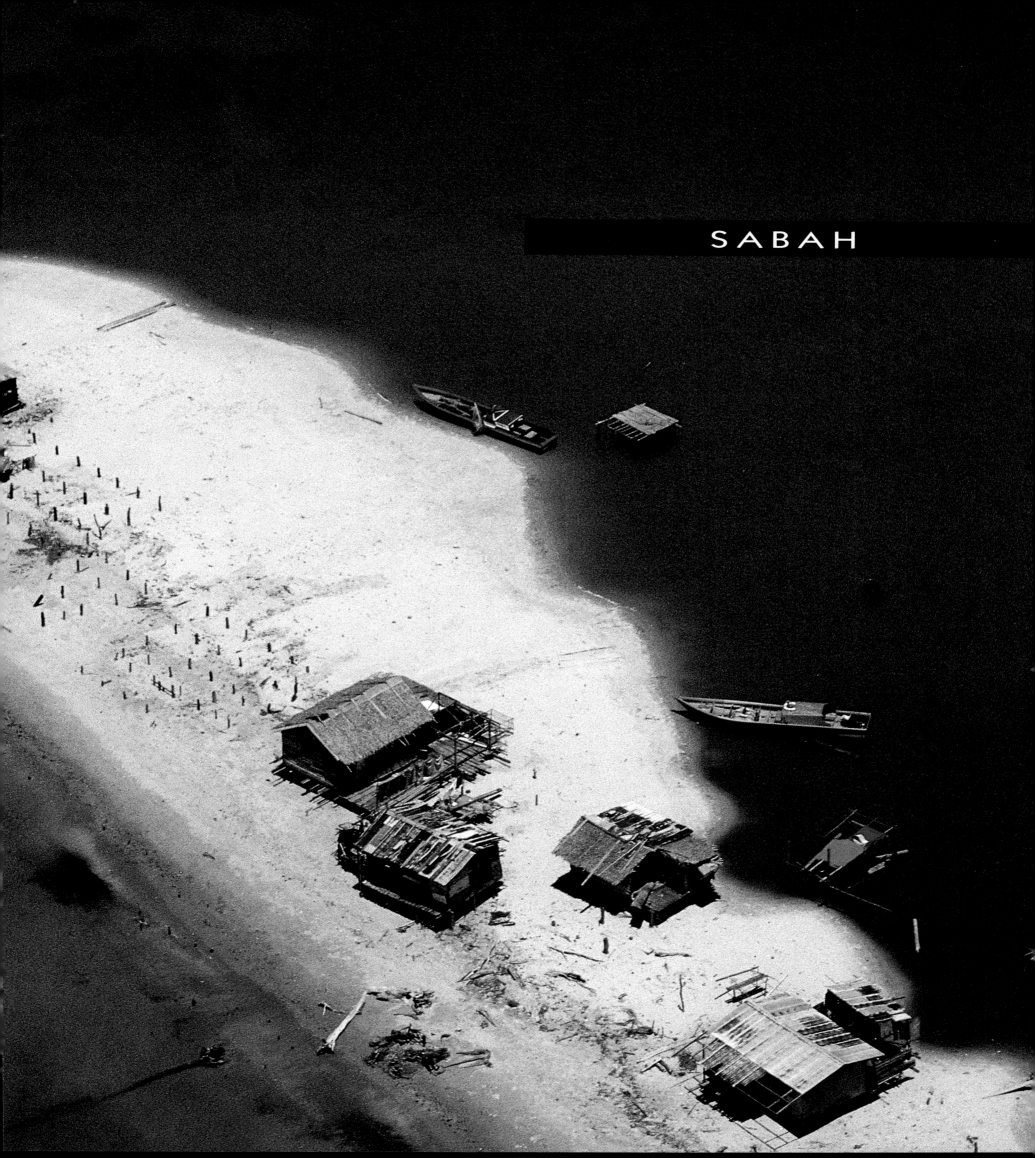

ven the heightened perspective of aerial photography cannot take in Sabah's most outstanding feature. Sabah is the land of Mount Kinabalu, Southeast Asia's tallest and most splendiferous mountain. At 4176 metres, more than 13,700 feet, the mountain peak towers above the range of the helicopters used for the photographs in this book. Aerial photographs of Mt Kinabalu may reveal a special sense of the mountain's majesty, but even the helicopter-riding photographer looks upwards to capture Mt Kinabalu through his lens. The mountain monopolises the Sabah skyline from every conceivable angle. Soaring majestically to embrace the firmament with its cloud-crowned and wind-swept head, Mount Kinabalu is Sabah's centrepiece. The mountain has given the state its identity as The Land Below the Wind. Sabah's greatest and most rock-solid asset is sacred to the Kadazans whose ancestral spirits look down benevolently from above as mortals look up in awe and admiration. Mount Kinabalu's peak is an ungainly raw mass of twisted rock, but a lack of the dazzling, aesthetically-pleasing symmetry of Fujiyama or Mayon does not distract from Kinabalu's towering omnipresence.

Sabah, the second biggest Malaysian state on the world's third biggest island, occupies the northern chunk of Borneo. The state is washed by the South China Sea on its western front, the Sulu Sea on the east and the Celebes Sea on the southeast. Bounded by Sarawak, Indonesian Kalimantan and Brunei, its total area of 73,620 square kilometres has a population of only 1.3 million. Sabahans are a polyglot conglomeration of some 31 ethnic groups, expressing themselves in 80 different languages and dialects. The situation is compounded when one race calls itself by one particular name but outsiders refer to them by a totally different name! The main indigenous groups include the Kadazan, Kwijau, Bajau, Murut, Illanun, Lotud, Rangus, Tambanuo, Dumpas, Bisayah, Maragang, Paitan, Idahan, Bamarau, Orang Sungai, Mengkak, Tedung, Kedayan and Suluk.

Sabah as a separate state only came into being in the 1880s in the wake of buccaneering Western opportunists. Prior to the white man's arrival to stake his claim, the area was a series of private fiefdoms, far-flung chieftaincies and autonomous pockets owing a loose allegiance to the sultans of Brunei. In 1704 a succession dispute was resolved with the intervention of the Sultan of Sulu. As a result, the ruler of the Sulu islands made a claim to the land east of Maruda Bay and it remains a prickly issue. Though Sabah's later history is linked to the United Kingdom, an American and an Austrian baron both had a hand in stirring up its affairs. An American trader persuaded the Brunei sultan to lease him the greater part of Sabah. This lease passed into the possession of the Austrian before an English businessman grabbed hold of it. Alfred Dent arm-twisted the sultans of Brunei and Sulu into converting the lease into a cession. In 1881 the Chartered Company of British North Borneo was set up to run Dent's acquisition. The Company ran North Borneo (Sabah's old name) like any other business entity till 1942 when the Japanese marched in. When they were swept out after World War II, the Chartered Company of British North Borneo threw in its feudal lord's hut to the British Government and the territory became a British Crown Colony. In 1963 Sabah gained her independence as a member of the Federation of Malaysia.

Kota Kinabalu (formerly Jesselton) is a pleasant enough capital, though it was almost

A sandspit off Sabah's East Coast, previous pages. Fishermen erect makeshift structures here, for drying nets and salting fish. This not-quite-an island, left, is visible off Semporna.

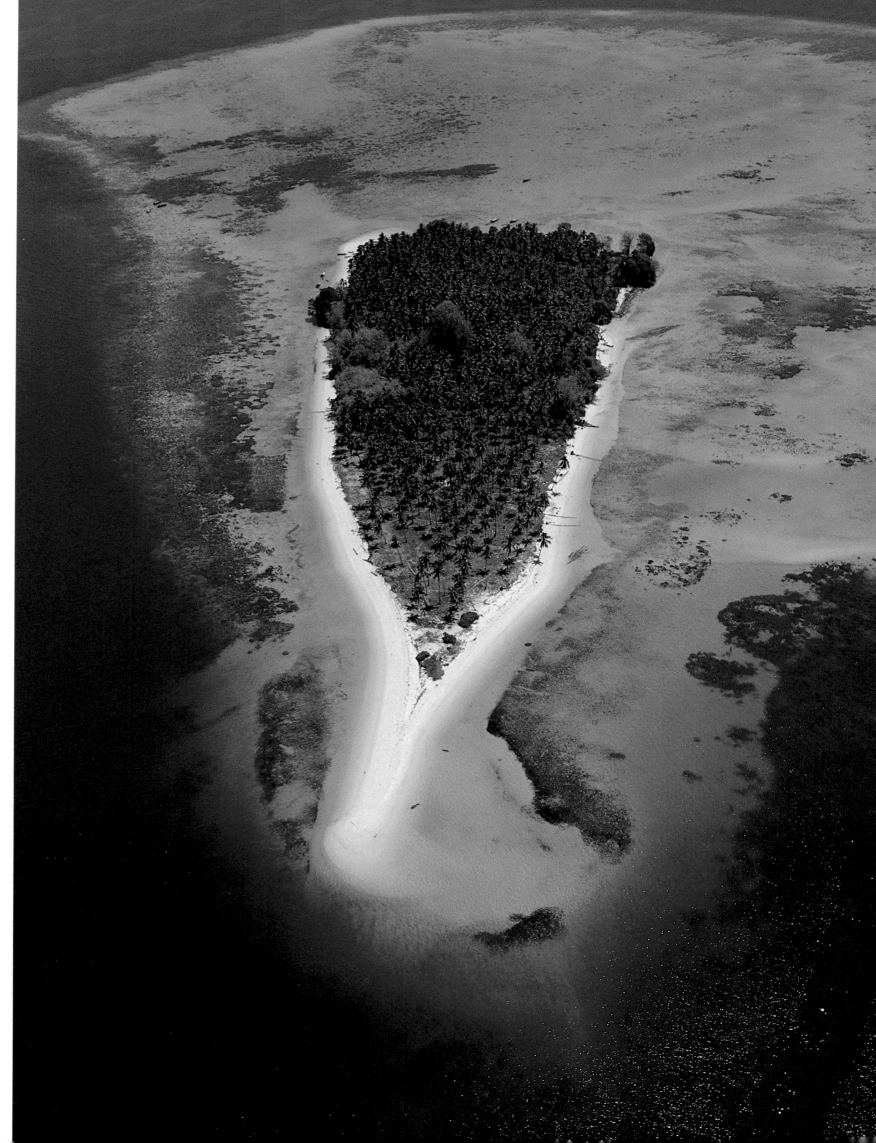

Pulau Sibuan is one of the beautiful islands that lie off the coast of Sabah near the town of Semporna. The islands are relatively undiscovered by travellers, though scuba divers now make a beeline for Pulau Sipadan, an oceanic island some thirty miles further off the coast than Sibuan. Because it rises directly from the ocean floor, Sipadan has an amazing wealth of aquatic life around its shores.

Rice is grown in north Sabah, watered by the many rivers that have their sources on the slopes of Mt Kinabalu. The stubble on these fields is likely to be burned, to return nutrients to the soil.

totally rebuilt after the War. It sits by the sea, just minutes from the beaches of Tuanku Abdul Rahman Marine Park. The State Mosque and the State Museum are attractions, but its most outstanding building is ten minutes east of the city at Likas Bay. The Sabah Foundation Building is one of just four buildings in the world that are actually hanging, its floors suspended from the load-bearing core. The 30-storey glass-cloaked sapphire cylinder is a symbol of Sabah's wealth and new found dynamism.

Sabah is geologically complicated, strapped to an unstable belt of the earth's crust. It shows a split personality: the Crocker and adjoining ranges are attached to the Tertiary folded mountains of Sarawak, Brunei and Central Kalimantan whereas to the east, the dominant structures are linked to the and Sulu archipelago and Sulu Sea Basin. Its dual persona is also reflected in its 1440-kilometre coastline. Most of the west coast is sandy and mangrove swamps rule the east coast. Remnants of intense volcanic activity are similar to those of the Philippines. In the Segama valley, Kota Belud region, Bangi and Balambangan islands, basaltic lava and pyroclastic rocks hark at a violent past, though today the only signs of such fiery provenance are hot springs.

Second to the mountain in forming Sabah's appeal and unique appearance from above are the coastlines. Placid, pellucid waters on the north and east coasts harbour wondrous marine life and magnificent coral, making this one of nature's most bountiful treasure troves. The beaches are little exploited. Off Sabah's east coast are the Selingan, Gulisan and Bakungan Kecil islands which form the Turtle Islands Park. Their main claim to fame are the Green turtles and endangered Hawksbill turtles. The former nest mostly on Selingan between August and October, and the latter on Gulisan from February to April. Pulau Sipadan and the islands off Semporna have some of the world's best scuba diving.

While the forests of Sabah look much the same as the forests of Sarawak, the broccoli canopy hides some variations. Mount Kinabalu, visible from the city that bears its name, is home to a host of unique flora. They take on drastically different shapes and sizes tier by tier. Primary forest marches resolutely up to 1200 metres before passing the baton to a montane oak forest. The trees' stature shrinks perceptibly and at 1800 m the moss forest assumes sovereignty. Taking up after 2800 m is an alpine scrubland of stunted trees sculpted by the wind, dwarf bushes and exotic unique flowers. The flora of Mt Kinabalu has earned five citations in the Guinness Book of Records. The world's biggest flower, seen and amply smelt along the slopes, is the parasitic Stinking Corpse lily (*Rafflesia arnoldii*). Each blossom can measure up to a metre across, three centimetres thick, and weigh seven kilograms. True to its name, the Rafflesia blossom exudes a horrid stench reminiscent of rotting meat. *Nepenthes rajah*—a kind of pitcher plant—makes the world's largest live buckets. Each pitcher can hold up to two litres of rain water! The world's biggest single leaf was found here: one leaf of the *Alocasia macrorrhiza* measured 3.05 m long and 1.94 m wide! The fastest rate of growth ever recorded for a proper tree (excluding bamboo which is a type of woody grass) is 7.15 m in 13 months for an *Albizzia falcata* planted on the 17th of June 1974. And there is more to this mountain than world records. Sprinkled along the the slope, on tree bark, in crevices and even underground are over 1000 species of orchids. The diversity is staggering. Sabah, the Land Below the Wind captures the senses whether you are above or below the clouds.

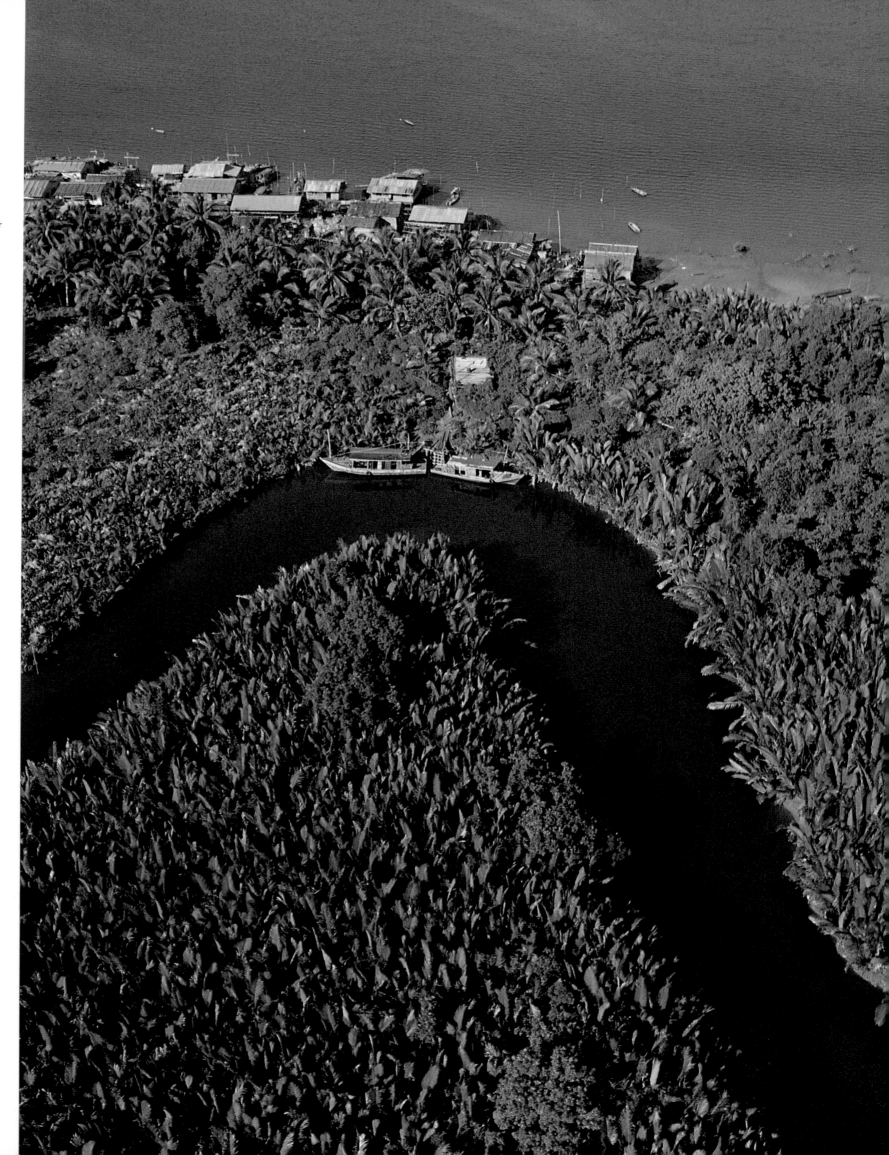

A bend in the river if there ever was one. This photo illustrates graphically the mixed farming and fishing environments of coastal dwellers in many of the low-lying seaside areas of Southeast Asia. One important crop for people in these areas is the sago palm, which can thrive on sodden soil and can tolerate brackish water.

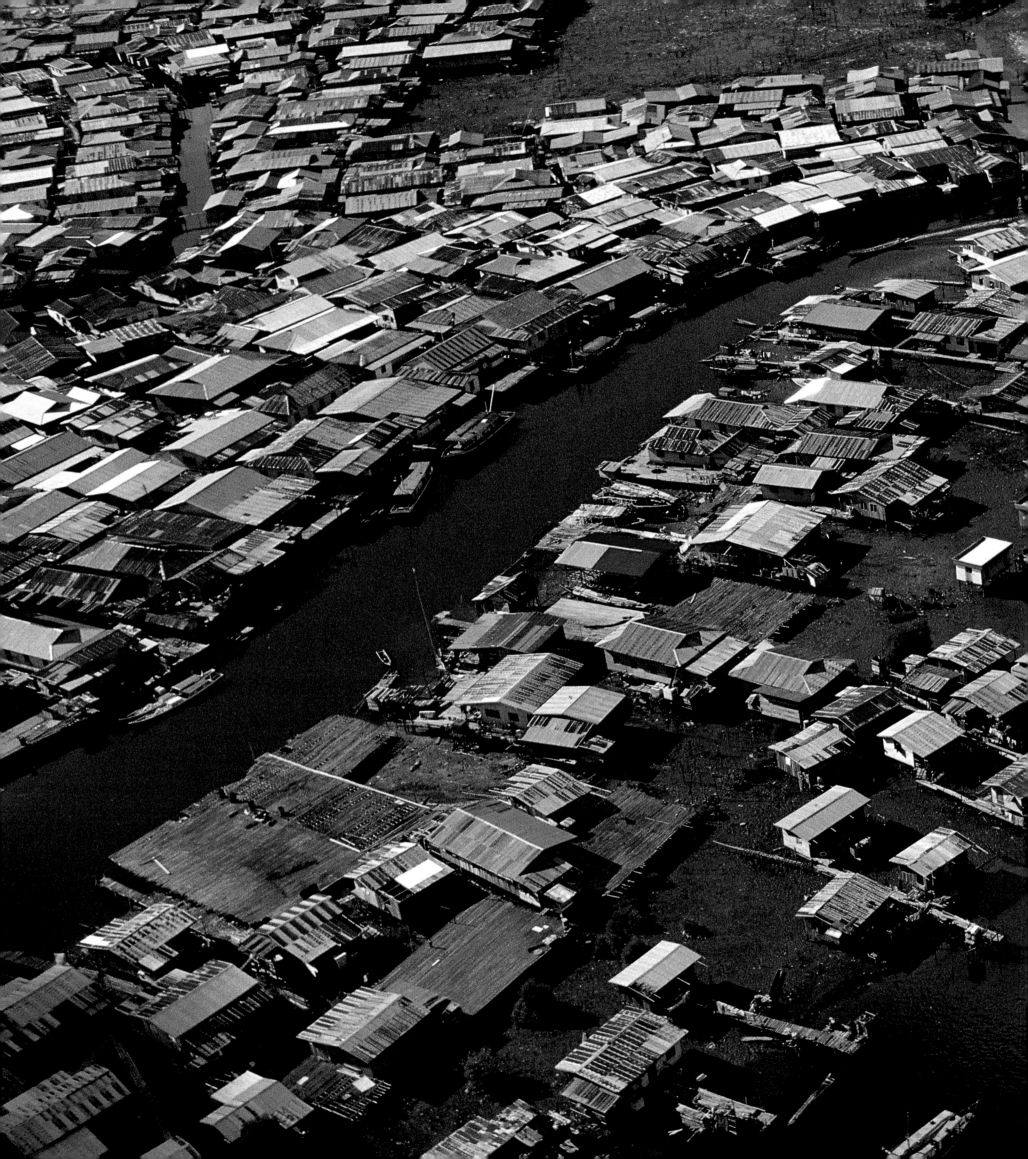

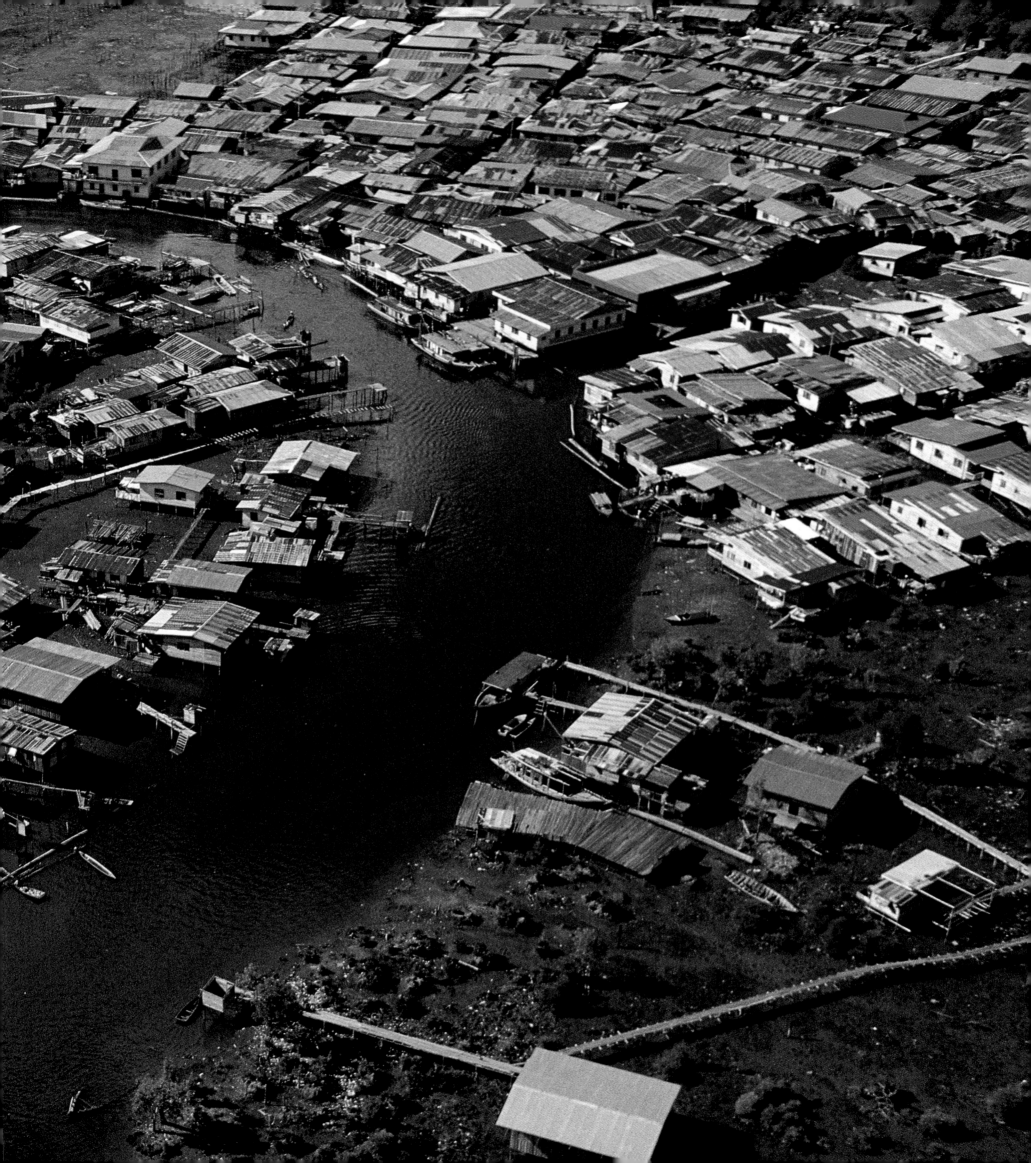

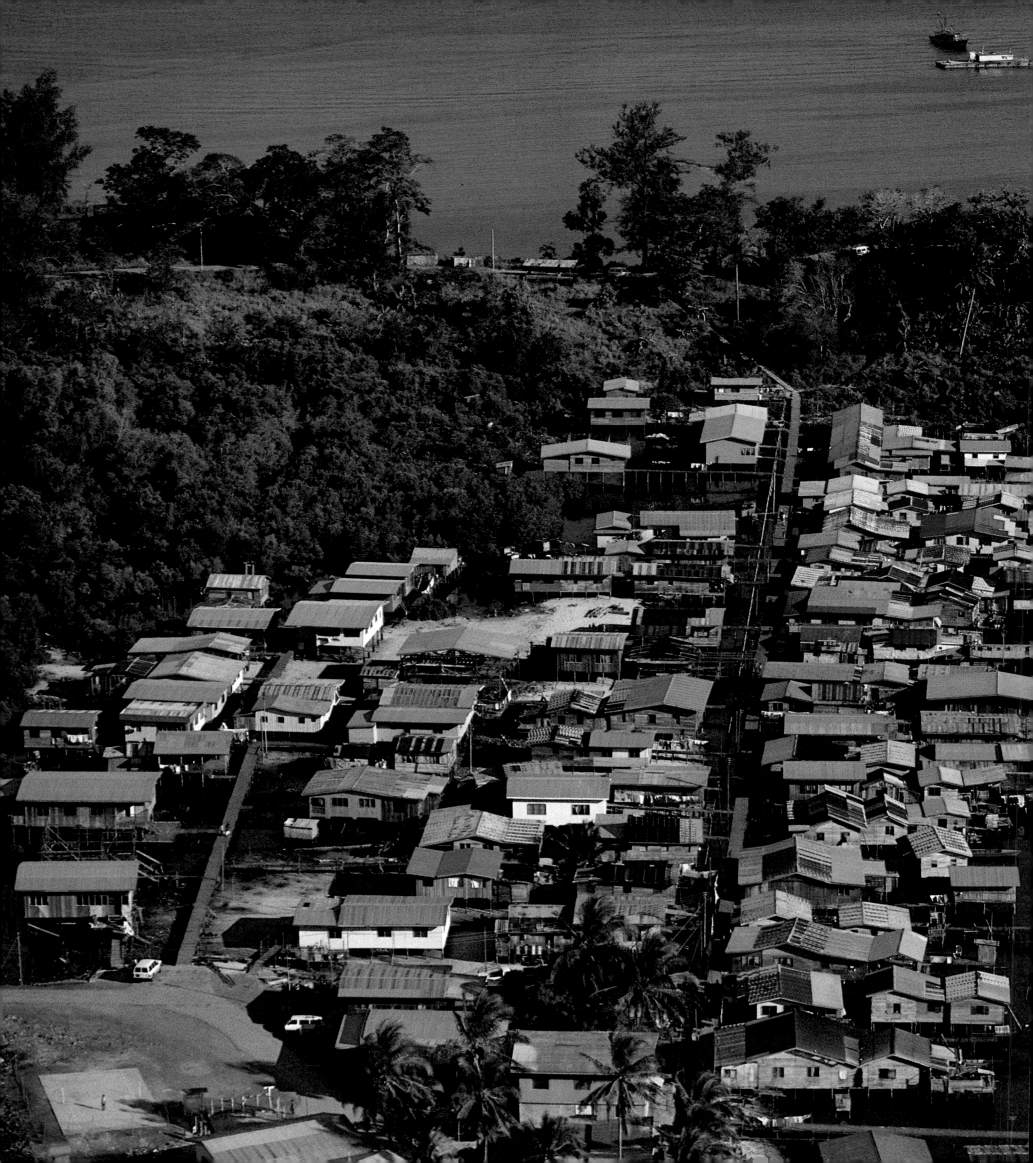

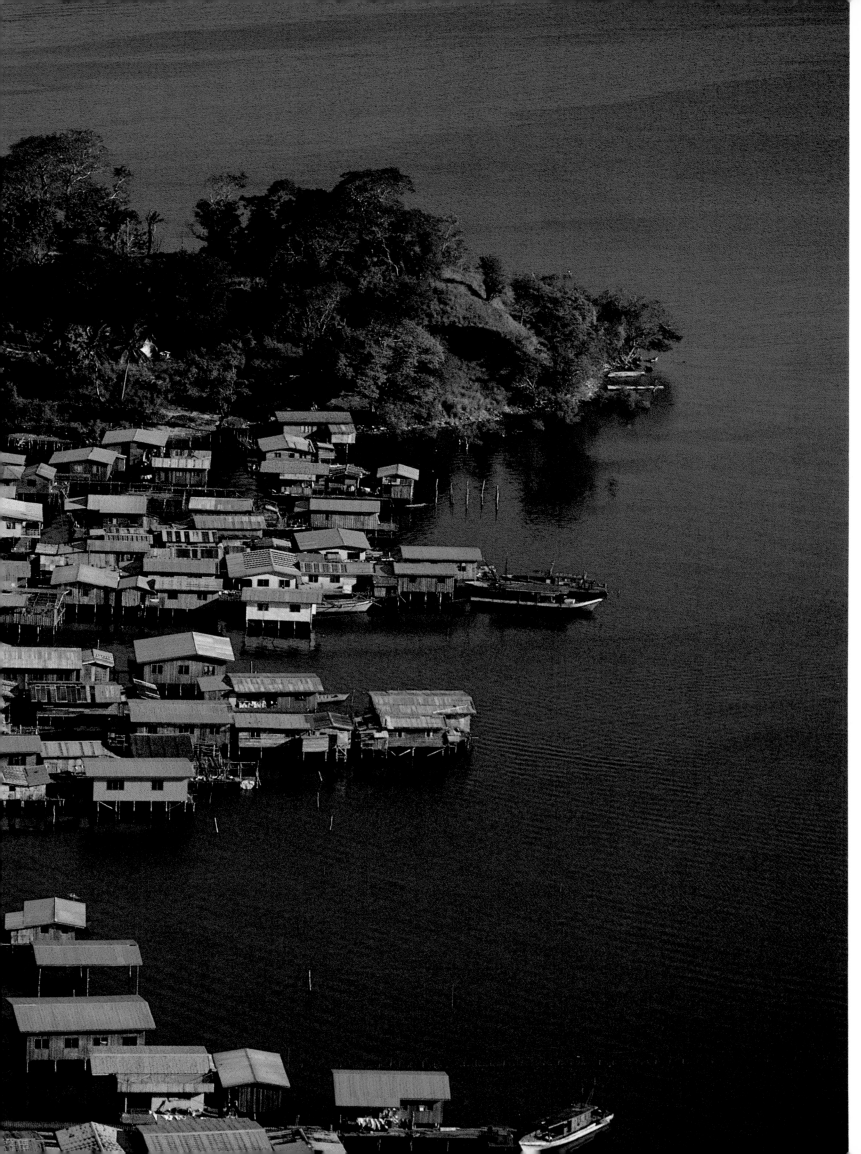

Sandakan, previous pages, was once the capital of North Borneo under the rule of the Chartered Company. The city has seen its fortunes ebb and flow several times. Now relatively prosperous due to timber wealth, the town boasts one of the most extensive *kampong air* in the state. Another *kampong air,* these pages, is found in Kudat, a town on the north coast of Sabah that became the capital after Sandakan.

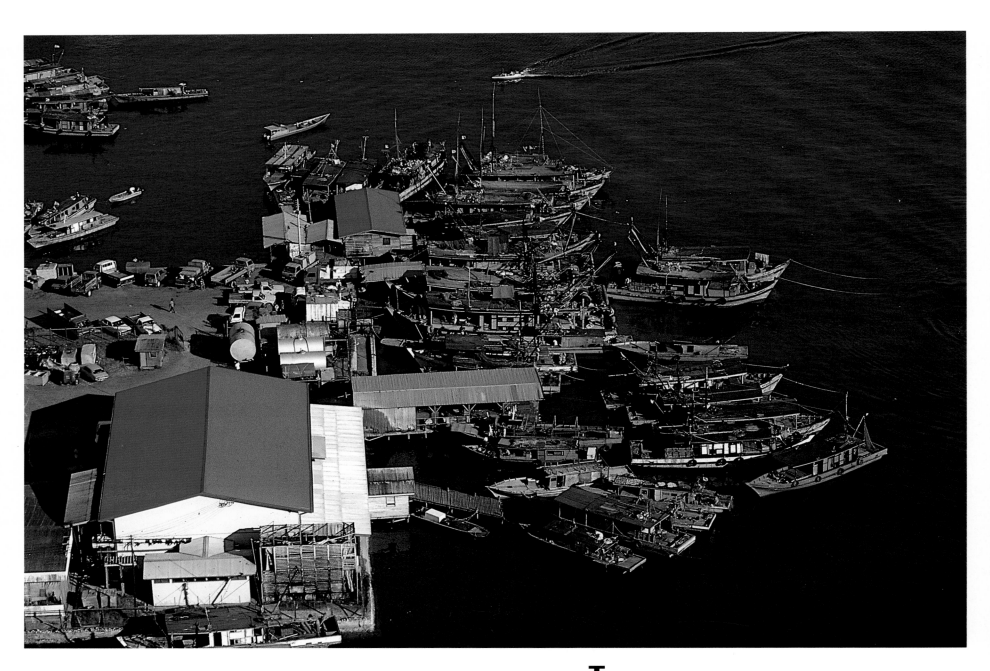

The busy fishing port at Kudat hints at the maritime traditions of this town, which was once an important emporium for the China trade. The waters of the South China Sea provide a bountiful living for fishermen; but the many magnificent beaches near Kudat have yet to be developed for tourism.

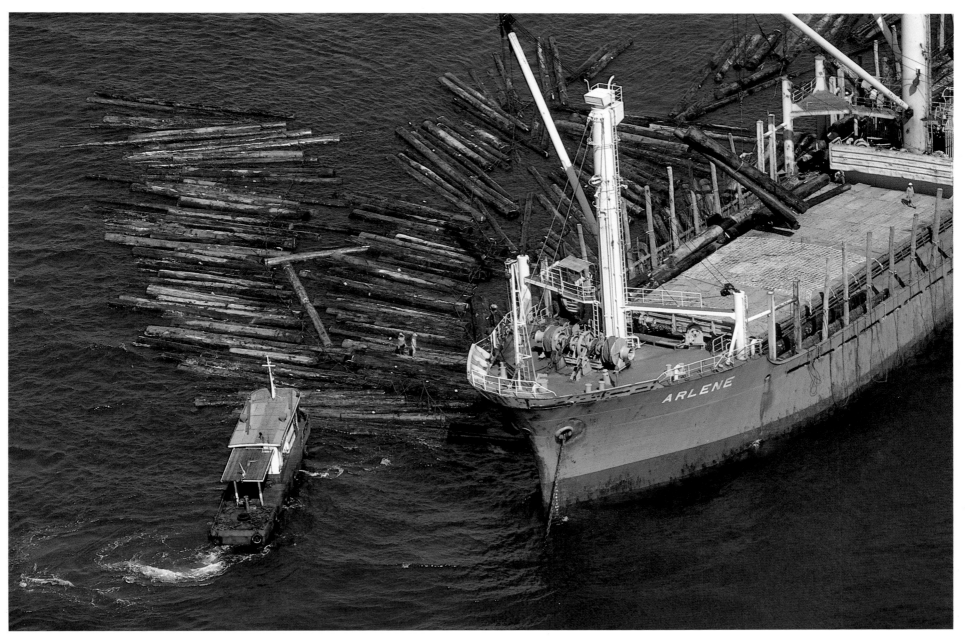

Water makes an efficient transport system for cut logs. They are floated down rivers in log rafts, corralled and pushed into place by small specially-designed tugboats, and then loaded from out of the water directly onto small freighters, like this one off the East Coast of Sabah.

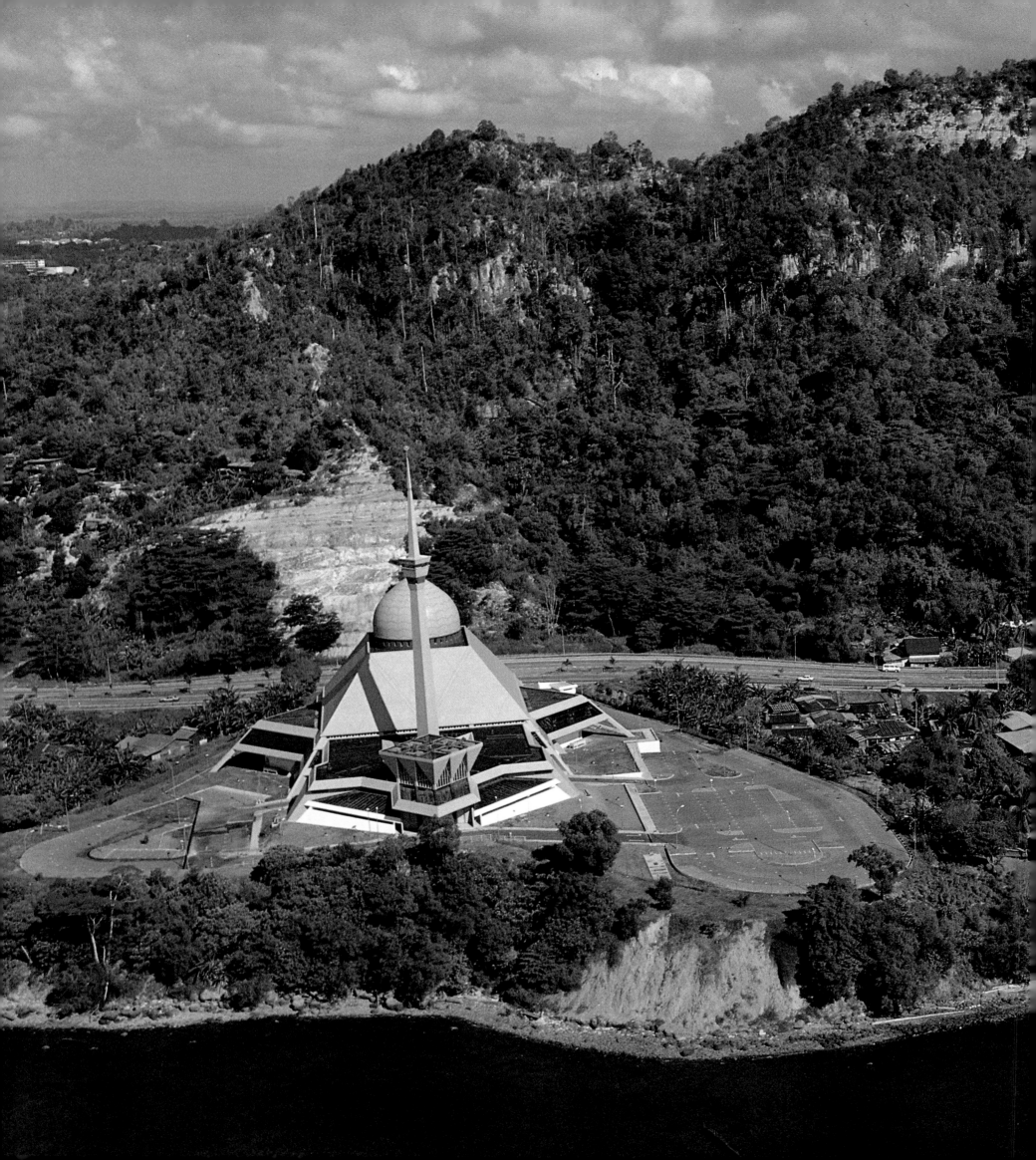

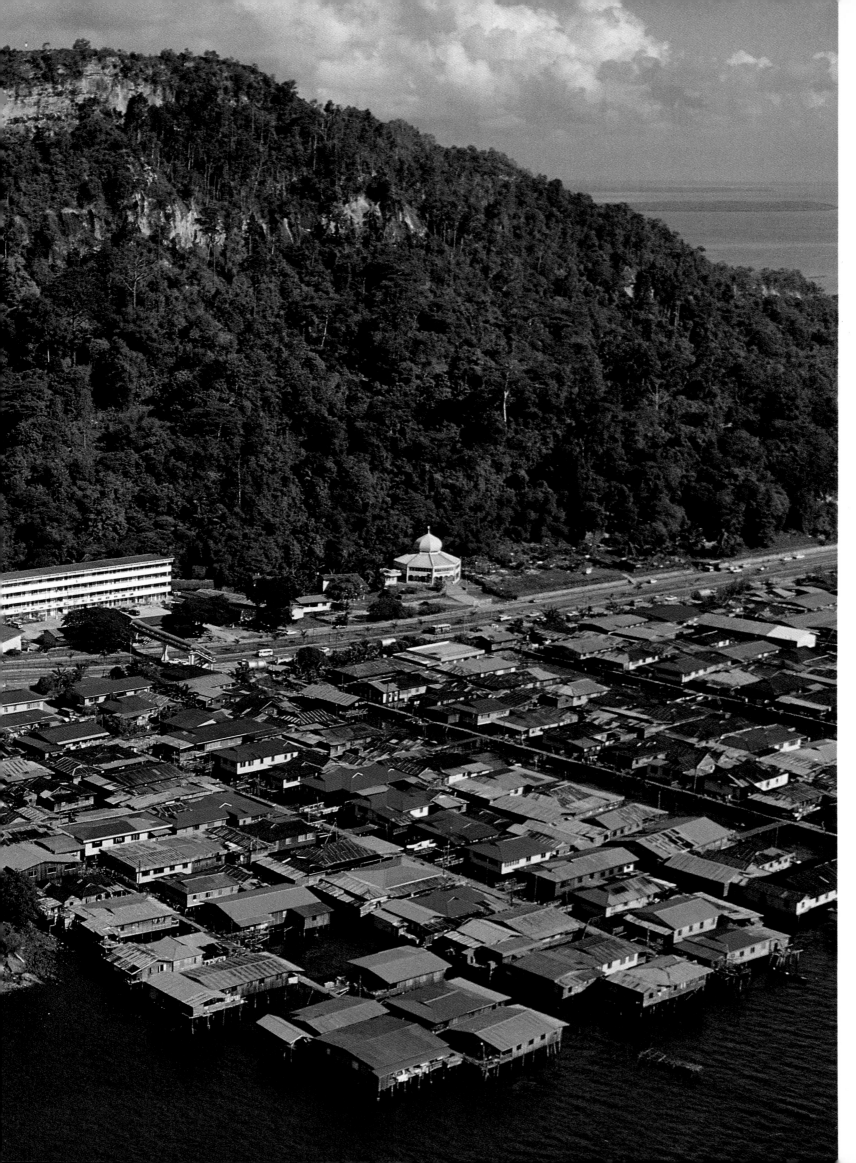

Part of the attraction
of Sandakan to the
North Borneo
Chartered Company
was its fine deepwater
port, at the head of
the large bay of the
same name. The city is
also defended
landwards by a large
limestone ridge, seen
here backing the
brand new mosque of
a fantastic, futuristic
design.

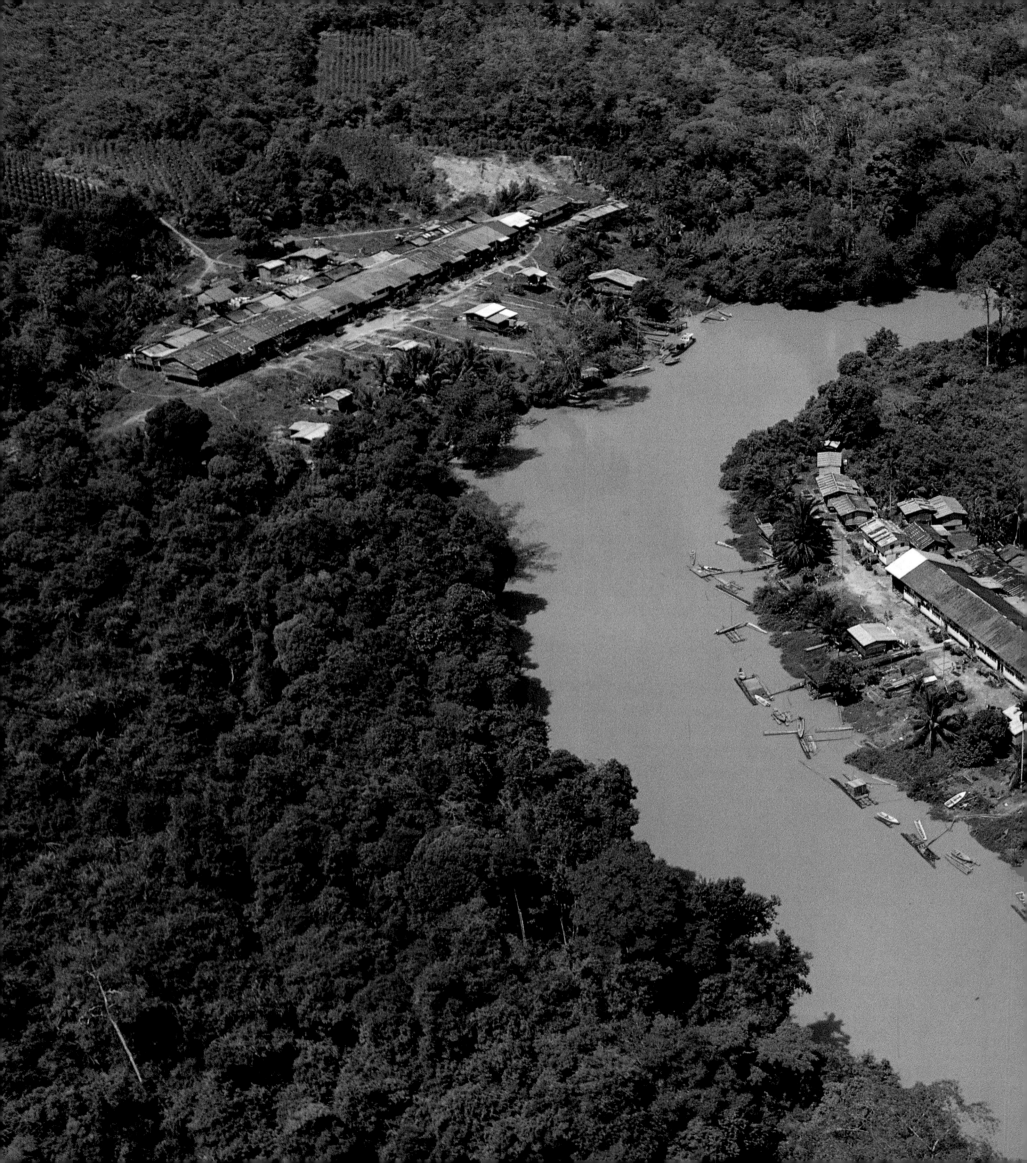

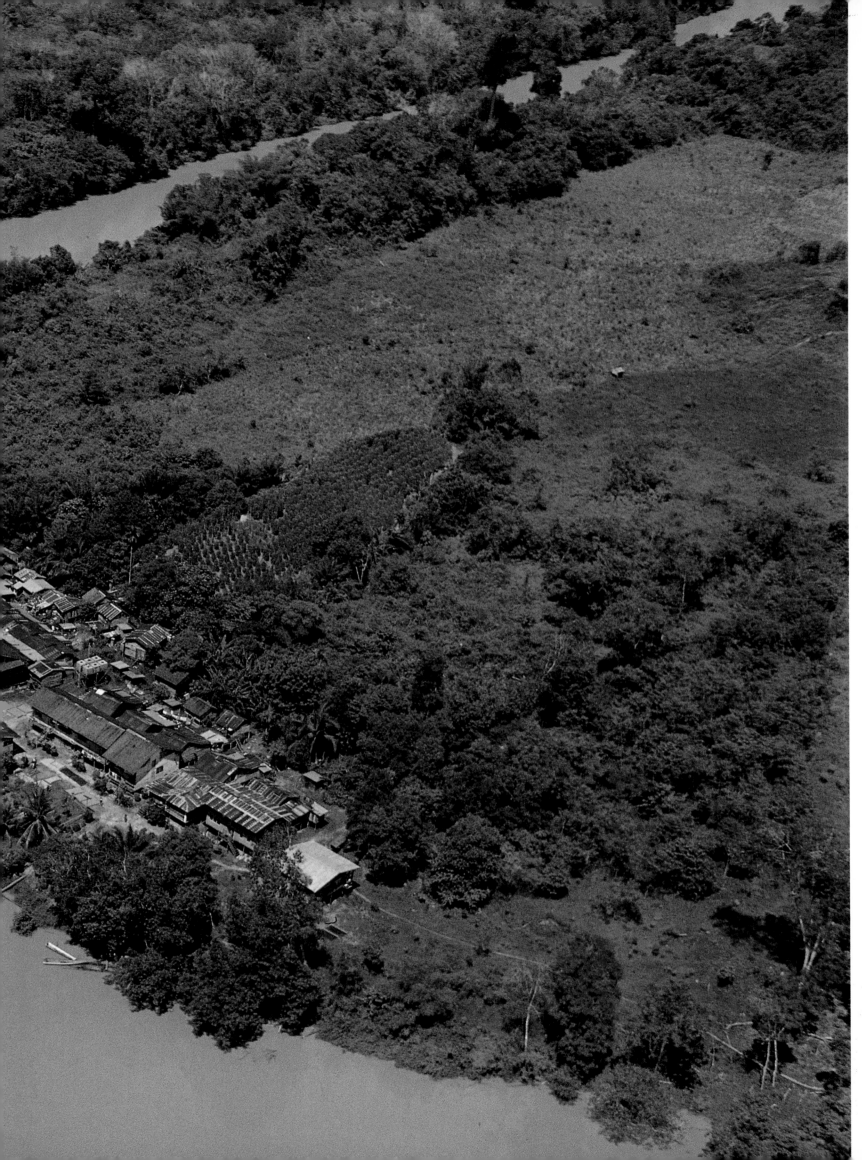

Longhouses are most usually associated with Sarawak, but many of the peoples of Sabah also live communally in this fashion. This particular community appears to have a progressive leader: a new settlement has been established on the other bank of the river, but the old longhouse is still maintained. Tall vines of the pepper plant growing on poles are cultivated behind the longhouse.

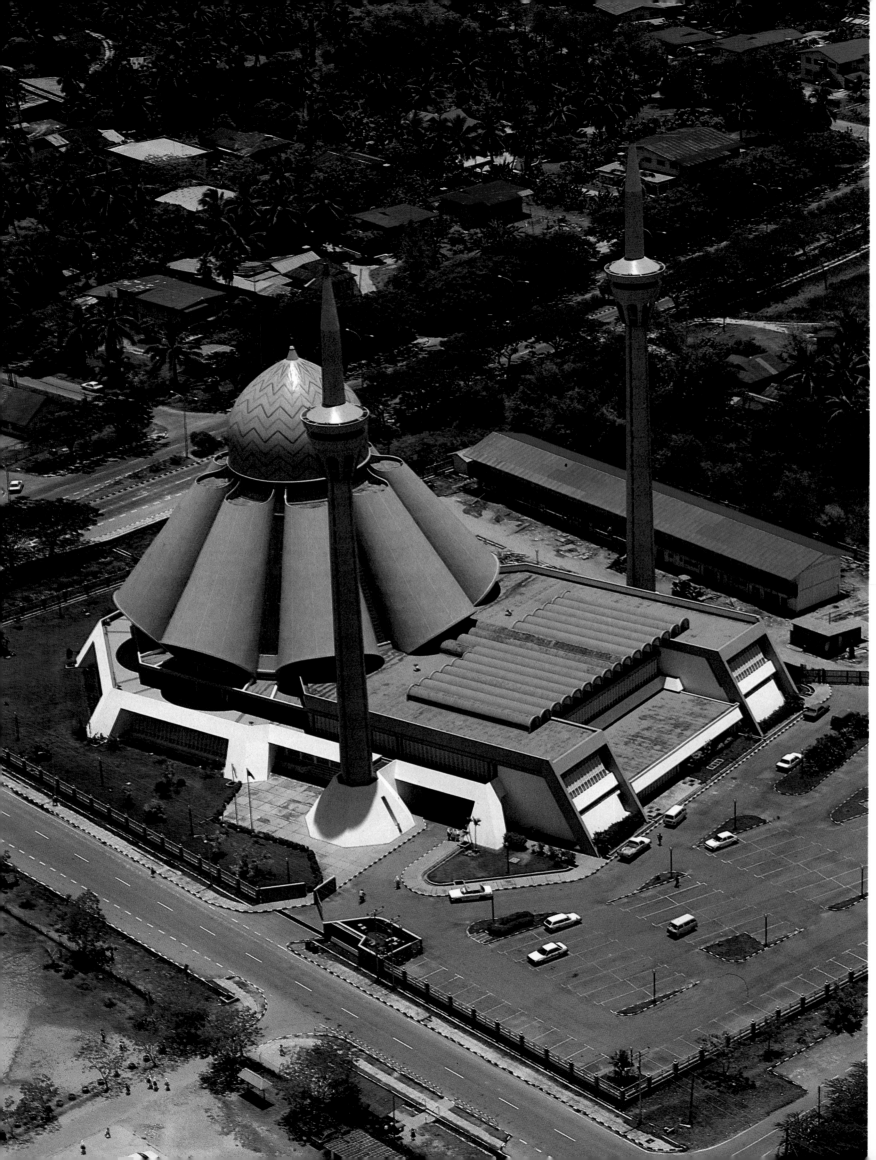

The island of Labuan, off the coast of Sabah, was once a British coaling station, and so has a different political history from Sabah and Sarawak. Now a Federal Territory, on par with Kuala Lumpur, Labuan is being developed as a financial centre and free port. The mosque is one of the most impressive buildings in the town.

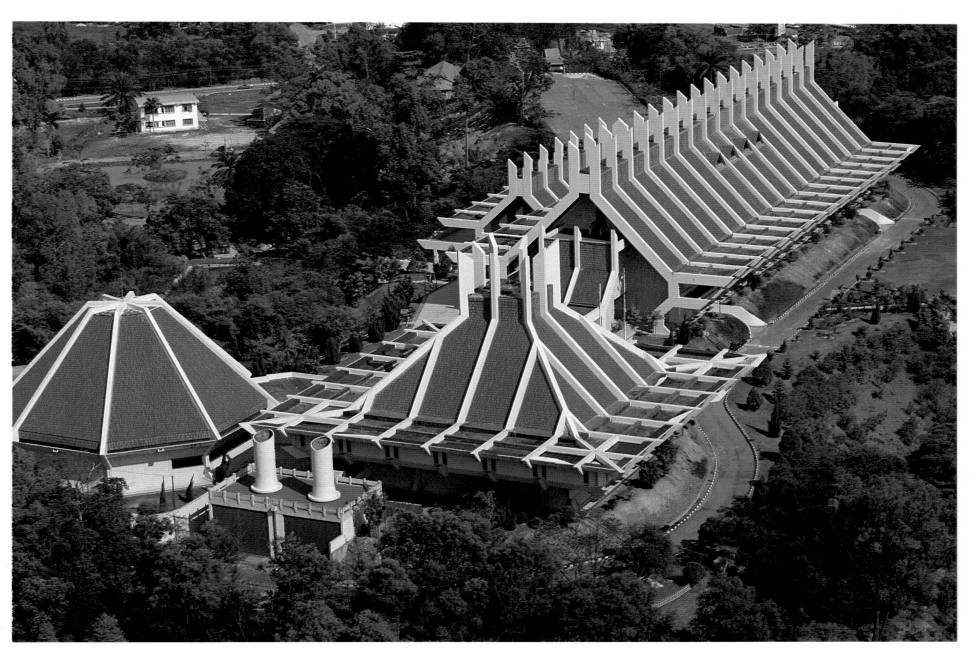

The Sabah State Museum is one of the great attractions of Kota Kinabalu. The lines of the building are based on the design for a traditional Rungus longhouse, which has outward sloping walls underneath a broad sloping roof. The Museum has the challenging task of adequately portraying the cultures and histories of Sabah's more than 30 ethnic groups.

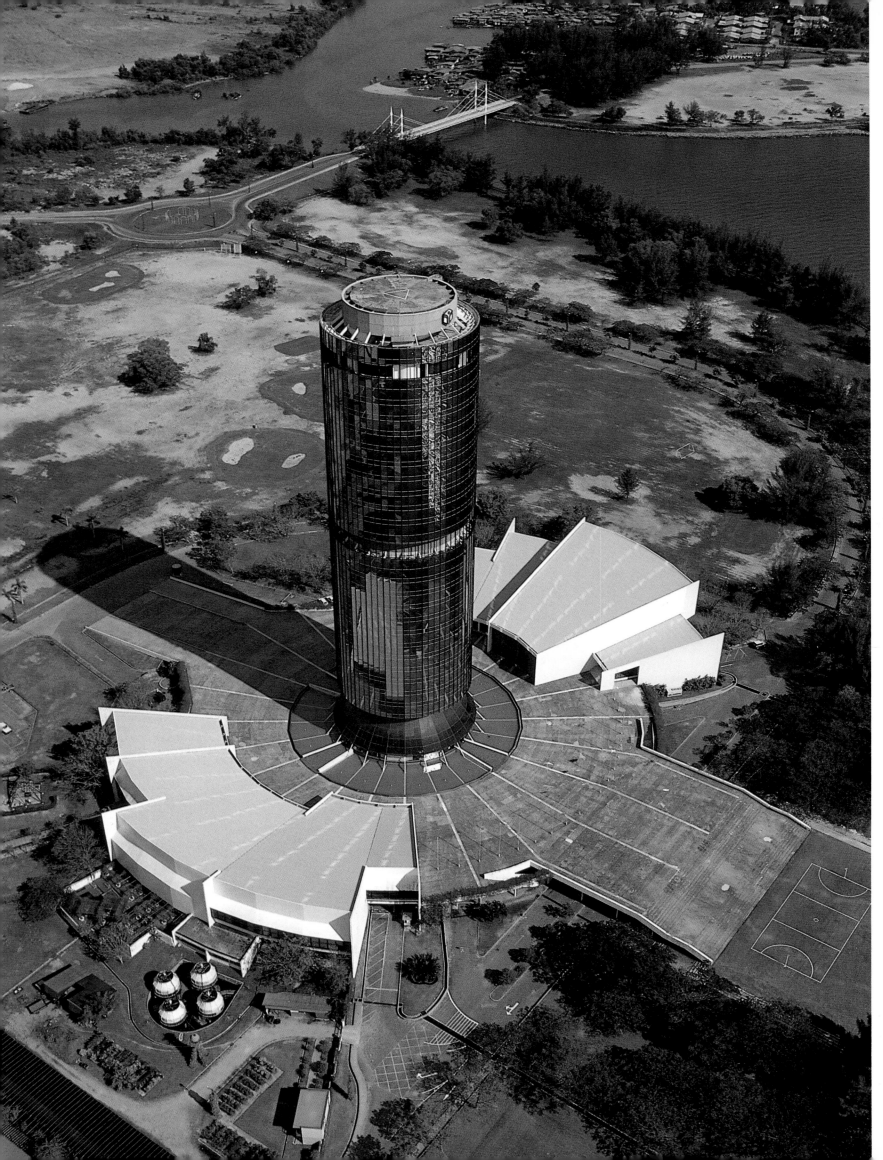

The most impressive building in Kota Kinabalu is the headquarters of the Sabah Foundation, a para-state welfare organization which provides scholarships for Sabahan students among its benevolent activites. Each of the building's 30 storeys 'hangs' from a central supporting core; each of its 72 sides are cased in glass.

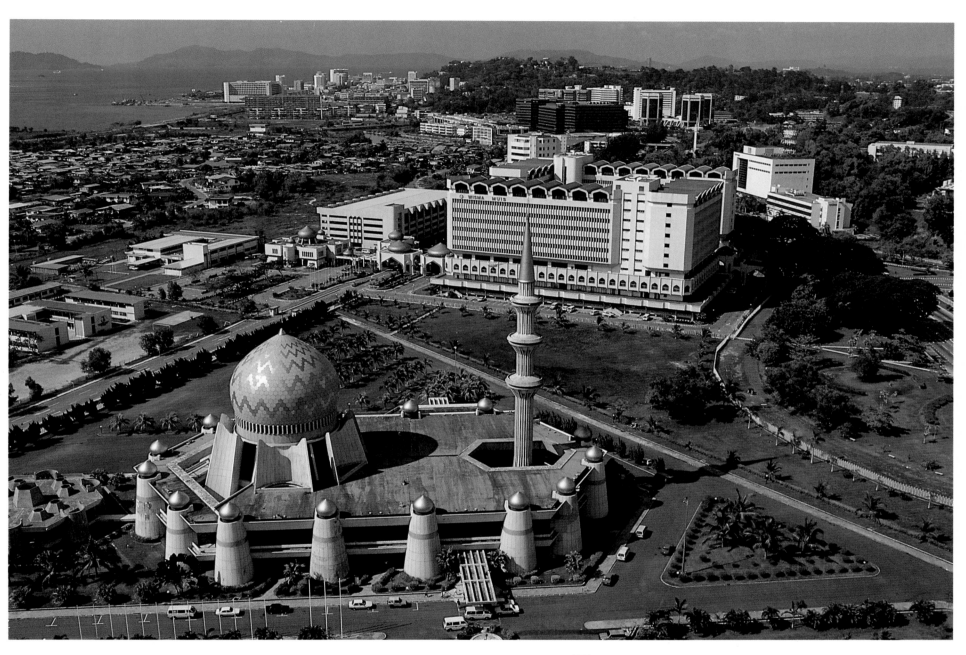

The citizens of
Sabah's capital
follow the Malaysian
fashion for abbre-
viating the double-
barreled name of their
city: Kota Kinabalu is
KK for short. The city
is modern, and it was
almost totally rebuilt
after World War II.
Competing with the
Sabah Foundation and
the Museum for the title
of most impressive
building in the city is
the Sabah State
Mosque.

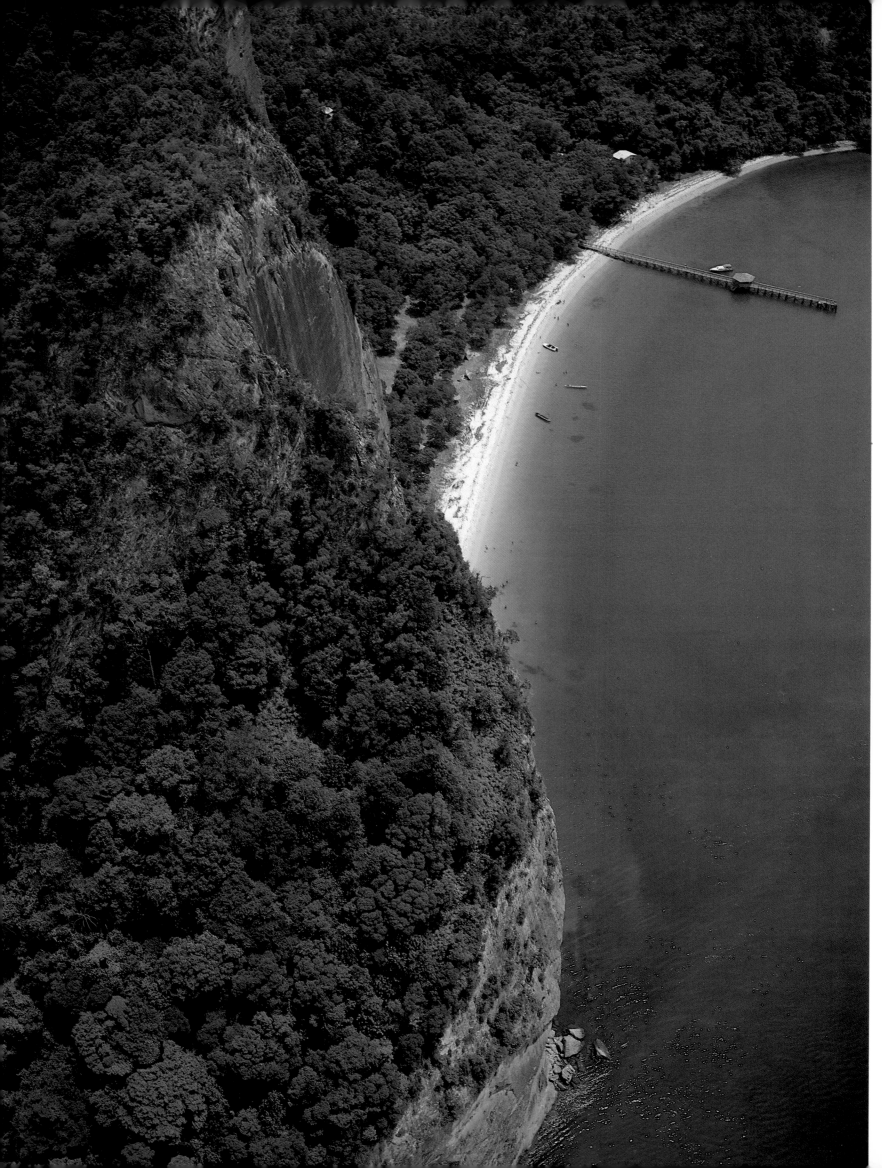

The impressive soaring cliffs of Pulau Bahala, in Sandakan Bay, frame a pristine beach, and make for a lovely touristic scene. During the war, Bahala was the site of a Japanese detention camp, and tales of tragedy from those days are still heard in Sandakan and the area today.

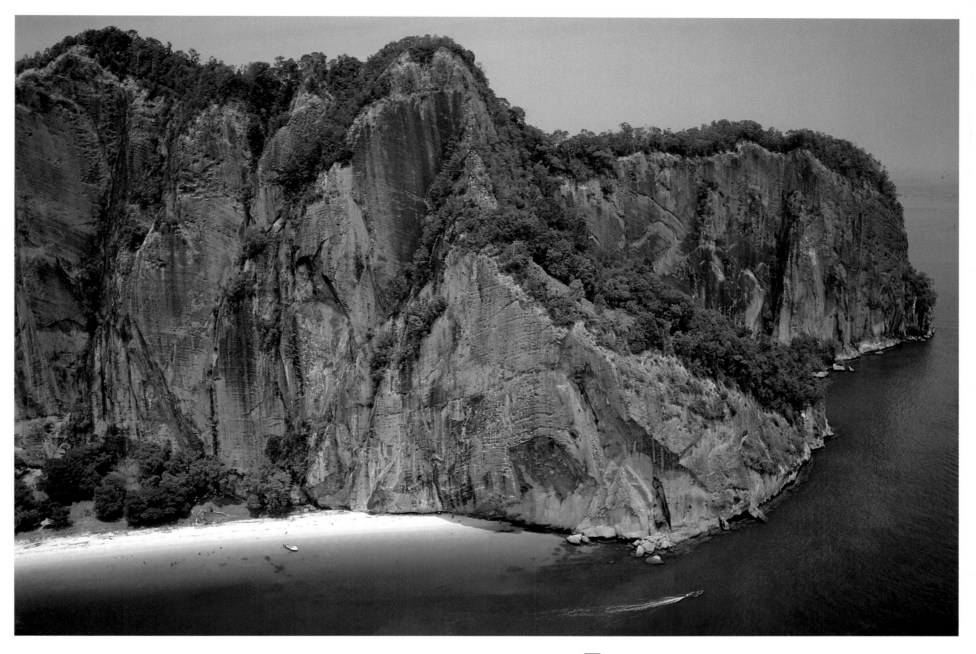

The large bays
on the East Coast of
Sabah are home to
nesting turtles and
other marine life.
Nearby to Sandakan
are other natural
attractions, including
the famous Sepilok
Orangutan Sanctuary
and the Gomantong
Caves, a major

bird's nest collection
site. On the following
pages is the peak of
Mt Kinabalu, taken
from a helicopter
hovering above the
clouds, but under the
4176-metre elevation
of the peak.

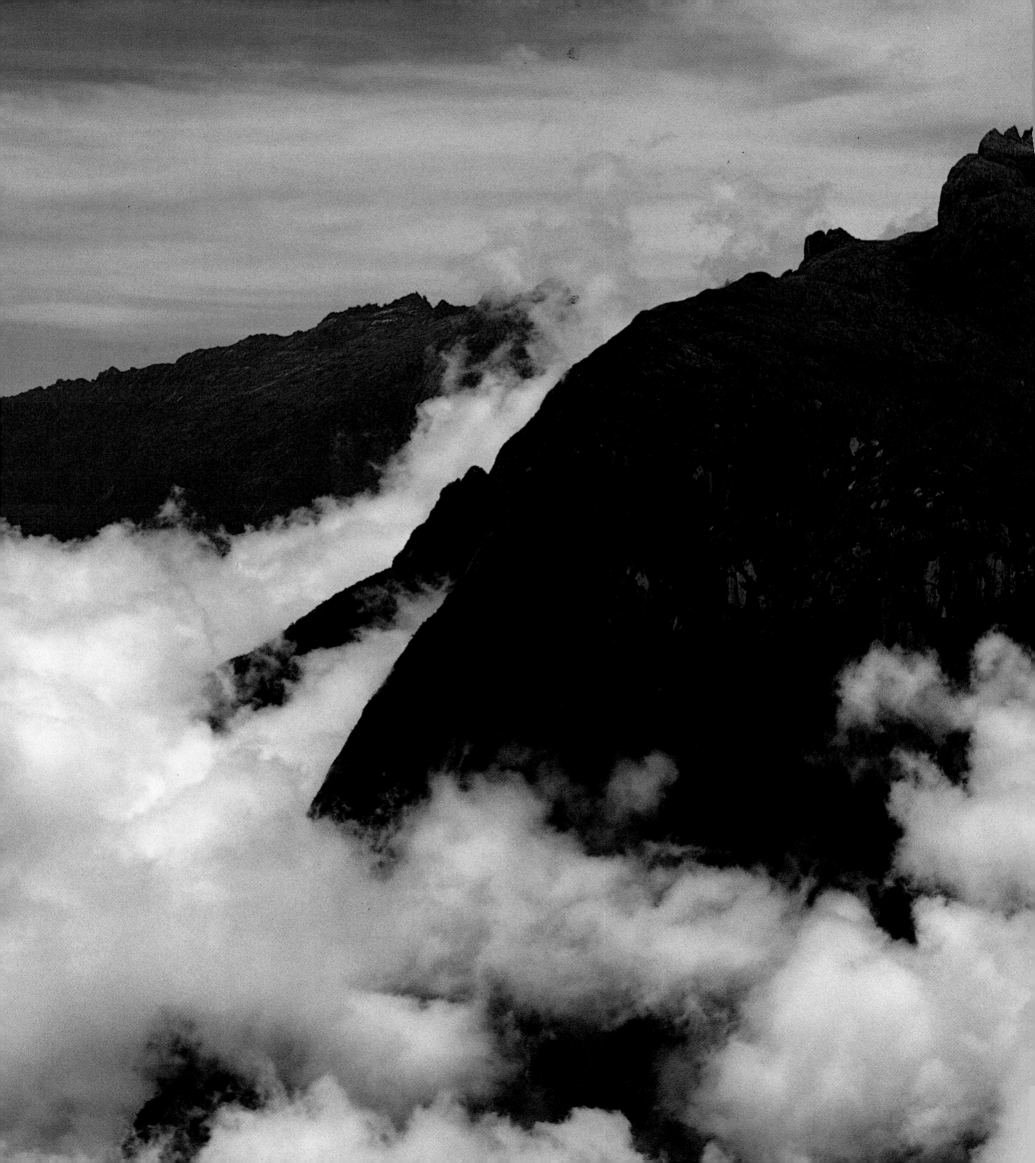

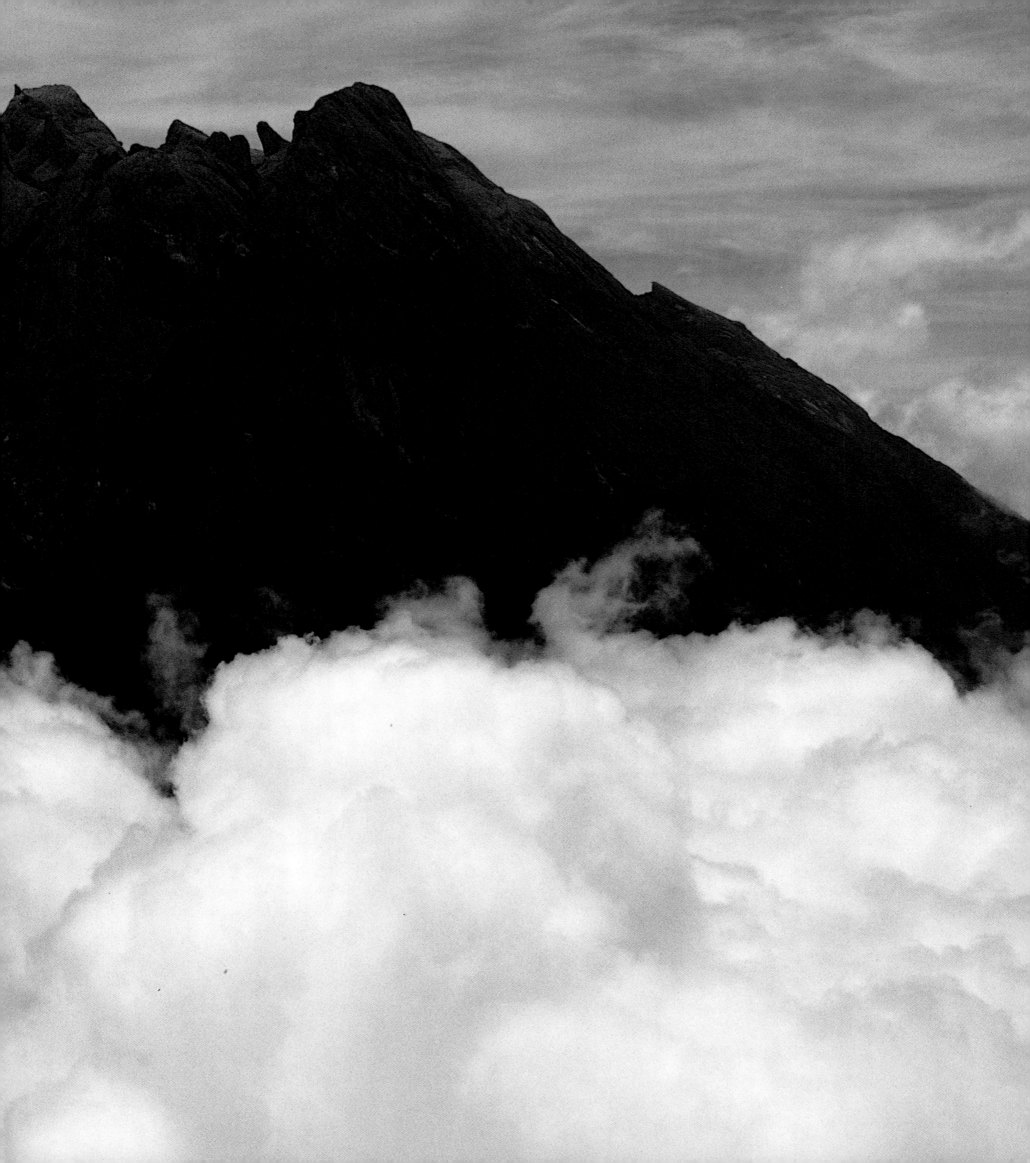

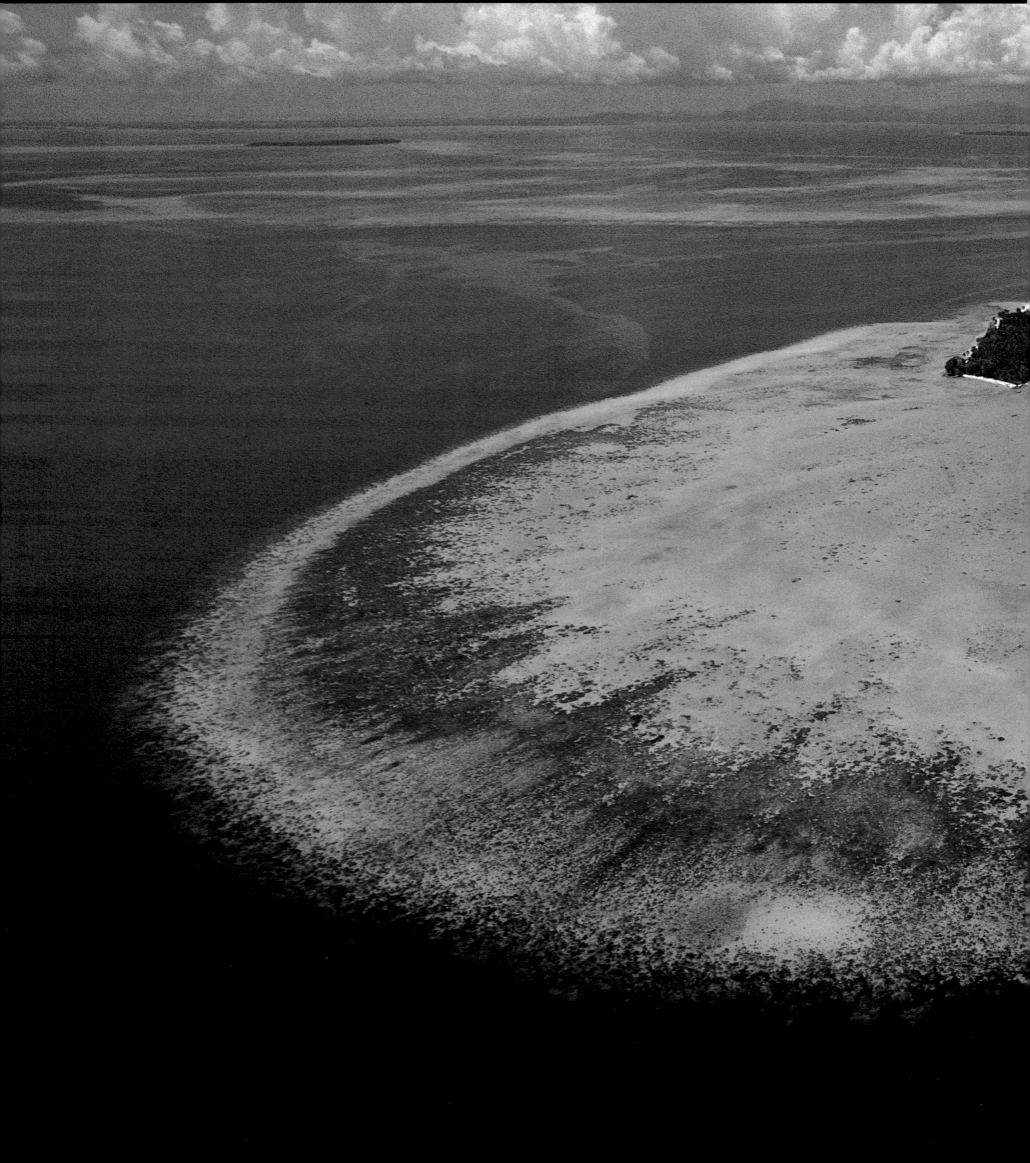

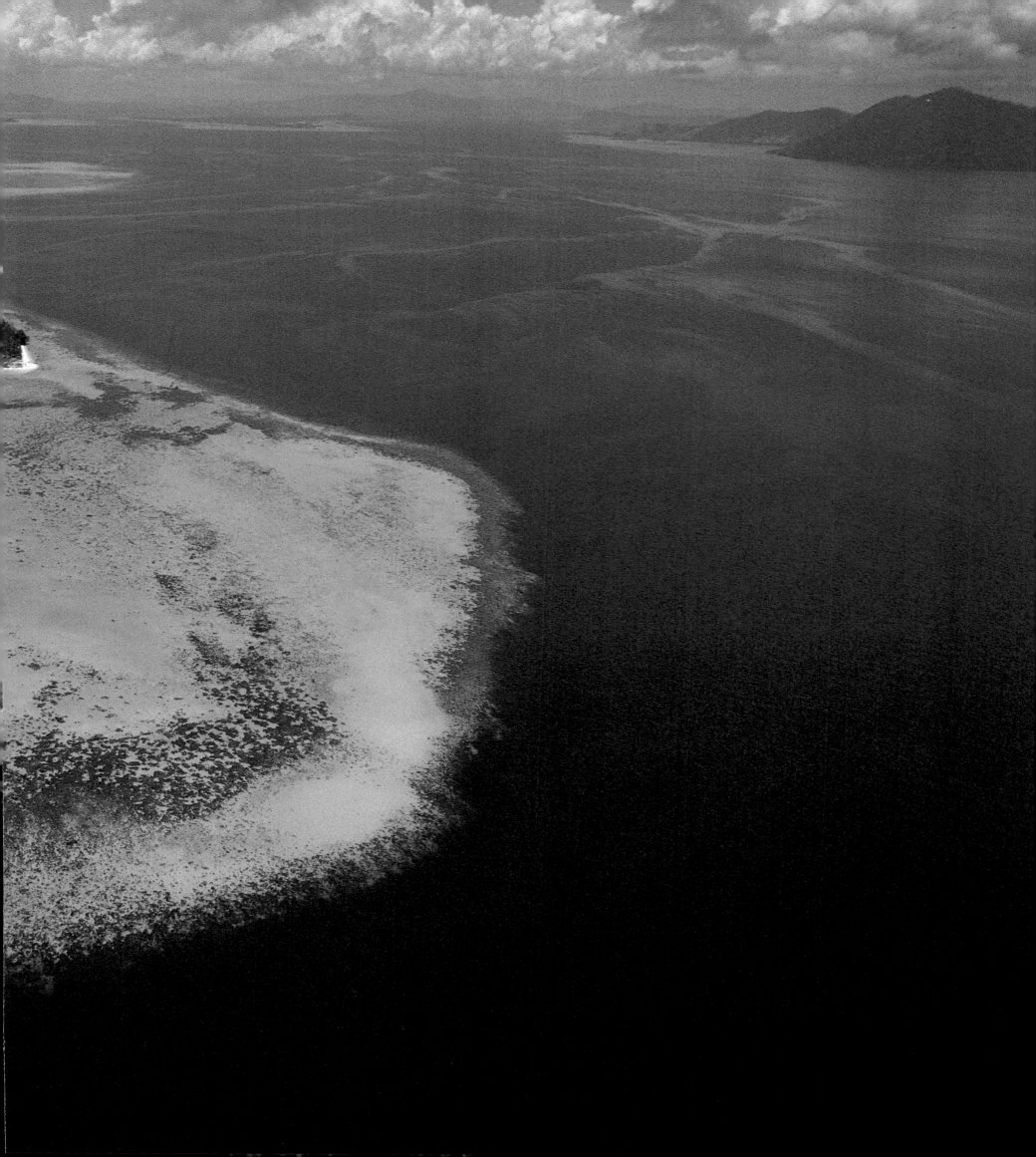

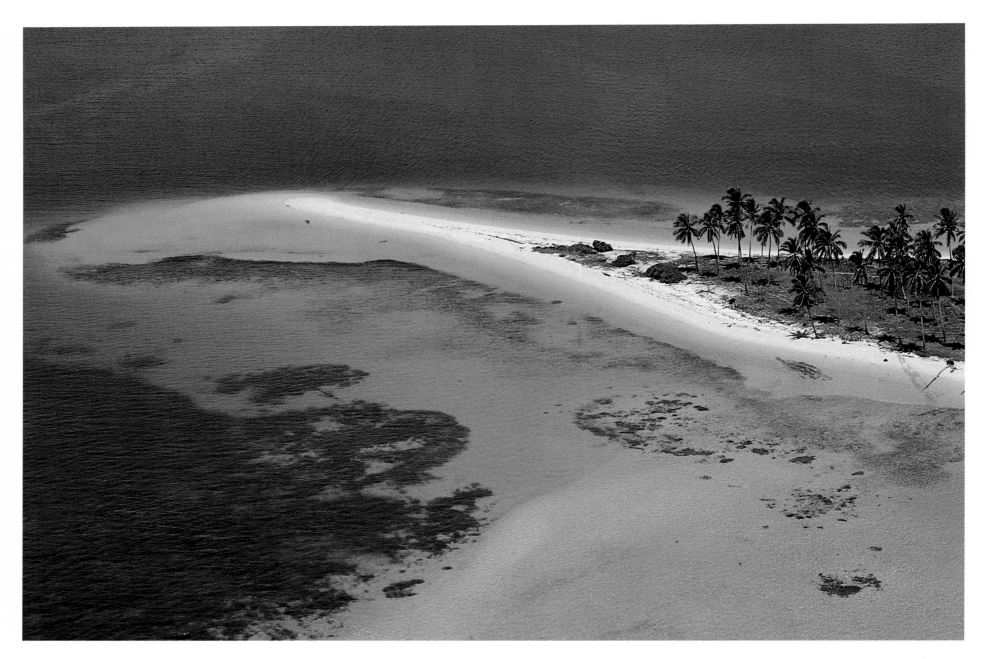

The Sulu Sea is a photographer's dream. Yes, the sea really is this blue, the palm trees do sway in the breeze, and the sand is pure white, perhaps tracked by a turtle's dragging flippers, during laying season. This is Pulau Sibuan, and on the preceding pages, one of the islands off of Semporna, a small town on the south-eastern coast of Sabah.

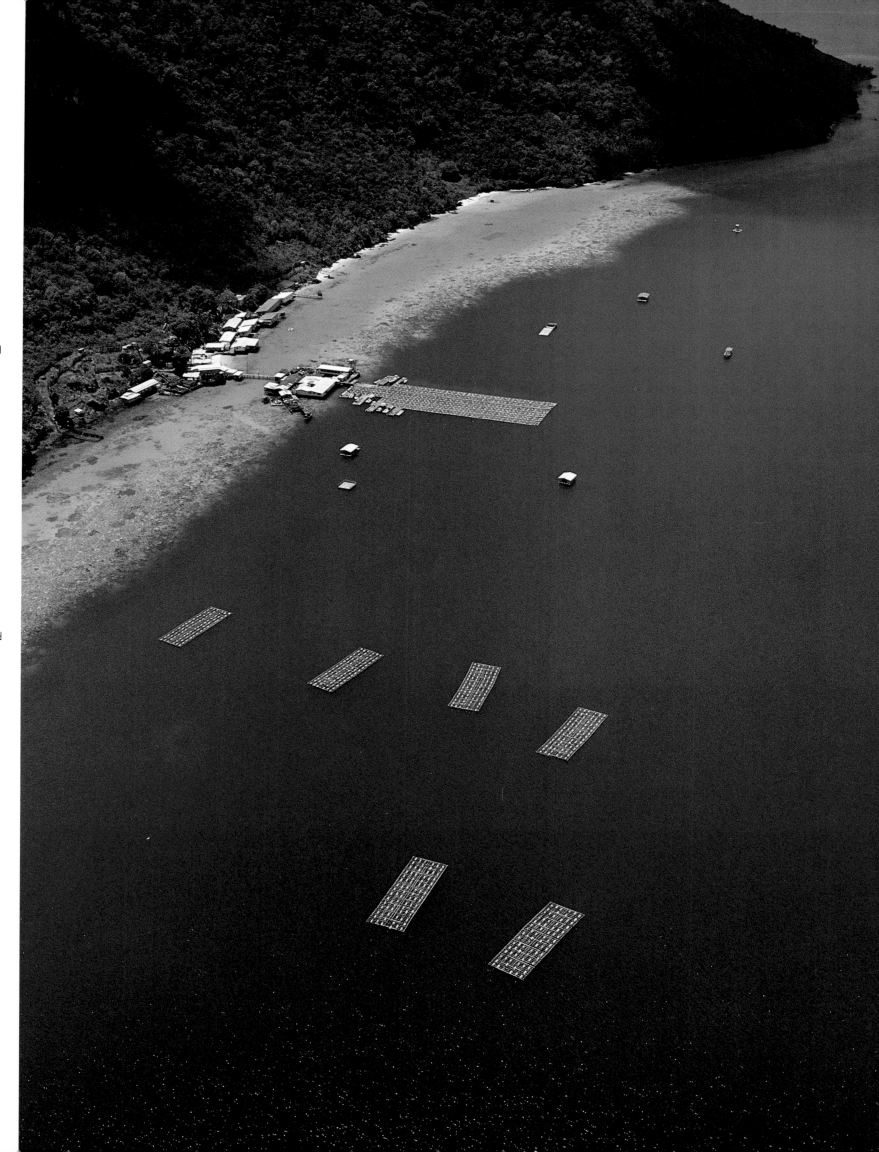

Rich in islets and inlets and hidden nooks, the Sulu Sea was once home to Borneo's most feared pirates. In the 18th century the Sultan of Sulu made a last stand against the Spanish encroaching from the Philippines, and neither side was nice in their methods. Rocks, islands and lagoons were dangerous to the proud galleons, but offered friendly shelter to shallow craft paddled by the canny sea rovers of Sulu. Small coastal settlements might be raided, burned down, deserted and built again a few months later out of the simple materials near at hand.

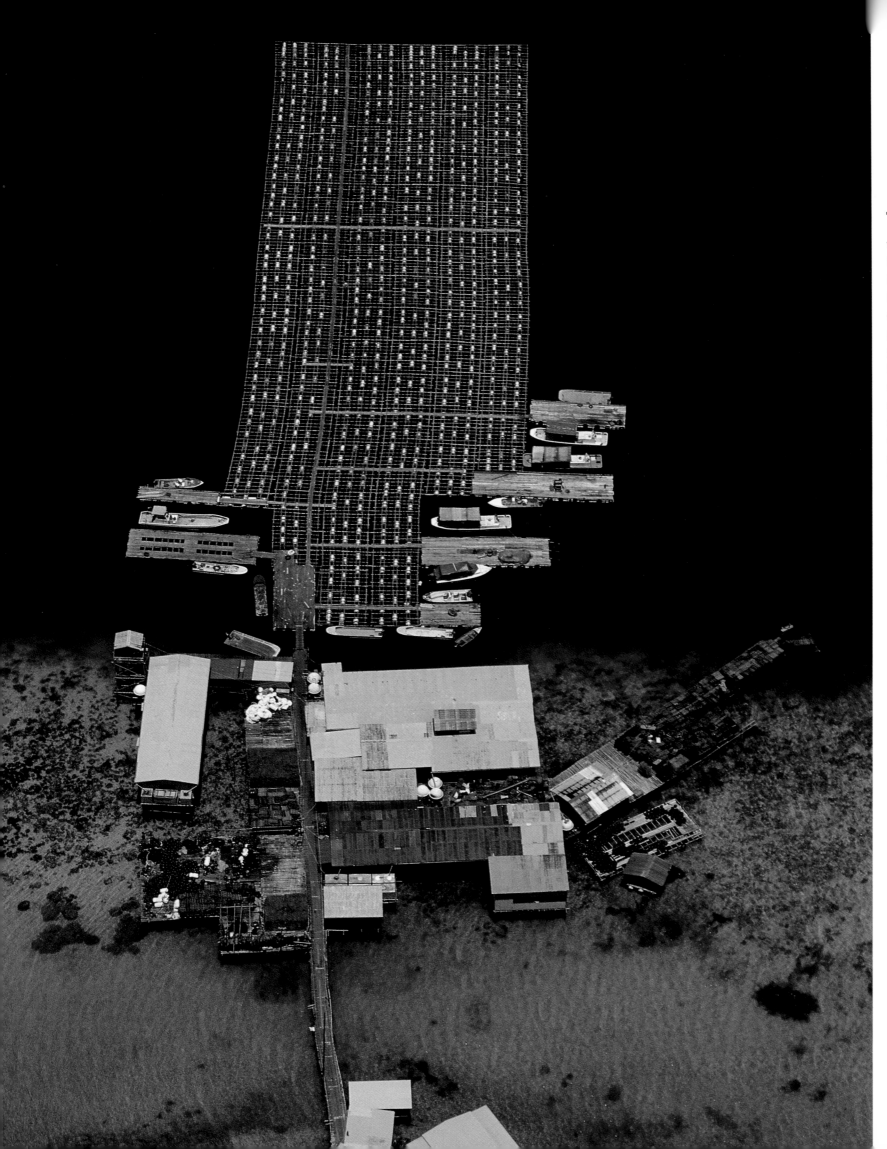

This is not a floating work of abstract art, it is the pearl farm on Pulau Boheydulang. Run by a Japanese company, this farm produces cultured pearls. The filigree-looking grid is a raft, set on white flotation tanks. It holds cages containing oysters that work so hard to satisfy a fastidious world market.

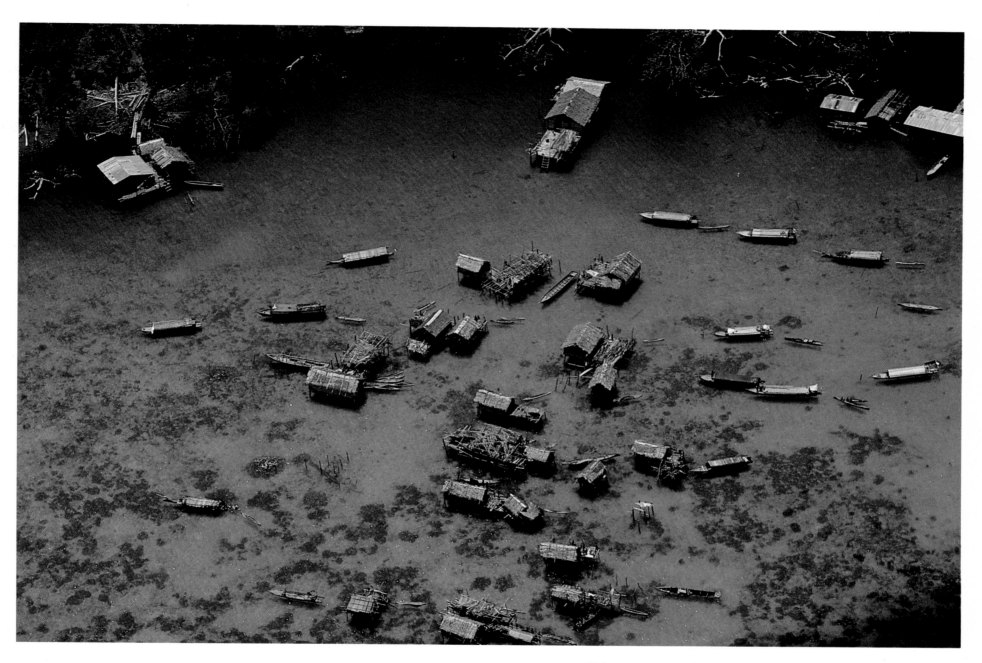

The East Coast of Sabah is host to an amphibious population, 'sea gypsies' who live in houseboats or on huts quickly erected over the tidal shallows. This photo shows a fishing site, not a village. The straw-like structures between the nets are fishtraps which are emptied regularly. The day's catch is salted and sun-dried as future provision and for sale.

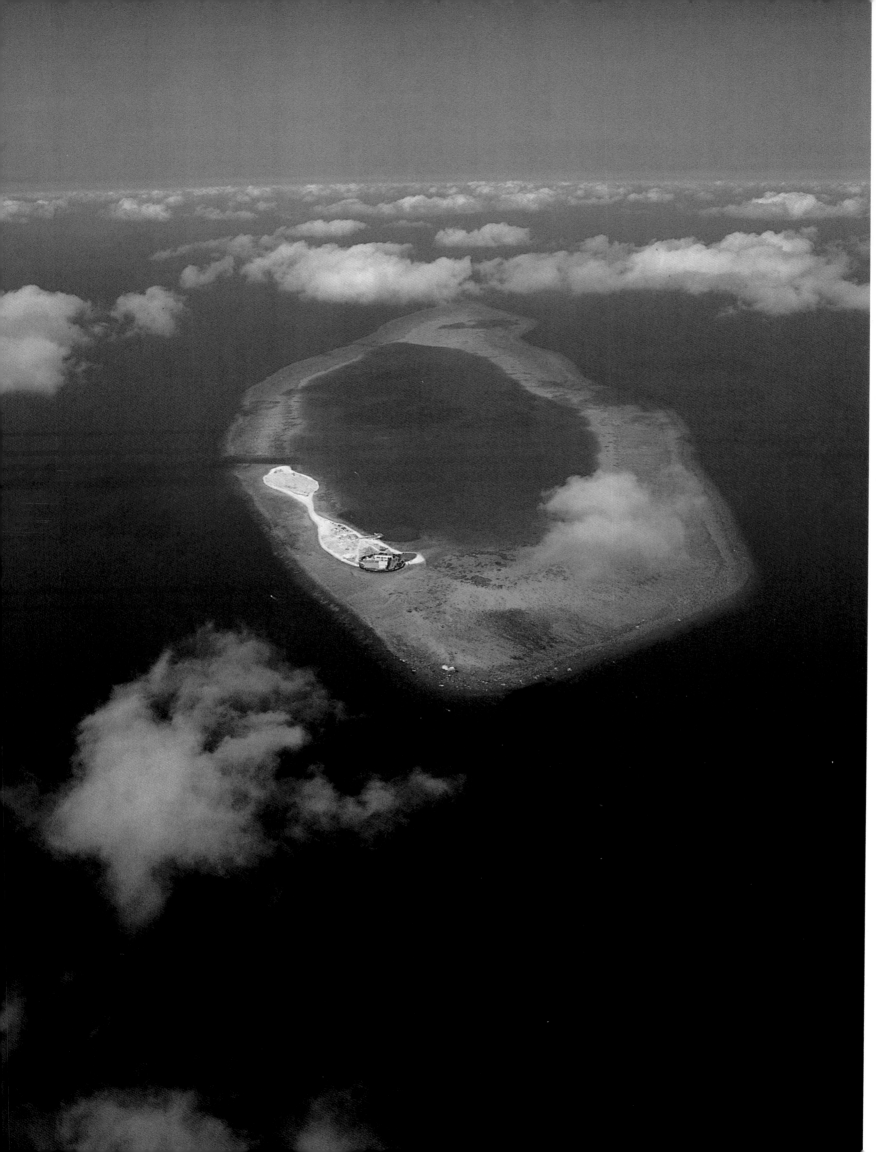

Malaysia's most
far-flung possession,
Terumbu Layang-
Layang is one of the
Spratly Islands, a
scattered chain of
atolls and islets in the
South China Sea, five
hours by helicopter off
the coast of Sabah.
This one is presently
occupied by the
Malaysian Navy,
partly to guard against
encroachments by
Vietnamese or Chinese
forces, who have laid
claim to the island in
the past. One plan is
for the military to
develop the atoll for
tourism, for those
travellers who desire
the experience of
an isolated desert
island.

All the archival research is by John Falconer. Pages 12–13: a photo by Charles Kleingrothe, circa 1907. Copyright John Falconer. Page 14: William Daniell, an aquatint after an oil painting by Capt Robert Smith, "View of Glugor House and Spice Plantations, Prince of Wales Island, Inscribed to the Proprietor, David Browne, Esq", from the *Views of Prince of Wales Island* set published in 1821, courtesy of the British Library. Page 15, top: William Daniell, an aquatint after an oil painting by Capt Robert Smith, "View from the Convalescent Bungalow, Prince of Wales Island", *Views of Prince of Wales Island*, 1821, courtesy of the British Library. Page 15, bottom: William Daniell, aquatint, "View from Strawberry Hill, Prince of Wales Island. The oil painting by Smith from which this aquatint was copied has yet to be discovered. From the *Views of Prince of Wales Island*, 1821, courtesy of the British Library. Pages 16–17: Panoramas, 1884 and 1882, copyright of the Royal Commonwealth Society. All photographs by Guido Alberto Rossi except for pages 10–11, 30–31, 33, 38, 39, 40, 41, 42, 48, 49, 66 and 67 by Tara Sosrowardoyo; pages 18–19, 34, 35, 50, 51, 52–53, 58, 59, 60–61, 63, 121, all by George Gerster; pages 62 and 118–119 by Bernard Hermann; pages 146 and 147 by Alberto Cassio, and page 96 by Rio Helmi. The map on pages 158–159 is produced by Swanston Graphics, Derby, UK. The publishers wish to thank the men and women of the Royal Malaysian Air Force for their assistance and cooperation in the making of this book. In particular, we would like to thank General Tan Sri Hashim Mohd Ali, Chief of the Malaysian Armed Forces, Lt-General Dato Seri Hj. Mohd Yunos Tasi, Chief of the Royal Malaysian Air Force, Colonel Rahim, Sgt Abdullah bin Abdul Rahman, and pilots Capt Ravi Chandran, Capt Omar Shuib, and Maj Prabakaran.

THAILAND

SOUTH CHINA SEA

• Alur Setar

KEDAH

George Town •

PINANG

KELANTAN

• Kuala Terengganu

PERAK

TERENGGANU

• Ipoh

PAHANG

• Kuantan

S. Pahang

SELANGOR

• Kuala Lumpur

• Pelabuhan
Kelang

NEGERI
SEMBILAN

Strait

MELAKA

• Melaka

• Mersing

of

• Muar

• Keluang

Malacca

JOHOR

• Batu Pahat

Johor Baharu •

SINGAPORE

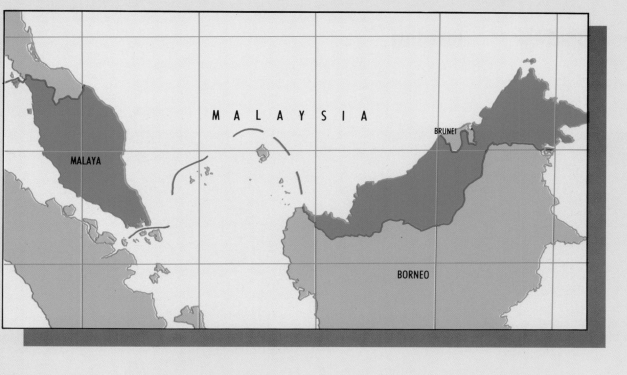

MALAYSIA

MALAYA

BRUNEI

BORNEO

PHILIPPINES

SULU SEA

Balabac Strait

• Kudat
• Senaja

Kota Kinabalu • • Ranau Klagan • Sandakan •
Bingkor • • Beluran
 S A B A H Pintasan •

Bandar Seri Begawan • • Muara
 Seria • WALKER RANGE WITTI RANGE
• Miri **BRUNEI** • Sapulut • Merutai
 • Tawau

 TAMABO RANGE *BRASSEY RANGE*
 • Bareo
 CELEBES

• Pandan • Long Akah *PENAMBO RANGE*
 SEA
 USUN APAU
• Belaga *PLATEAU*

 Merit • Rajang *LINAU BALUI*
• Sibu *PLATEAU*

 S A R A W A K *HOSE MOUNTAINS*

 BOVEN KAPUAS MOUNTAINS

Kuching •
 B O R N E O

Serian •
 KLINGKANG RANGE • Simanggang

 I N D O N E S I A

Makassar Strait

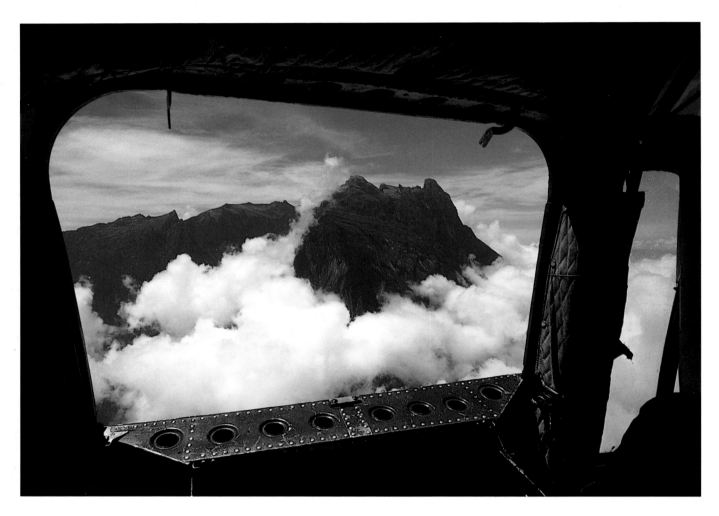

 RESORTS WORLD BHD

This book would not have been possible without the active support of Resorts World Bhd and Malaysia Airlines. MAS' connection with things aerial is obvious enough; Resort World owns Genting Highlands, famous for the near-aerial view from its heights. This book was originally photographed from helicopters of the Royal Malaysian Air Force. Just about the only spot in Malaysia that the helicopters of the Air Malaysian Air Force. Just about the only spot in Malaysia that the helicopters of the Air Force did not manage to top was the peak of Mt Kinabalu.